DATE DUE

FRANK STELLA

AN ILLUSTRATED BIOGRAPHY

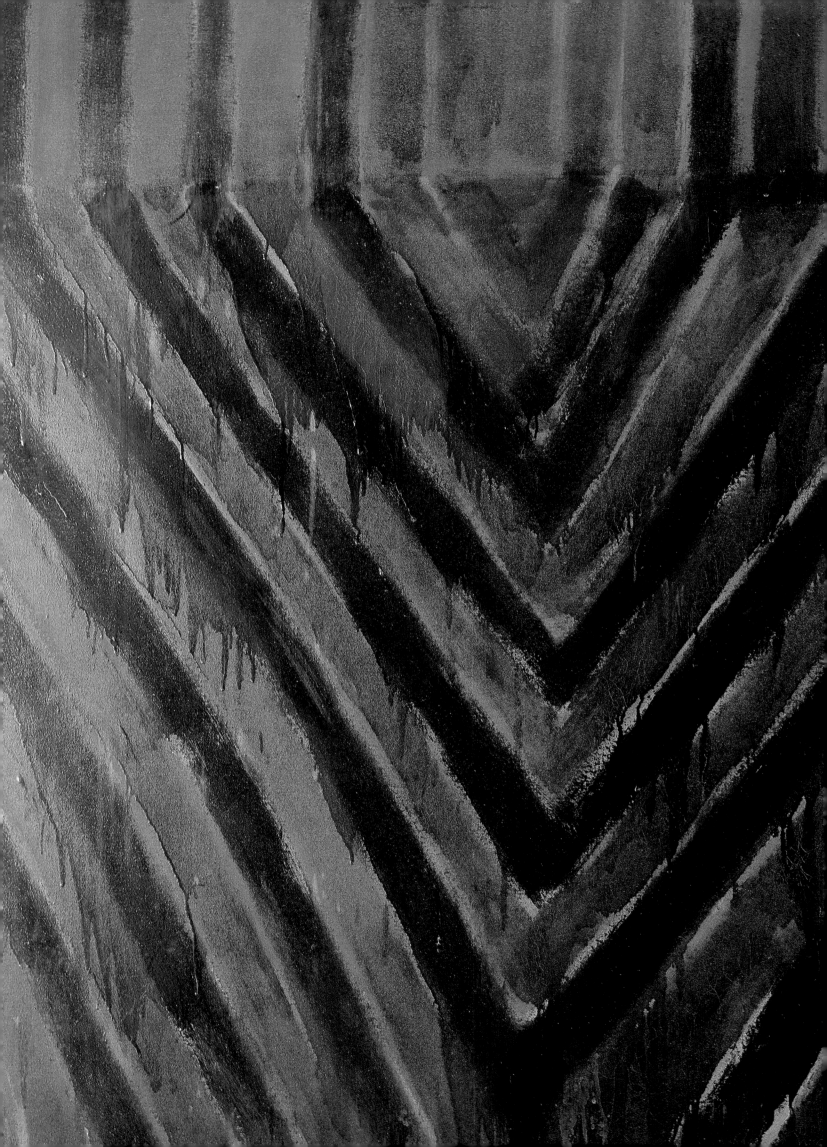

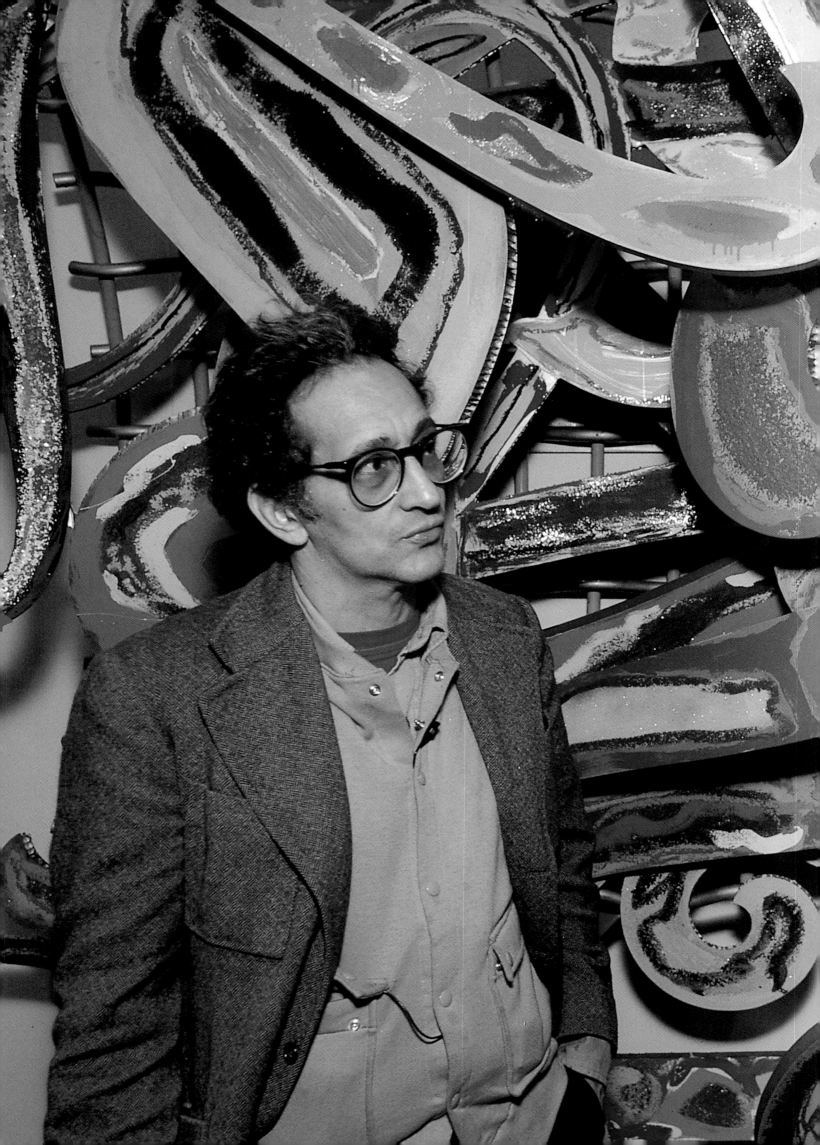

FRANK

AN ILLUSTRATED BIOGRAPHY

STELLA

SIDNEY GUBERMAN

RIZZOLI
NEW YORK

FOR REBECCA WILSON GUBERMAN

First published in the United States of America in 1995 by
RIZZOLI INTERNATIONAL PUBLICATIONS, INC.
300 Park Avenue South
New York, New York 10010

Library of Congress Cataloging-in-Publication Data

Guberman, Sidney
 Frank Stella / by Sidney Guberman.
 p. cm.
 Includes bibliographical references and index.
 ISBN 0-8478-1843-8 (hc)
 1. Stella, Frank. 2. Painters—United States—Biography.
I. Title
ND237.S683G83 1995
759.13—dc20
[B] 95-15120
 CIP

page 2: Detail of *Delta*, 1958.
page 3: Detail of *Sarraguemines,* 1992.
pages 4–5: Stella at the Fogg Art Museum Exhibition, 1983.
pages 8–9: Detail of *Katsura* (#11, 5.5x), 1979.

Designed by Alex Castro
Printed in Japan

ACKNOWLEDGMENTS

In 1991 John McPhee explained to me how to write a proposal for a biography of Frank Stella. The proposal convinced the agent Jacques deSpoelberch that the project and I were worth the risk. My debt to each is considerable.

Frank and Harriet Stella have been consistently helpful and have given generously of their time. Frank's mother, Constance Stella, filled in parts of the picture as no one else could have. Jenny McPhee, my editor, Elizabeth White, project manager at Rizzoli, and Rebecca Guberman, my wife, have all been enthusiastic and of great help with this manuscript. Similarly Paula Pelossi, Frank's former associate, has made significant contributions.

Leo Castelli, Frank Stella's first dealer, deserves special thanks as do Carol Corey of Knoedler & Company and Kay Bearman.

Friends and colleagues of Stella's who provided both support and expertise include Carl Belz, Malcolm Campbell, Earl Childress, Sophie Consagra, Ben Forgey, the late Christian Geelhaar, Stephen Greene, Walter Hopps, Caroline Jones, Robert Kahn, Philip Leider, Bill Matalene, Franz Meyer, David Mirvish, Jerald Ordover, Brenda Richardson, Judy Ringer, Tom Rose, Larry Rubin, Robert Rosenblum, Peter Smith, Paul Sorren, and Erwin Oberwiler.

Any "Life of Stella" must include the now twenty-eight-year collaboration between Frank and Ken Tyler. Ken and his wife, Marabeth, have been selfless and energetic in their support.

Thanks to Judy Barber and The Hambidge Center for providing a cabin in the woods and undistracted time to start the writing, and to Tom Tansell and The Guggenheim Foundation for encouragement that has lasted years after the original fellowship ended.

And special thanks to Richard Meier for his recollections of Frank and his postscript and to William Rubin for his foreword to this book.

S.G.

PUBLISHER'S NOTE

The publication of *Frank Stella: An Illustrated Biography* would not have been possible without the support of Knoedler & Company, New York. We are extremely grateful to Ann Freedman, President, and her colleague Carol Corey, who have assisted us throughout the preparation of the book. Ms. Corey has been particularly helpful in providing transparencies and information about Stella's work from the gallery archives, and our debt to her is substantial.

We would also like to recognize the support of Ron Pizzuti, a major collector of Stella's work, who has contributed significantly to the production of the book.

FOREWORD

Few of the best modern artists have been able to remain on the cutting edge of the avant-garde for more than a decade. Frank has been there almost four, and his work represents the best hope for the art of painting in the face of the challenge from a variety of new modes in the plastic arts that are related in one way or another to "theater." Frank established the basis for Minimalism with his work of 1957–61 and, in subsequent work that invented the "shaped canvas," he re-created himself as a daring colorist. This first phase of Frank's painting gave way in the 1970s to three-dimensional works (first in cardboard and wood and then in metal) in which his painterly "handwriting" took on a life of its own. Since then, he has developed successive series of very contrasting kinds of painted reliefs. These remain essentially within the pictorial framework of the art of painting. But Frank did "spin off" from them a few truly wonderful free-standing sculptures, as well as projects for architecture and for large scale ensembles of architectural murals.

This "second wind," which contradicted the flatness and geometrism of his early work, is still propelling him. Though the materials, morphologies, and handling of his pictures since the mid-1970s seem at opposite extremes to the sobriety, control, and detachment of his early years, there is a clear continuity in the manner of thinking and working. Saul Steinberg once warned me to beware of any artist whose work did not "look like him." I have known Frank well since his very early days and find that the work of what is sometimes called his "second career" looks as much like him as that of the first. Whether submissively controlled or kinetically released, everything Frank develops—the great as well as the things that don't quite come off—contain the vital energy and pictorial plasticity that constitute Frank's greatest gift. When these are strained through his remarkable critical mentality, the results produce images we will be looking at hundreds of years down the pike.

Salta del Mia Sacco, 1986, in Stella's studio.

William Rubin
April 1995

MALDEN AND ANDOVER, MASSACHUSETTS

F rank Philip Stella was born in Malden, Massachusetts, on 12 May 1936. Both of his parents, Frank Stella and Constance Aida Santonnelli Stella, were first-generation Sicilian-Americans, living in what was frequently referred to as a blue-collar town only fifteen miles from the Common in Boston. Dr. Stella, a gynecologist, had studied at Tufts University. Frank's mother had gone to art school.

Frank's early childhood was unremarkable save for one terrible event. On a Sunday afternoon in early spring 1945 Frank and some neighborhood children were playing on the Stella back porch. Concrete urns flanked the stairs leading up to the porch. When one of these toppled and fell, its ninety pounds crushed Frank's left thumb and index finger. A good hand surgeon probably could have saved the fingers, but there were no hand surgeons in Malden. At that time, as Frank Stella himself recalls, "All the good doctors were away in the army. The guy who worked on me had a very vague idea of what he was doing."

Stella lost the first and second joints of his left index finger as a result of the accident and the botched operation. The thumb was so badly damaged that the first joint was removed, and the surgeon mysteriously left his patient with a stunted, rounded-off thumb with no nail except a tiny horn-like protrusion. Stella's career as a pianist was abruptly ended but not before he played a recital piece for three hands with his teacher, who had composed it to make him feel better. The number brought down the house, and according to Stella, all the other piano students hated him for it.

By eighth grade Stella was a wild, street-smart wise guy. Constance Stella had her work cut out for her taking care of Frank and his siblings, Marie

Opposite: detail of *Still Life*, 1954.

Frank Stella in 1937 (below) and in 1941.

Stella at work in his Andover art class in the early 1950s.

and Paul, running the household, and placating Frank's father, who was not an easy man. Dr. Stella regularly put in sixty-hour weeks at his practice, and he was an inveterate handyman around the house, building, fixing, painting. He frequently enlisted Frank in his projects. It was clear to his parents that Frank was very intelligent and that sending him on to Malden High School would only encourage his smart-aleck, pranksterish ways.

About twenty miles from Malden, in Andover, Massachusetts, is Phillips Academy, one of the great secondary schools in America. The fourteen hundred dollars paid by Dr. Stella in the fall of 1950 for Frank's room, board, and tuition for one year was a sacrifice, but both parents expected their children to become well-educated, professional people. Frank had misgivings about going to prep school, but the thrill of getting out of the house and away from his father's glare outweighed his fear of the unknown. After plenty of toughening up on the streets of Malden, he expected that he could hold his own with preppies from New York and Boston. It would help that he loved sports of all kinds and that he was an incredibly quick study.

Bill Matalene, who knew Stella all four years at Andover and roomed with him freshman year at Princeton, recalls their first encounter:

He was playing ping-pong—not just pushing the ball over the net with square little pats of the paddle, but moving his feet and stroking the ball like a tennis player. He dispatched all comers quickly until Vreeland Whitall, from Bermuda, who was a tennis player, took the paddle of the last loser and began returning most of what Frank served up. The Atlantic sun had bleached Whitall's blonde hair and tanned his skin. Frank had a great, foreign-seeming mop of black hair, and he was dark, too, though not from the sun. At first I thought he might be a Negro, but then I saw that he was not. Though we had been at school together for barely an hour, others in the room already knew his name. It was "Stella," and he was tough and cocky. He had a way, as the ball bounced high after a weak return off a difficult "get," of slapping the paddle with his left hand before smashing the ball away for a winner.

When Stella arrived at Andover everything—his clothes, his shoes, his hair—was wrong when judged by the sartorial standards of an eastern prep school. Once he figured it out, he wore the right loafers, the right chinos, and the roll of his button-down collars was according to Brooks Brothers. His unruly hair was cropped close to the head and parted. In the early fifties

manliness was the ideal—as personified by Humphrey Bogart and John Wayne—and the concept of the sensitive soul as hero, embodied by James Dean and Montgomery Clift was a few years away. Manliness counted for a lot at Andover and at the other large eastern secondary schools. If you came to Andover from public school you were manly. Matalene describes Frank's status on this count at Andover:

Most manly were those who had survived the real world of public schooling. Having come to Andover from the working-class Boston suburb of Malden, Frank scored high on this scale. He told us of his fights with the Irish kids who used to lay for him after school to throw the "Guinea" into the Malden River. I had never heard the use of the word "Guinea" before, and since I was used to seeing Buckley boys called for after school by liveried chauffeurs in dark limousines, I admired Frank for the romantic dangers of his past.

Frank got through the first year and a half at Andover without any kind of academic distinction. Then in the spring semester of sophomore year he discovered the art and music course, which first put him in touch with Patrick Morgan.

Bartlett Hayes, head of the art department at Andover and director of its Addison Gallery of American Art, was the embodiment of tweedy conservatism. Though he and Frank gave each other a fairly wide berth, Frank did absorb something of Hayes's philosophy. Hayes believed that everybody had not only the verbal and mathematical aptitudes traditionally focused upon by schools, but perceptual aptitudes as well. The study of the visual arts, he was convinced, is vital to the full development of our power to see. For Hayes, studying meant not only looking but doing. The right kind of study, then, involved not only conventional instruction in art history and art appreciation but studio instruction as well. He reasoned that physics would not be taught without labs and that by the same token, the study of art needed to include studio work.

In the second semester of his second year at Andover, Frank signed up for the art appreciation cum studio course. Patrick Morgan, an abstract painter, not Hayes, was in charge that semester, and he and Frank hit it off. Morgan and his wife, Maud, were both serious artists who visited the galleries in New York regularly and whose personal art collection included

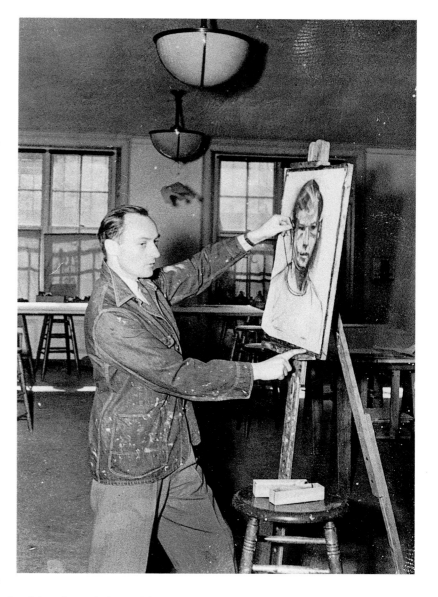

Andover art teacher Patrick Morgan in the studio.

paintings by Hans Hofmann and Arthur Dove. They were generous people and frequently invited students to their house. For Frank, the art on display there was as exciting as the modern section of the Addison Gallery. He loved what he saw and longed to try his hand at painting. To get into Pat Morgan's painting major was another matter. Stella recalls:

It is hard to gauge the significance of first experience with endeavors that later become the working, effortful focus of one's life. At Andover, I was already interested in art, but the opportunities seemed to thrust themselves at me. The idea that in the midst of a grinding mechanism of elite education, Andover offered an oasis of self-indulgence and pleasure—a major course in studio art, eight hours a week in which one could smear free cadmium red around on shellacked cardboard rather than face the chemistry lab—seemed unbelievable. When I signed up for a preliminary prerequisite course, half art history and half studio, I was very anxious. I wanted to qualify for the major course.

The painting studios were in the basement of the Addison Gallery, which sits at the top of a great expanse of lawn rising gently from the town's main street. The collection includes the work of Stuart Davis, Edward Hopper, Winslow Homer, and John Sloan, to name but a few—what Stella has described as a concise, up-to-date history of American painting.

The "try-out" for Morgan's course amounted to painting a still life of something in the studio, and Frank's something was some sickly ivy coming out of a pot. At first he could think only that he didn't want to learn to paint anything so dreary; he wanted to paint something like the recent American abstract paintings in the gallery upstairs and at the Morgans' house. He began to daydream, seeing some of the paintings he admired and then thinking of the teacher, Pat Morgan, sitting in the corner by the north window, working on fairly small abstract paintings. He has said that he liked the naturalness of Morgan's commitment to abstraction, as well as "the precocious intensity of the work of some of the advanced students, hipsters like Hollis Frampton and Carl Andre." He remembers:

I started dreaming of a big black-and-white Franz Kline. I wanted to make abstract paintings, paintings with just paint A lecture about Seurat and the post-Impressionists started to replay itself in my mind—daubs of pigment on top of each other and next to each other, mixing optically to create the complementary colors observed in nature. Then I looked at the vine on the table, at the shadows and the play of light. I did not see anything that reminded me of Seurat, just as the slides of Seurat paintings that I had seen had not reminded me of anything other than a reductive static scheme of things I might have seen. That was it. My fingers tapped the equation on the counter top: static scheme plus daubs of pigment equal a still-life painting. Problem solved.

Of the moment he has said, "My elation carried me pretty high."[1]

Between Frank and his father there was an unspoken agreement that he would go to a great college, to graduate school, probably in law, and have a profession. "Real life doesn't leave you much time for what you love," was Dr. Stella's credo according to Frank. If Frank had tried, in 1952 or at any time along the way to his improbably great success, to explain to his father that through painting he experienced a kind of elation which could propel him for the rest of his life, it is fairly safe to assume that Dr. Stella would not have been sympathetic.

Stella in his Andover graduation photo.

A second violent accident at Andover in 1953 left Frank further disfigured. Some students in a dorm lounge were engaged in a kind of horseplay that consisted of covering one of them with a blanket while the others hugged the walls trying to avoid the flailing, churning fists and arms of the hooded one. Frank happened along and in an exquisitely timed moment walked into the figure's abruptly rising elbow. More pain and blood, and this time the loss amounted to the upper four front teeth. Three were knocked out by the blow; the fourth was removed with the braces that were to have come off in a couple of weeks.

When Stella entered Phillips Andover Academy in the fall of 1950 there were fewer than 900 students, all boys. He was five feet tall and weighed 138 pounds; by the time he graduated in June 1954 he was 5'8" and weighed 130 pounds. Besides growing up, his dedication to wrestling and lacrosse contributed greatly to the dramatic changes in his physique. His father was a complete zealot for wrestling. He attended all the varsity meets for Frank's two seasons, and during Frank's bouts, he would frequently work his way down from his seat in the stands to take up a four-point position on the edge of the mat itself. He was reprimanded more than once by the referee.

More remarkable were the clinics he would give in Frank's room following home meets. He could remember every error Frank had made and most of the mistakes committed by the rest of the team. The demonstrations were strictly hands-on, and the room and the hall outside the door were packed. Frank won two varsity letters, and by March of his senior year he was good enough to earn runner-up honors in the national A.A.U. competition, wrestling in the 132-pound category.

As for lacrosse, he had never seen it played before he got to Andover, but the game appealed to him. By junior year he was fast and tricky, the kind of athlete sportswriters like to call "nifty." Matalene recalls:

In the spring, on the lawn behind Will Hall and in front of Junior House, Frank could often be seen practicing lacrosse with the old, sawed-off attack stick that I think he used for as long as he had anything to do with the game. There were embellishments in Frank's recreational lacrosse. He didn't just play catch, he put on an exhibition. He ducked and pirouetted, sliding off imaginary defense men before delivering the ball back to his partner.

By senior year he was a varsity attackman, and named to the third all-New England high school lacrosse team.

Stella's parents, Dr. Frank and Constance Stella.

The Stellas wanted the best for Frank, and just as the best high school was Phillips Andover, Dr. Stella determined that Harvard, Yale, and Princeton were the best colleges. "If you want to go someplace else," he told Frank, "you can pay your own way." Frank had given the matter some thought. Harvard was too close to home. About seventy guys were going to Yale, and he felt he had seen enough of most of them. He knew almost nothing about Princeton and decided that was good enough reason to plan on spending the next four years there. Both Harvard and Yale offered some studio courses in art. Princeton in those days offered none.

Still Life, 1954
oil on paper
Addison Gallery of American Art,
Phillips Academy, Andover,
Massachusetts.

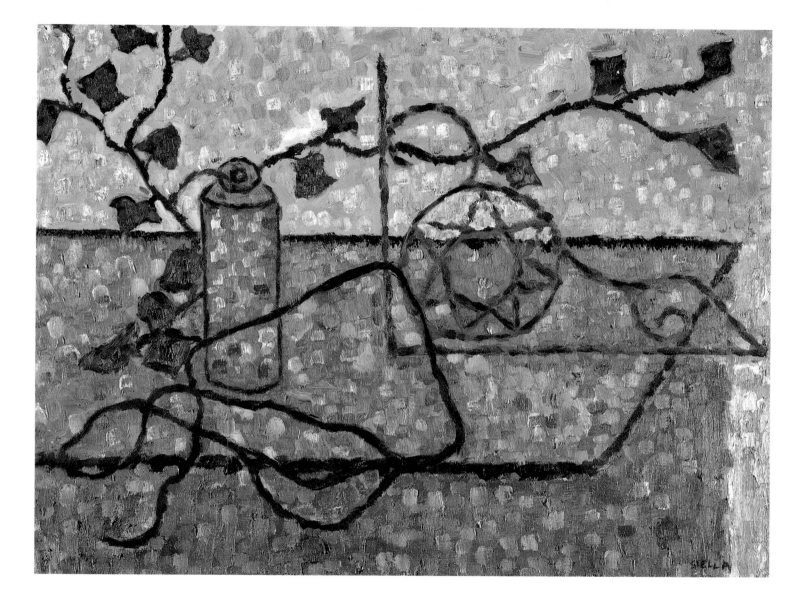

PRINCETON, NEW JERSEY — VISITS TO MANHATTAN

Stella's transcript for his four years at Princeton shows a predominance of courses in the art history department, regarded in those days as one of the country's best. His grades were ones (Princeton's grading system until 1970s was on a one to seven scale) in art history and in the studio courses once they were offered for credit, but if he was bored by a course he would stop going to the lectures and hope for a passing grade on the exam. With the complicity of his advisor, Norman Kantor, he managed to turn a history major into a two-year investigation of various aspects of early Christian art.

Sports soon fell by the wayside. He went out for freshman wrestling, but quit after a week. In the spring he was starting attackman on the freshman lacrosse team, but gave it up by sophomore year.

The first time I met Frank Stella was in his dorm room in the early spring of 1955. I had gone there with one of his roommates, Tom Rose. Frank was sitting on a sofa working on a small abstract painting that was balanced on the edge of the coffee table. I asked, "Who's the painter?" He replied, "Who wants to know?" Our brief conversation took place toward the end of freshman year, but Frank and I didn't become friends until we were juniors, a year and a half later. I remember leaving his room after that first encounter amazed that a student at Princeton was actually painting.

William Seitz was an art historian, lecturer in twentieth-century art, and curator of exhibitions of nineteenth and twentieth-century painting at Princeton. He was also an abstract painter. It was Seitz who had organized the first not-for-credit painting studio at Princeton. When Stella heard about the course, he took some of his paintings to Seitz, who invited him

Opposite: detail of *Tundra*, 1958.

Above: Frank Stella at Princeton in the 1950s.

to join the informal group of students painting at night in one of the architectural drawing studios. Stella accepted and immediately became friends with a senior, a dashing handsome fellow and a serious painter, Darby Bannard, now Walter Darby Bannard. No supplies of any kind were provided by the university, but Bannard could always come up with oil paints. Frank and Darby became friends, and Frank benefited from his largesse with his paints.

Seitz was a lovely man, generous and secure, and a good teacher of painting. He would remind Stella to "watch the edges," and when he would say of a work in progress, "that's interesting," it meant that the painting had a long way to go. Seitz encouraged Stella to go to the galleries in New York City as often as he could.

When Frank went home after his sophomore year at Princeton, his father enlisted him to work around the family's summer house at Ipswich. The project was to build a stone wall behind the house. One morning Frank got up, left the house, walked right by the unfinished wall, and kept going until he got to the highway, where he stuck out his thumb.

Stella's Andover friend Matalene was working as a trainee in my father's

Stella and Stephen Greene.

clothing store in Colorado Springs, and Colorado Springs became Frank's destination. He stayed only a few days. We played a lot of ping-pong. My father and I had set up a table in the garage and I thought I was pretty good. Against Frank I seldom got ten points in a game.

My mother had one of the few abstract paintings in Colorado Springs at the time, a Jean-Paul Riopelle, thick paints right out of the tube, loaded onto a palette knife and smushed down on the canvas. Frank gave it a hard look but didn't say anything.

"But don't you like it, Frank?" pressed my mother.

"It's okay." End of conversation.

After a few days he took off for New Orleans to hear some jazz. He didn't call home until he got to New Orleans.

When Frank, now a junior, returned to Princeton in the fall of 1956, he began dropping by my room in Blair Hall from time to time. I was an architecture major with a serious interest in painting but it hadn't occurred to me that painting was something one could do for a living. I often made small, sentimental collages (of which Frank dubbed me the master) to send to girls, and a few times we

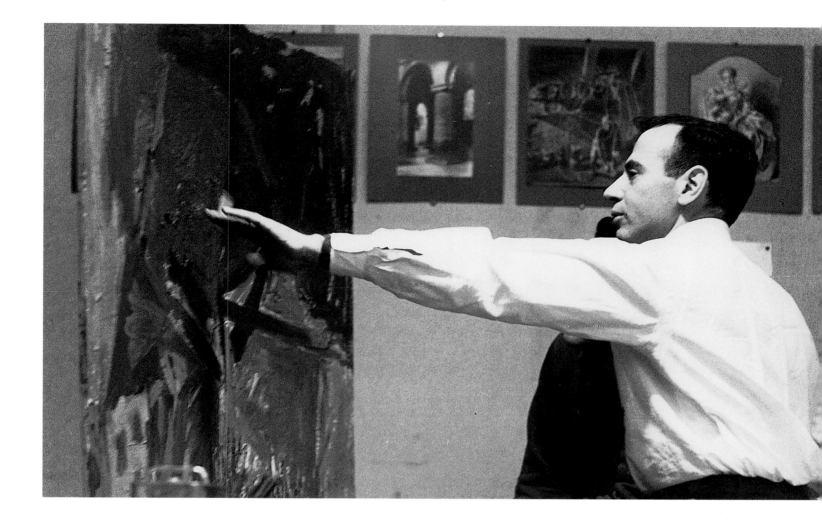

Greene teaching in the Princeton studio.

collaborated, sitting on the floor, cutting up magazines, tickets, programs, letters, telegrams—and even old books bought for the purpose for dimes and quarters at the Firestone Library's sales—to glue up. We both admired Kurt Schwitters but never quite got to his level of well-calculated elegance.

In 1956 at Seitz's urging and after an extended search, Princeton created an artist-in-residence position. Stephen Greene, a good painter who was well known on the New York scene, was hired by the university. For the first time in Princeton's history, studio classes in painting and drawing were given for credit. Greene taught painting two nights a week and drawing one night. He was surprised to find a painter of Stella's dedication and ability at Princeton.

The following winter I did a series of India ink drawings on full sheets of *The New York Times.* They were pinned to and filled an entire wall of the room. Frank came by when I wasn't there, removed the drawings, and took them to Steve Greene, who was impressed enough to send word that I could be in his painting course in the fall.

The second he finished his last exam in the spring of 1957 Frank went back to Ipswich. Three weeks later he wrote me a letter full of the usual irony, sarcastic comments on his painting and mine, and, between the lines, his boredom and frustration at the prospect of spending an entire summer in Ipswich. He refers to Lena, a Swedish exchange student at Vassar whom I had been dating.

Frank Philip Stella *G and L Club*
June 26, 1957
Ipswich, Mass
Scattered Showers

Dear Sidney,

I am writing from Ipswich-by-the-Sea as you can see from the heading mainly because of bad weather. The northeast wind threatens rain and threatening rain prevents me from painting the house, the task which presently occupies my creative energies. For my own amusement and my father's dismay I have stretched and sized a 7 by 5 foot canvas which is too big to go down the narrow attic stairway. What I have painted is too bad to ever go out of the attic, so the problem cancels itself out. Painting big pictures is tiring, but fun and I hope to make at least 5 big frames before the summer is out, though I am already feeling the press of time.

Please write and tell me the details of the projected Odyssey to Mexico so I can savour them. I am trying to rationalize myself into a position where I will be thankful that I am not going to Mexico, but it is equally stupid and hopeless as any rationalization. The saddest part is that I could have had a ride to Colorado with some friends who were driving to the West Coast. They left yesterday.

I have no sympathies for your mother's concerns over Lena. I think she will be real easy to please. Although she obviously won't make the ideal house guest like Frisbee Long or Wild Bill Matalene. I am also extremely jealous that you will be engaging her time with petty physical pursuits rather than with a stimulating insight into scenic Colorado and American cultural problems as would befit the proper host.

Don't forget to paint a lot of pictures, because I told Mr. Greene that you would probably paint something good in spite of yourself and I don't want to be more of a bum than I already am painting bad pictures and recommending worse ones. Paint in Mexico. Don't worry about traveling and seeing every thing, you can do all that after you're dead. You will be reincarnated as a TWA pilot so don't worry.

I hope (sincerely) that you have been a credit to your community, your school, yourself, your parents and your club during the recent crucial matches. I hope that you will continue to be a gentleman in all things.

> *With deepest sincerity,*
> *Frank P. Stella*

By fall semester 1957, Frank was producing paintings of two kinds: very thick gestural action paintings, built up with spackle and inspired undoubtedly by Franz Kline and Willem de Kooning, and smaller paintings controlled and delicate, with exquisite balance and color arrangements suggesting a meeting of Paul Klee and Nicholas de Stael. He also took a shot at an enormous (six by six foot) compartmented wall construction

with scores of found objects as well as raggedly painted areas. Architecture students would bring their dates to look at it for the shock value alone. A couple of dismembered dolls and their various parts added a particularly gruesome note. Since there was no storage space in or near the painting studio, Frank gave away most of what he did.

About the time Frank was told he had to get the wall construction out of the building, our classmate John Taylor asked if he could have it in his room. The three of us got it out of McCormick and across to Taylor's second-floor room in Little Hall, where it stayed until the day after graduation, when the janitors destroyed it and threw out the pieces.

That fall in a burst of organization, Frank applied for a Fulbright to Japan. We carried seven or eight of the paintings to the back of McCarter Theater to photograph them to support the application. The slides came out fine, but the application was turned down. A professor, a graduate student in architecture, and one of our classmates later bought three of the paintings.

If Andover had provided a friendly climate for painting, Princeton was mostly indifferent if not hostile. The studio was, in fact, the architectural drawing classroom of William Shellman, an elegant, effete Savannah aristocrat. He hated the painters in general and Stella in particular. Those of us in the painting course from the architecture program he regarded as traitors.

McCormick Hall, a real hybrid—a quasi-Mediterranean villa with ceramic tile roofs, towers, and turrets—contained the archaeology department, the architecture department, the art history department, the art and architecture library, the slide library, all of the architecture studios, all of the art history classrooms, and a beautiful courtyard surrounded on three sides by a glass-enclosed cloister. Antioch court was decorated, inside and out, with mosaics that had been brought over from the university's dig in southern Turkey. It was a mazelike building which attracted the art historians, the architects, the archaeologists, and the thousands of undergraduates— over the years—who took courses in these departments outside their own majors.

From the turn of the century until the mid-1960s, the university's philosophy had been to put the architects, the art historians, and the archaeologists, and all their books together in the same building. When the administration somewhat reluctantly added studio courses in 1956, the only site on campus that made sense was McCormick Hall. Putting this diverse group—the painters—into the same idiosyncratic building provided a natural cheering squad. Of the people who actually bought paintings from Stella between 1957 and 1960, Robert Rosenblum, James Holderbaum, and Malcolm Campbell were on the art history faculty. Keith Kroeger and Willis Mills were architects. Rosenblum has been important to Stella's career from the beginning. Had Rosenblum's classroom and Shellman's drawing studio not been in close proximity, it is reasonable to

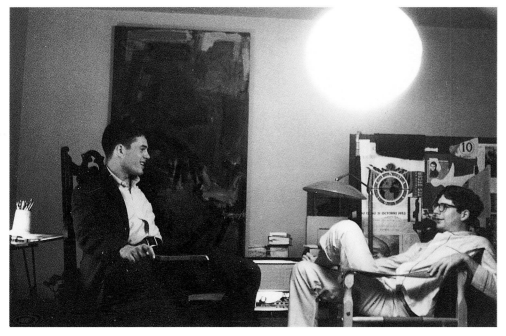

Bardyl Tirana and John Taylor in Sidney Guberman's dorm room. The painting is one of Stella's student works.

assume that the former might not have known about the "the genius making those huge paintings."

Generally the handful of students in Greene's course didn't stretch linen across wooden stretchers, then go through the accepted ritual of preparing the canvas with sizing and gesso. Some people did buy presized canvas, but plywood and masonite were popular because they were so cheap. *Funeral for Mrs. Beck,* one of Frank's paintings in the Antioch court show at the end of the year, had once been a piece of scenery known as a flat from the Theatre Intime's fall production of *The Rainmaker.* The show's director, David Sawyer, was also in Greene's class and invited us to design and produce the sets. Neither Frank nor I had ever made a set before but we designed and built and painted the three-part set. As for the theft of the flat, nearly six feet on a side, nobody said anything about it.

Ten years later Frank would design the sets and costumes for dancer Merce Cunningham's Scramble, performed in August 1967 at the Connecticut College Dance Festival and repeated in December at the Brooklyn Academy of Music.

Often at the end of the painting studios, after the other students had left, Frank and I would prop up what we had been working on, pull up two chairs, and look at the work. Frank would light up a Lucky Strike. Discussion would follow about how to fix or improve the paintings. While I rather liked these critiques, Frank was beginning to resist any concern for what to put where.

In early 1960 Frank gave a talk to students at the Pratt Institute in New York dealing with the problems of painting as he saw them, including the arbitrary aspect of the enterprise:

After looking comes imitating. In my own case it was at first a largely technical immersion. How did Kline put down that color? Brush or knife or both[?] Why did Guston leave the canvas bare at the edges? Why did Helen Frankenthaler use unsized canvas? And so on. Then, and this was the most dangerous part, I began to try to imitate the intellectual and emotional processes of the painters I saw. So that rainy winter days in the city would force me to paint Gandy Brodies as [a] bright, clear day at the shore would invariably lead me to DeStaels. I would discover rose madder and add orange to make a Hofmann. Fortunately, one can stand only so much of this sort of thing. I got tired of other people's painting and began to make my own paintings. I found, however, that I not only got tired of looking at my

own paintings but that I also didn't like painting them at all. The painterly prob-
lems of what to put here and there and how to do it to make it go with what was
already there, became more and more difficult and the solutions more and more
unsatisfactory. Until finally it became obvious that there had to be a better way.[1]

In the fall of 1957 I began joining Frank on his trips to New York to visit
the galleries and the Museum of Modern Art and the Whitney, which were
contiguous at the time. In January 1958 during the break between final
exams and beginning of spring semester we took the train into New York
to see the Jasper Johns show at the elegant Castelli Gallery at 4 East 77th
Street, a stunning location within fifty yards of Fifth Avenue and Central
Park beyond. Targets and flags. Some of the target paintings had little
wooden compartments built onto the top. Each compartment had a little
door and contained plaster replicas of body parts painted in various bright
colors including a nose, an ear, a penis, and so on. The viewer could par-
ticipate by opening and closing the little doors of the compartments.
Frank was not so interested in that aspect of the paintings. He was clearly
impressed with the targets and more so with the flags. Within a few days
he began to make paintings with ragged stripes and rectangles. They were
mostly flaglike paintings and mostly much larger than Johns's.

In "A Perfect Day for Bananafish," J. D. Salinger has Seymour Glass com-
mit suicide in a Miami Beach hotel room. We both had read and admired
the story. Stella had, since I had gotten to know him well, spoken often of
life's boredom and the certainty of not needing to live beyond forty.

A Perfect Day for Bananafish, a big painting, mostly ocher with a delicate
band of pink no more than eight inches deep running across its top, is
divided into smaller zones by a vertical grouping of stacked rectangles—
yellow, magenta, gray—and a wide horizontal band along the right three
quarters of the canvas, supporting the pink, made up of ragged white and
blue over gray stripes. The painting was nearly completed and was stand-
ing against the wall in the Princeton studio sometime in late February
1958. Stephen Greene happened by the empty studio, appraised the paint-
ing and knew, I suspect, not only the implications of this striking arrange-
ment of stripes and rectangles, but also what it portended. With a handy
brush charged with paint thinner and blue paint he wrote across the top
of the painting "God bless America." Stella didn't speak to Greene for
days. Greene says it was an impulse that he still regrets and that he never
doubted for a second Stella's sincerity and commitment.

In early 1958 there was a show of our work—Stephen Greene's
Princeton students—at the Y.M.H.A. at 92nd Street in New York. The
lobby outside the auditorium was used as an exhibition space. We all were
very proud of the way the show looked, and Frank and I received letters
from people who had seen it, offering to buy paintings.

Frank recommended two books senior year. One was Billie Holiday's
great heart-wrenching autobiography, *Lady Sings The Blues,* which details a

life that was mostly misery, drugs, and disappointment, mixed only occasionally with the real satisfaction of a song or group of songs well sung with some of the jazz greats of the thirties and forties. The other, recommended as "the only novel you need to read," was Ford Maddox Ford's *The Good Soldier*, a beautifully structured work dealing with passions, sex, position, privilege, and slavery to custom and money, and death. The cover drawing for the Vintage paperback, which was in print for over thirty years, was by our friend and mentor, Steve Greene.

Spring 1958 was a busy time for Stella. He completed a dozen or so paintings, did a few covers for *The Nassau Literary Magazine*, passed all his courses, and, almost as an afterthought, wrote a senior thesis on early Christian art in Ireland. Casually, not having played in nearly three years and nearly a month after the season had started, he went out for varsity lacrosse. Coach Ferris Thompson and Frank disliked each other but the team needed a scoring punch. Within two weeks, Stella was a starting attackman.

Early May can provide days in central New Jersey that are not unlike Georgia in early April. Clear, dry, warm, with bright blue sky and the air full of the scent of magnolia, which blazes into bloom a month after it does in Augusta. On 3 May 1958 my father and I walked across the campus and down Prospect Street to the old lacrosse field where Princeton was playing West Point, two of the best teams in the country. I had never seen Frank play in a game before. What I saw was amazing and at the same time not surprising. Early in the second half he broke down the left side between the center of the field and Army's goal. As he cut sharply right on a path paralleling the goal mouth, he picked up a pass and ran, cradling the ball until he was in front of the goal, twenty feet out. Two enormous West Point defenders converged on the expected line of flight of the shot. Stella faked a high, hard one, the big fellows collided, their sticks rattling above their heads. The goalie leaped high to make the save, and the ball, fired underhand, scorching the grass, entered the goal untouched. That score—including the plan, the path, the fake, and the shot—offers plenty of information on the player. And the artist. Had he played in the last game of the year, against Yale, he would have received a varsity P. He quit

Nude after Laschaise, 1958
green pencil, 9 x 5½"
Kunstmuseum, Basel.

the team a couple of days before the game because, he said, "I don't want Ferris to have the satisfaction of giving me a letter."

On Wednesday, 21 May 1958, an article ran in *The Daily Princetonian,* the student newspaper, under the headline, "Freedom of Expression in Antioch Court," with the byline Thomas A. Carnicelli. It was a review of a show of paintings by undergraduates at a college with no formal painting curriculum hung on walls reserved for drawings of architecture students. It was notable too that at least half the paintings were abstractions. Carnicelli wrote:

Stella's painting is characterized by audacious yet usually harmonious colors, variety and intricacy of shapes, variety of textures, and an overall sense of spontaneity and power. When these qualities are linked with compositional unity, the results are exceptional: Funeral for Mrs. Beck *and* Venice Lagoon *are the two highlights of the exhibition. When the compositional unity is lacking, the result is a painting like* Demise of Peter Rabbit, *a confusion of incredibly well painted passages, but a confusion nevertheless.*

In August 1991, as Stella and I were walking across Washington Square, he pointed to the New York University Law School and said, "That's where I was going. There or Columbia. I didn't really tell myself that I had no intention of going to law school until a few days before graduation."

Frank could have told his father that he hadn't made plans that included law school in the fall, that instead his plans were to move to Manhattan in order to paint. But he said nothing, avoiding the blow-up likely to follow the airing of so crazy a scheme.

Sketch for one of the Transitional Paintings, 1958
grease pencil on paper
9 x 5½"
Kunstmuseum, Basel.

Perfect Day for Banana Fish, 1958
oil on canvas, 76¼ × 102¾".

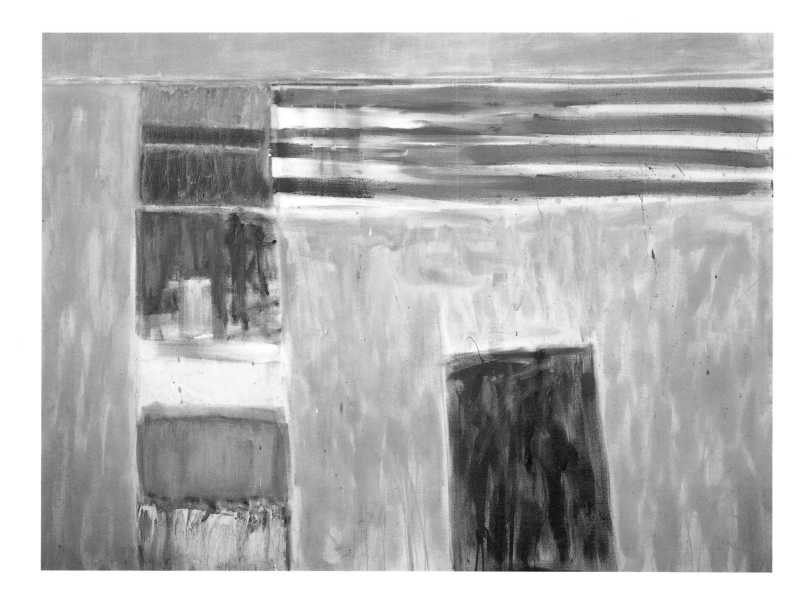

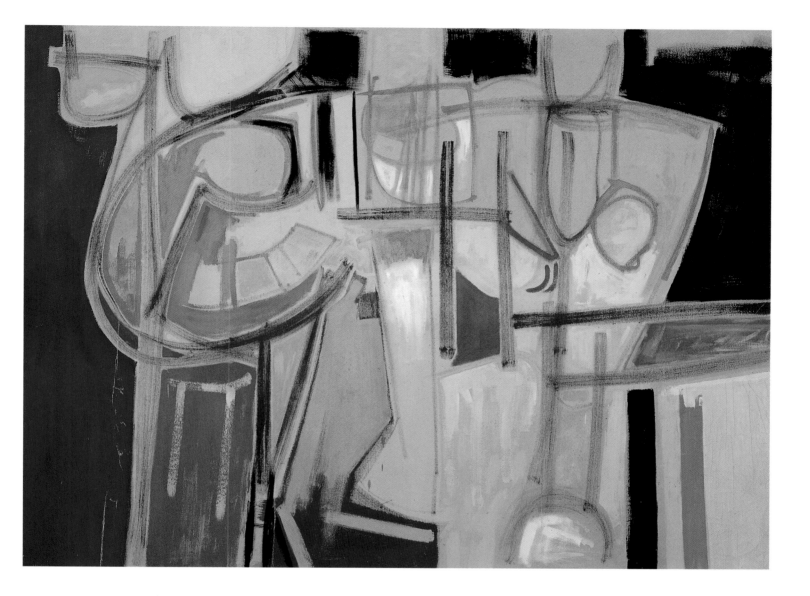

The Hunt, 1957
oil on canvas, 85 × 60½"

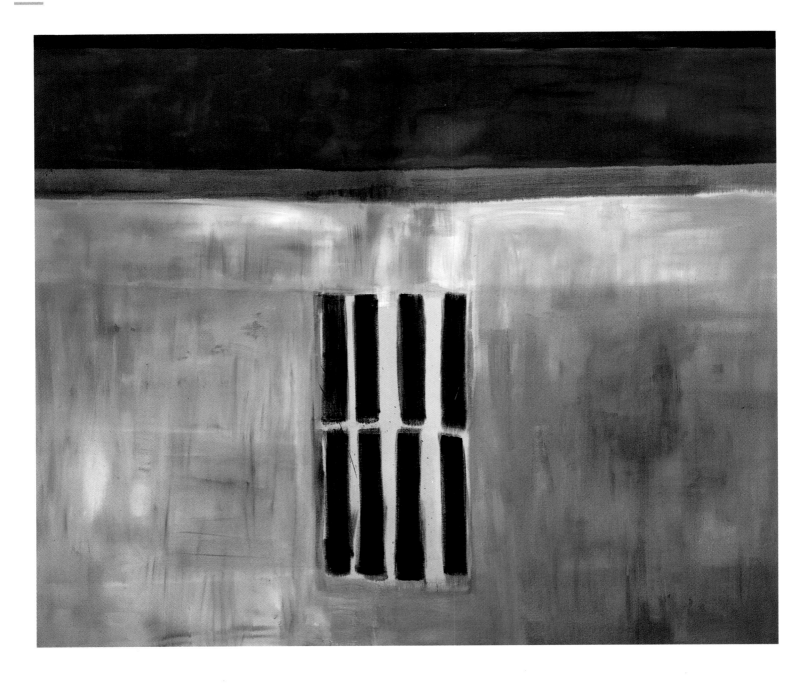

Tundra, 1958
oil on canvas, 73¼ × 98½".

West Broadway, 1958
oil on canvas, 78⅝ × 90¾"
Kunstmuseum, Basel.

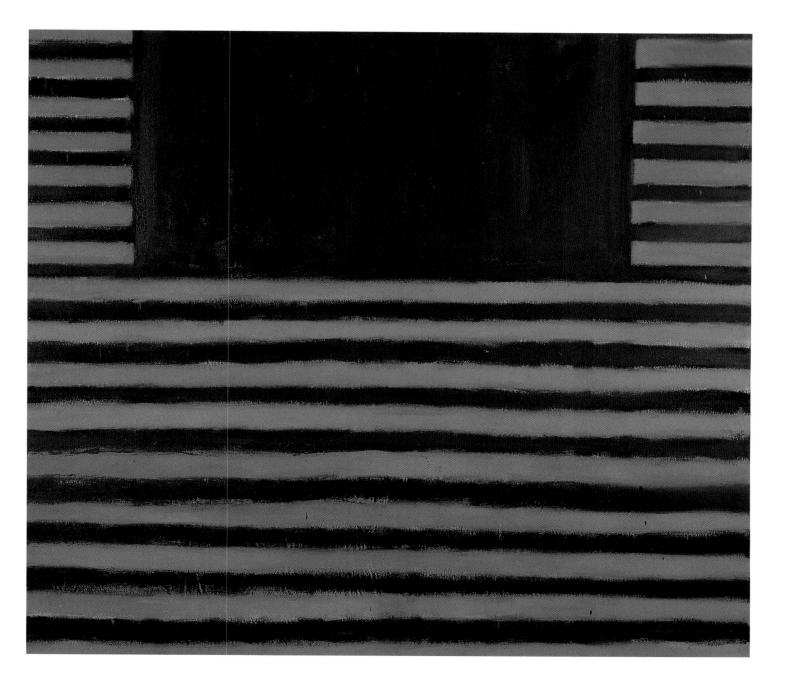

3

TO NEW YORK, SIXTEEN AMERICANS AT MOMA

Stella's early flowering of talent and promise were a given to anyone who knew anything about him. But most people knew very little other than that the artist was young and that he had graduated from Andover and Princeton. In *The New Yorker*, 23 September 1991, George Steiner wrote of Goethe in his review of Nicholas Boyle's biography *Goethe: The Poet and the Age*: "The point is not easy to make, but crucial: No other genius has had so much good luck in being in the right place at the right time." I believe this statement applies equally to Frank Stella. The genius part has long since been established. A close look at some of the events of late 1958 and 1959 reveals that his gift and his industry coupled with his consistent good luck—of being in the right place at the right time—propelled him to the forefront of American art and, by the time he was thirty, to recognition as one of the greatest living artists.

A month after graduation, Frank was working and living in a narrow store-front on Eldridge Street, near the Manhattan Bridge. His space was filled with home-built stretchers, canvas, paint, and paintings in progress. All the stretchers were more than six feet on a side and he was painting directly onto unsized cotton duck. Students are told that the oil in paint will rot unsized canvas, but Stella was using cheap oil-based house paint that he bought on Essex Street for no more than a couple of dollars a gallon— colors people didn't want. "I was doing nothing but painting every day for about a month," he wrote of those early post-Princeton days. "I was managing to stretch a graduation present of three hundred dollars into a

Opposite: detail of *Getty Tomb*, 1958.

summer vacation on Eldridge Street, a street that is part of the heart of the Lower East Side, which, in turn was to me the heart of the practicing part of the New York art world." He was not being entirely ironic in calling his stay in New York a summer vacation. He was doing what he liked to do best, and he knew it had to end in September when he was scheduled to go home to be drafted. As Stella himself has frequently pointed out, he and New York were just right for each other: "If you're going to be a painter, New York is the best place to do it."

In the summer of 1958, New York *was* a kinder, gentler place for an artist. A subway ride cost him a dime, he would rarely spend more than three dollars a day on food, a pack of Luckies would last him a week, and he seldom drank anything stronger than orange soda. The Museum of Modern Art, the Met, and the Frick were free. His only expensive vice was painting. For three hundred dollars on July 1, he probably got something like this: two months' rent (a hundred dollars), canvas, wood, and paint (a hundred dollars), food, fares, and Luckies (a hundred dollars). His mother was sending him a little money, and between January 1958 and January 1960 he sold several paintings in the seventy-five- to two-hundred-dollar range to friends, mostly in Princeton.

After seeing the Johns show in January, Frank stopped making paintings reminiscent of Franz Kline or Willem de Kooning. On Eldridge Street he continued his in-depth examination in painting of the possibilities of squares or rectangles as well as stripes—the wide, ragged bands of alternating colors. Many of the paintings began as pencil sketches on paper. Stella gave these drawings to the Kunstmuseum in Basel, Switzerland, in 1977 and they were included in an exhibition of his working drawings in 1980. The catalog to this exhibition included the drawings he made on Eldridge Street. Dr. Christian Geelhaar, curator of the exhibition and author of the catalog, bought two important paintings for the museum. Stella also sold him *Green Grate*, done in the fall of 1958. It is a hauntingly beautiful painting—a sketch as Stella termed it—in greens and black, almost seven feet on a side. The actual painting is still very loose and with plenty of evidence of painting-over, of problems being worked out on the canvas itself.

As for the solitude that is a part of being a painter, he seemed well equipped to deal with it. If he needed company he would get on the train or hitchhike back to Princeton and spend the weekend with Darby Bannard and his wife, Kit.

Right after Labor Day Frank went up to Boston for a pre-induction physical. He had understood that there would be several weeks grace between the physical and actually getting drafted, so he had locked the door at Eldridge Street, leaving it full of new paintings, materials, and his few possessions. In the course of the physical, the examining physician asked him to take an envelope between his left thumb and forefinger, the ones which had been badly damaged in 1945. The test was to pinch the

envelope so hard that the doctor couldn't pull it away. But Stella didn't have the necessary pinch. He was designated 4-F on the grounds that he had "faulty opposition" between thumb and forefinger. Frank was stunned. It had never occurred to him that he might not be drafted. After the exam he didn't go by the house. The thought of explaining to his father that he was not going into the military and instead was returning to New York to continue painting was worse than daunting. As far as Dr. Stella was concerned, painter was simply not a proper metier—certainly not after Andover and Princeton. "What had felt like a summer vacation suddenly looked like the rest of my life." He knew for sure what he wanted to do. The problem was to figure out how to get enough money to keep doing it.

Frank has always maintained that painting's two major problems are "what to paint and how to paint it." He had solved the latter and was very close to solving the former. That fall, the other two problems, how to get the money to keep painting and how to get the work seen, were beginning to look like they had solutions as well.

He signed on with a few employment agencies as a house painter, his only marketable skill, learned from helping his father paint their houses. His most regular employer was J. Huriash, who worked out of Astoria, Queens. He got plenty of jobs, usually for two or three days at a time, which gave him enough money for his needs and left time to paint. Another serious problem was space. He had filled up the room on Eldridge Street. In the early fall he moved to a small loft on the second floor over a diner, the Purity Lunch, at 366 West Broadway. Today that address is considered chic, in the heart of Soho, home of smart shops and restaurants and prestigious art galleries, but in 1958 the area was commercial/industrial with empty buildings, cheap space, and still mostly undiscovered by other artists.

During the summer Stella ran into Carl Andre, one of the fellow painting students he had known at Andover. Even though, according to Stella, they had not known each other well they had plenty to talk about. When Carl Andre saw what Stella was up to in the studio on Eldridge Street and the extent of the commitment, he was astounded.

Frank showed me the colored stripe paintings, the stripe paintings before the black ones, very beautiful paintings. I looked at them and thought that Frank was a lunatic. I thought he had probably gone off the deep end, because my idea of art was still related to some kind of abstraction from something outside of art—it had to be derived from paintings and have that interior logic, but to me they just looked blank.[1]

Delta, painted that fall, is generally considered the turning point between the colorful paintings of the summer and the all-black paintings. Stella was seeking to make paintings which would have a strong and immediate visual "imprint." The painting he wanted would be "direct—

right to your eye . . . something that you didn't have to look around—you got the whole thing right away."

In Geelhaar's catalog, two black crayon sketches are reproduced. Each has an inverted triangle, a delta, set just below the center. And in each, the sides of the triangle are connected, respectively, to the lower corners of the image and to the top center. In one, the rough lines above the triangle are horizontal, running the width of the image behind the bar which connects the top of the triangle with the top of the drawing. In the other the lines on the top half of the drawing are short vertical lines.

Two paintings, *Criss Cross*, brooding blackish blue, and *Yugatan*, black and black/gray, are based on these sketches. If the delta shape with its three wide bars connecting its sides with the corners and top was intended as a kind of clamp over the entire image to facilitate its being taken in at once, then it may not have succeeded. Also, the paintings are so dark, the values so close that the structural device of the delta and bars are almost invisible.

Stella painted *Delta* as a red and black painting. He has said that he was never happy with it, could never get it to do what he wanted. But since the painting does suggest his movement closer and closer to making a black painting, Calvin Tomkins's statement in his *New Yorker* profile of Stella, "the idea for the black paintings came more or less by accident," seems imprecise.

The drawing of *Delta* is clearly freehand. Its image leans and is asymmetrical. In the catalog for the 1976 exhibition at the Baltimore Museum of Art *Frank Stella: The Black Paintings*, the curator Brenda Richardson writes:

Delta *was started as a red and black painting. As it was worked and reworked the artist gradually covered over wider and wider bands with black paint to correct unsatisfactory areas. The painting is heavily scrubbed from many reworkings and does not have the thin, basically matte character of the paintings that started with black paint on raw canvas. It is also much more "expressionistic" than the subsequent Black paintings, with drips and rivulets of black paint and sharper contrast between shiny and "dry" areas of surface. The interstices are the red of the underpainting rather than the "white" of the raw canvas which forms the interstices of the Black paintings. The artist says it was only after* Delta *that he "consciously set out to make a black painting"—to the best of his memory the first of which was* Morro Castle.[2]

But if you take a look at *Morro Castle* in its permanent home at the Kunstmuseum in Basel, you will see what Franz Fedier, a painter and teacher at the Basel Beaux-Arts and a respected critic, has seen: "Beneath the black a dark red appears at the edges of the stripes. Was the picture initially in color? Red? And is the black only the result of the color having

been covered up, having been renounced?" Upon careful examination, one can detect that the drawing is freehand and skewed. The next painting, *Reichstag*, was painted entirely with black paint, after a diagram had been executed on the canvas.

For Stella, the Black series represented a new way of making a painting. As was his practice, he would begin with diagrams. When he had an image he liked, he would calculate the size of the stretcher and build it, using, as he had been doing, clear grade one by threes. The stretcher was covered with heavy-duty cotton duck, stretched tightly and stapled to the back of the perimeter stretcher bars. At that point, and for the first time, with sharpened pencils, yardsticks, and long, straight pieces of lath as straight edges he would draw a careful diagram of the sketch. The precisely drawn pencil lines were parallel and two and three-quarter inches apart. Using a house painter's brush two and one-half inches wide he would paint between the pencil lines. Of course, the paint bled somewhat. With the very early paintings in the series there was almost no unpainted canvas showing between the black stripes. The path of canvas behind and directly beside the pencil lines, however, had less paint on it than the actual stripes. Whether there was raw canvas showing between the stripes or a different, less dense black than the black of stripes, the effect was the same. The paintings would shimmer in an almost magical way. By 1 January 1959 he had completed *Morro Castle*, *Reichstag*, and *Arbeit Macht Frei*.

Upon completing *Reichstag*, using the precisely drawn pencil lines, everything was evident. "After that it became really clear how to organize them," says Stella, "so I made a bunch of drawings with the various possibilities. I was afraid it might go away—I wanted to hold it down and establish control."

Each of the Black paintings is named. In her catalog Richardson explains the meaning of the titles of the twenty-three Black paintings. In *Frank Stella*, William Rubin also sheds considerable light on the titles of Stella's paintings and their implications:

Stella invests considerable interest in his titles, which sometimes bear a rather direct associational relation to the image. Die Fahne hoch—*The Flag on High—like other titles of the Black pictures, has a simple emotional straightforwardness that is akin to its emblematic mode. "The title," says Stella, "seems to me the way the painting looks, to say something about it. The feeling of the paintings seems to me to have that kind of quality to it—Flags on high!—or something like that....The thing that stuck in my mind was the Nazi newsreels—that big draped swastika—the big hanging flag—has pretty much those proportions."*

As in Stella's other series, there is an underlying unity among the titles of the Black pictures, though these titles were not arrived at as systematically as later ones were. The earlier, rectilinear Black pictures bear titles reflecting what Stella calls "downbeat" or "depressed political" situations. "Tomlinson Court Park," for

SIDNEY, GREETINGS

I WANT THE REMBRANDT
PASTELS. THEY COST 55 DOLLAR
S IN THE U.S.A. I DO NOT
OWN AN AFRICAN CAMP CHAI
R WHICH IS WHAT I RRESUME
YOUR SCRIBBLES WERE TRYIN
G TO REPRESENT. I HAVE NOT
WRITTEN BECAUSE I HAVE
BEEN SICK PHYSICALLY. DO
YOU HAVE TO GO IN THE
ARMED SERVICES? WHY NOT?
IF YOU COME BACK TO
AMERICA YOU MUST LIVE IN
THE PERSIAN EMPIRE ● NEW
YORK ADMITS OF NO SUBSTITU
TES. I HAVE TO CUT OUT HER
E DAD TO MAKE THE SCENE
AT READE STREET JACOB
GRIFFEL AND SONS F.P. STELLA

Dear Sidney

I hope that your father and
mother are better, as usual
nothing is happening in N.Y. at
least nothing is happening to me.
I am listening to B.B. King sing on
WNJR. I have been seeing quite
a bit of Darby + Mike. Kit is in
N.Y. looking for a high priced
modelling job. She + Darby seem
to be have some difficulties +
differences. Karl Haffenreffer
is a sort of jack ass. Will
you ever come to N.Y.? If I ever
come to Colorado it will be in
the fall. Why do you not work
on Reed and go into the art
business? It seems much more
sensible than being a stock boy
 Frank

DEAR SIDNEY

I AM VERY HARD PRESSED. I
MUST PAY MY $40 RENT FOR AUGUST AND THE
TELEPHONE CO HAS SHUT OFF MY SERVICE.
I OWE THEM $36 AND THE CONED HAS
THREATENED TO SHUT OFF MY LIGHTS. I
OWE THEM $24. I MUST ALSO EAT AND
I NEED MONEY FOR PAINT AND WOOD, I
HAVE $6 (SIX DOLLARS). IF YOU ARE
GOING TO SEND MONEY THE EARLIER THE
BETTER. I AM HESITANT ABOUT SEND-
ING THE BLUE + GREEN PAINTING. IT IS
7 x 9 THE 9' BEING THE VERTICAL DIMENSION
I HAVE NO FAITH IN YOUR ABILITY TO HANDLE
IT PROPERLY AND TO FIND IT A PERMANT
PLACE.
 WRITE
 FRANK

example, refers to the Bedford-Stuyvesant area. "Arundel Castle" is the name of an apartment house near Tomlinson Court Park.[3]

By fall 1958 good things had begun to happen for Stella. Through Rosenblum he met Jasper Johns and Robert Rauschenberg, both of whom were with Castelli. Seitz and Rosenblum saw the new work and talked about it to Jerome Rothlein, among others. Rothlein, an art historian, urged John Myers at Tibor de Nagy Gallery to look at the work. Myers showed *Club Onyx*, the seventh of the Black paintings at Tibor de Nagy in April 1959. Thanks to Seitz's and Steve Greene's enthusiastic recommendations, Charles Parkhurst, director of the Allen Memorial Art Museum at Oberlin College, included Stella in the exhibition *Three Young Americans* in May.

The loft at 366 West Broadway housed more than Frank and his paintings. He had invited Carl Andre to work there. Andre was writing a book, but he was also making sculpture out of pieces of wood the size of railroad ties.

Hollis Frampton had graduated from Western Reserve and had moved to New York to make his way as a photographer. Andre had stayed in

Opposite: Letters to Sidney Guberman from Frank Stella, 1958–59.

Below: Frank Stella in his studio with *Tomlinson Court Park* in 1959, photographed by Hollis Frampton.

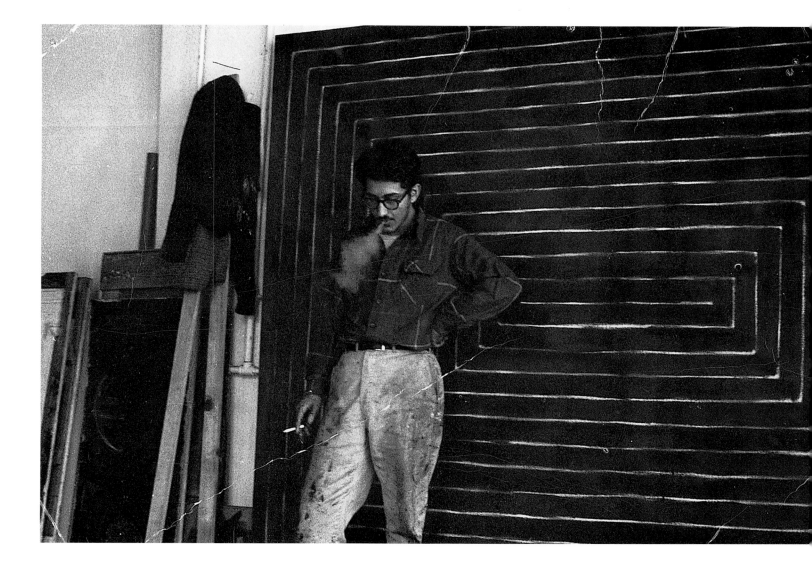

touch with him since Andover and brought him around. He too spent a lot of time in Stella's studio and documented Frank in the act of painting the Black paintings in his matter-of-fact black and white photographs.

The third person to make use of Frank's studio was Richard Meier, then fresh out of Cornell's architecture program. Meier had been taking a painting course with Steve Greene at The New School. Steve got Frank and Dick together and Meier ended up painting in Frank's studio for a few months in the evenings when Frank would leave to make the scene in the Cedar Bar where he would sit by the hour, nursing a beer, once in a while smoking a Lucky, and saying almost nothing, watching for Adolph Gottlieb or Mark Rothko to show up. He was in the process of thinking of paintings which would put an effective end to Abstract Expressionism.

I was living in Europe that year and on 12 January 1959 Stella wrote to me: "Soon I will run out of room in this loft. At that time I will run out of money and I will have to go to work. Do not ever work. Death is better. All hard work does is kill people. You can kill yourself without hard work. Its necessity is a great myth." Stella was living on about one hundred and fifty dollars a month. Gloom and poverty notwithstanding, by May 1959 the work was going well on the Black paintings. Three of them, *Bethlehem's Hospital, Club Onyx,* and *Seven Steps,* as well as two pre-Black paintings, *Astoria,* and *Luncheon on the Grass,* were ready to go to Oberlin.

In a letter dated March 1, he wrote:

If your father is serious about buying one of my pictures, you had better prepare him to pay 200 or be disappointed because I will only sell 1 of the last 5 pictures I have painted. All before that (some 25 or so) are in the process of being permanently rolled up so that they can be stored in my tomb, which I hope you will design. The new paintings are painted in black & NO COLOR (a Stella original) stripes and they are BETTER than regular oleomargarine.

My parents visited Frank in the studio but my father didn't buy. "No room," he said.

During the 1958–59 academic year, Stella went down to Princeton on a fairly regular basis. Mostly he spent time with the Bannards and Michael Fried, a fellow painter at Princeton who became an art historian and critic. As early as the fall 1957 Frank was convinced that there was a lot of money to be made investing in art. His conviction was that if you bought Picasso drawings and paintings by Hans Hofmann, de Kooning, and Kline, you could make a killing in a few years. In the March letter he wrote:

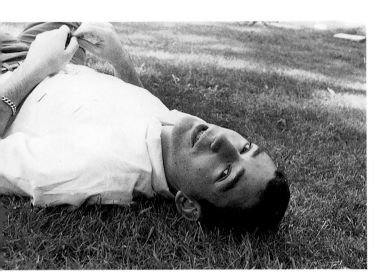

Above: Michael Fried at Princeton.

Opposite: Leo Castelli photographed by Robert Maplethorpe.

He [Bannard] wants to buy the Little Gallery now that he is running it on his own. I suggest that you get Reed [a wealthy friend and a classmate] to buy it as a preliminary to his attack on the art world. Michael F.[Fried], W.D.B.[Bannard] and I are going into the real big and bad art world if we can get Reed to put up about $200,000 so we can buy widely and wisely. If we could get past Reed to Reed's father & the money our progeny will have a great deal of art & Money with which to make fools of themselves.

Reed did show up at some point. He gave Stella a check for two hundred dollars for one of the Eldridge Street paintings but never picked it up.

Although very little money was coming in, the great good fortune would continue. Leo Castelli opened his gallery in 1957 and within a year he was the most important dealer in New York in terms of young artists. Castelli recalls his first two trips to Frank's studio:

Now, the Stella story is really quite amusing. Somebody back in the early fall of 1958 mentioned this young painter to me. I don't even remember who it was. So I went down to the studio, which at the time was on Broadway. It was a relatively small studio with a very high ceiling and windows. So here was this young man maneuvering around these rather large paintings, which seemed huge to me at the time but actually were ten feet by six or eight, or something like that. But he maneuvered them around in a very small space very, very gracefully. They were the famous Black paintings. He showed me these paintings, and I again had the same experience that I had with Jasper Johns. Perhaps—I don't know why—but probably I understood him so well right away.

The next time Castelli visited Frank, in August 1959, he took Dorothy Miller, a curator at the Museum of Modern Art:

Dorothy Miller needed some young painters, and I told her about this young painter I had seen. So we went together to the studio, and she was also terribly impressed and told me, "I must have these paintings in my show."

So I said, "Dorothy, you mustn't do that. He's much too young"—twenty-two years he

was then—"that's one reason; and the second reason is that I have planned a show of his at my gallery in October or November."

So she said, "Never mind your show. You can find something else. And as far as his youth is concerned, well, if he's not strong enough to withstand things like that, then he does not deserve to become a great painter."[4]

The record indicates that Stella joined Castelli's gallery in August 1959. Given the general reaction to the Black paintings, one can appreciate the magnitude of Leo Castelli's commitment.

The exhibition *Sixteen Americans* opened at the Museum of Modern Art on 17 December 1959. When Stella heard from the museum that he would need to provide a photograph of himself and an artist's statement for the catalog, he was ready. Frampton took a picture of Frank standing, one foot extended, wearing a three-piece suit, a shirt and tie, against a seamless, white background. Elegant. Cool. Deadpan.

Carl Andre's statement was at least as cool as the photograph:

Preface to Stripe Painting

Art excludes the unnecessary. Frank Stella has found it necessary to paint stripes. There is nothing else in his painting.

Frank Stella is not interested in expression or sensitivity. He is interested in the necessities of painting.

Symbols are counters passed among people. Frank Stella's painting is not symbolic. His stripes are the paths of brush on canvas. These paths lead only into painting.

In her foreword to the catalog, Dorothy Miller wrote, "Whether as a result of years of experiment and achievement or through an early flowering of talent and promise, each artist brings to this exhibition a personal expression distilled out of his own world and thought."

At the time that general catch-all for "young and old alike" was bland enough in itself. The oldest artist in the exhibition, Albert Urban, was born in 1909, the year of the birth of the father of the show's youngest artist, Frank Stella. Miller had been very open-minded and catholic in her selection process.

The opening at the Museum of Modern Art had a pretty slim turnout. Frank's four paintings were in a rectangular space—one wall each—as elegant as they deserved. Frank too was elegant in a dark suit and a hugely expensive Sea Island shirt. He and Andre and Frampton were very laid back, very cool. It was obvious to Frank that most people did not like the work.

The critics for the New York papers and for the national news magazines hated the paintings. Emily Genauer of *The Herald Tribune* wrote about "White pin stripes on a black background." She went on to call the paintings "unspeakably boring." Over Stella's signature, Frampton wrote

to *The Tribune*, "I paint what I paint, not what I leave out. . . .People who make claims for taste should remind themselves, from time to time, that the arts are based upon data." *The Herald Tribune* published the letter without comment or apology.

Three of the four paintings from the *Sixteen Americans* show, *Tomlinson Court Park* (second version), *Arundel Castle*, and *Die Fahne hoch!*, were returned to the Castelli Gallery after the show closed on 27 February 1960. The museum bought *The Marriage of Reason and Squalor* with money from a fund Larry Aldrich had established for the acquisition of works by new, young artists. Castelli had priced the paintings at twelve hundred dollars each, but he and Stella agreed to sell the painting to the museum for nine hundred dollars because the fund stipulated a maximum price of one thousand dollars.

Early in 1960, Stella learned that Castelli was advancing Johns and Rauschenberg each seventy-five dollars a week. He requested and received the same advance against future commissions. By then Ivan Karp was Leo's gallery manager and wrote the checks. Karp and Castelli appeared somewhat like a couple of stand-up comics; Leo small, dapper and urbane, and Ivan, hardly taller than Leo, plump, cigar chomping, wise-cracking in the classic New York mold. But Leo has always known exactly what he wanted

and in Ivan he got someone who was popular with the artists, extremely intelligent, and a devotee of art.

In 1970 Rosenblum wrote in his monograph *Frank Stella*:

One constant, at least, of this decade is the importance of the Black paintings as epochal art history; for now, like then, they retain the watershed quality so apparent when they were first seen in 1959. Today too they have the character of a willful and, one might add, successful manifesto that would wipe out the past of art and that would establish the foundation stones for a new kind of art that, as it turned out, was not only Stella's own but the core of a group style of the early 1960s to be labeled Minimalism.

Yet gradually our perception of these pivotal paintings, which to many looked like unfeeling geometric diagrams, began to change, supported by the insights of art historians who would explore the nuances, whether historical, visual, or emotional, of these poker-faced works.[5]

In lectures at Pratt in January 1960, Stella explained the scheme to achieve the appearance of flatness. The first part was symmetry, but that was not enough to achieve what he was after. If, for example, he were to paint *Them Apples*, twice identically, side by side, each one being the mirror image of the other, he would have had symmetry but not the flatness because there would remain the problem of the illusion of depth generated by all of the variations in color, value, and paint thickness. To achieve flatness use one color, one value, and apply the paint evenly over the entire surface. Hand in hand with symmetry would be the creation of paintings of parallel black stripes, all stripes basically the same in width and paint density. "The solution I arrived at forces illusionistic space out of the painting at constant intervals by using a regulated pattern."

I have always felt that the expression, "forcing illusionistic space out" suggests something like slow motion, but motion nonetheless, not unlike toothpaste being squeezed out of a tube. The Black paintings, in particular those of Group I, work as Stella intended. There is an imprint of the entire painting. And while Stella now insists that there are "events" all over the surface of the Black paintings where the eye can pause, the imagery of these paintings remains static in the best sense. The design of a graceful bridge by, say, Calatrova, whom Stella admires enormously, is based upon a part of mechanics called statics. Things which are supposed to stay put, do, in fact, stay put. To this day, when I summon the image of Stella's *Getty Tomb* it clicks onto my mind's screen in its serene, static majesty.

Between New Year's Day and early spring 1960, Stella completed all of the Black paintings. But he had already begun making sketches for the next series of paintings which would be stripes of commercial radiator paint and would come to be known as the Aluminum series, the first large shaped canvases.

Opposite: Photograph of Stella by Hollis Frampton used in the *Sixteen Americans* exhibition catalog.

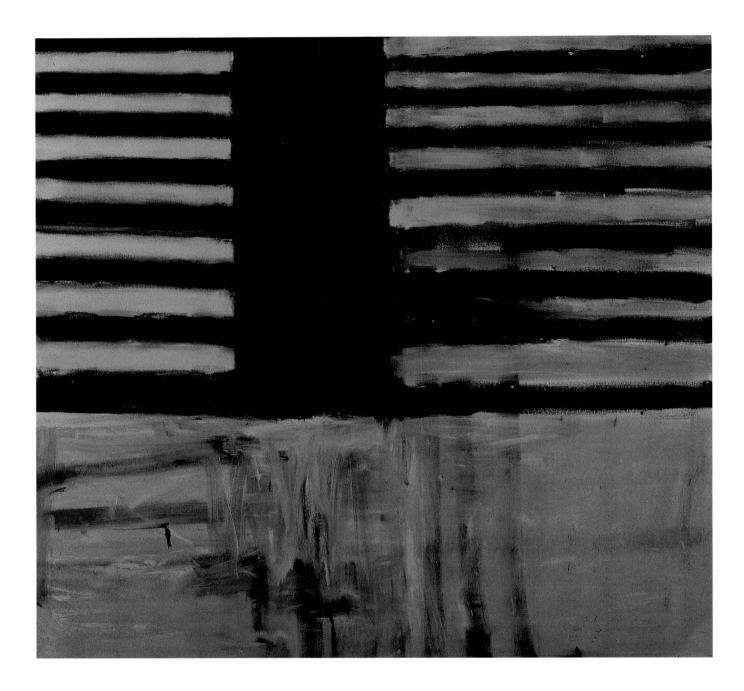

Green Grate, 1958
oil on canvas, 72 × 84".

Plum Island (Luncheon on the Grass),
1958,
oil on unprimed canvas, 73 × 85".

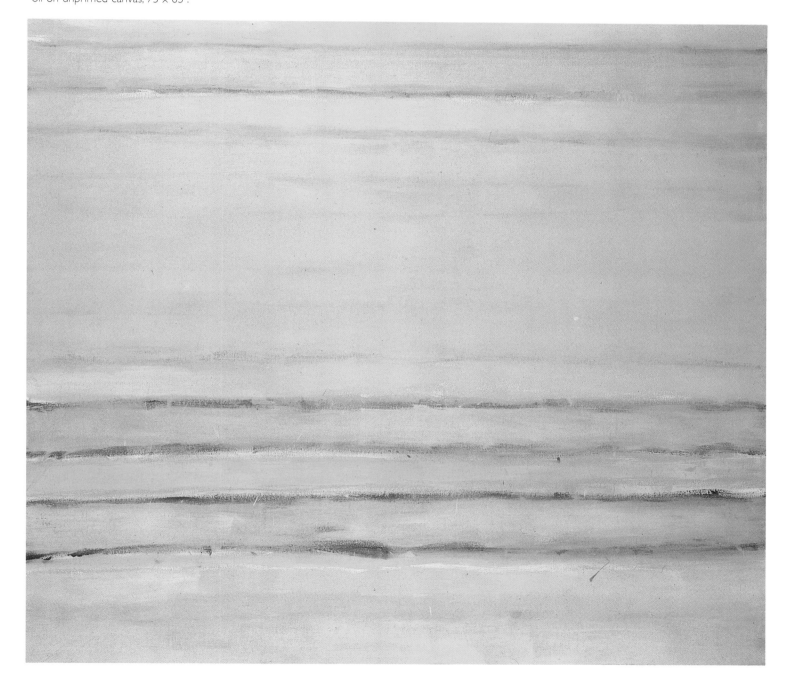

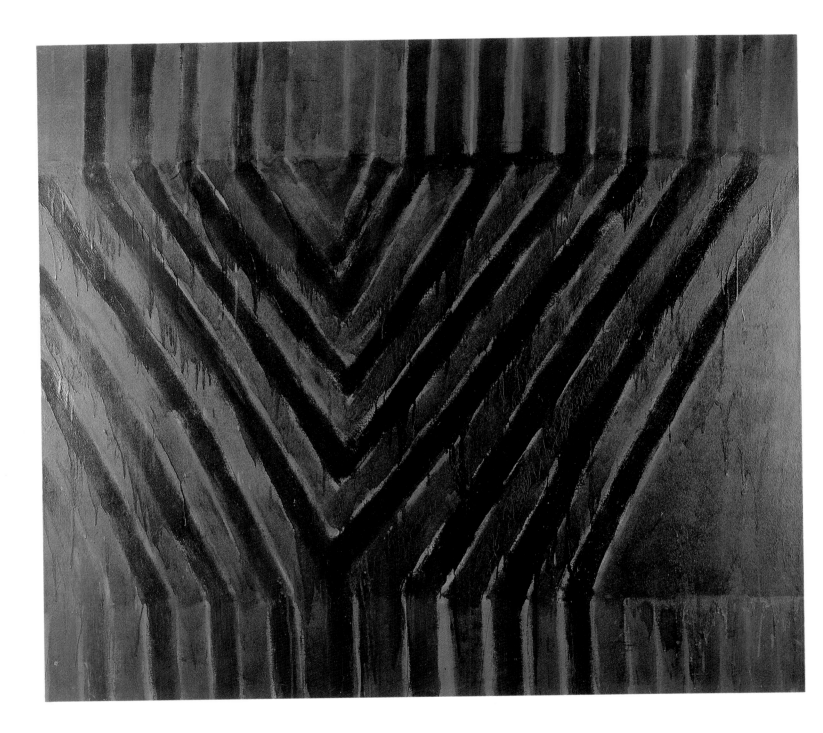

Delta, 1958
enamel on canvas, 85⅜ × 97".

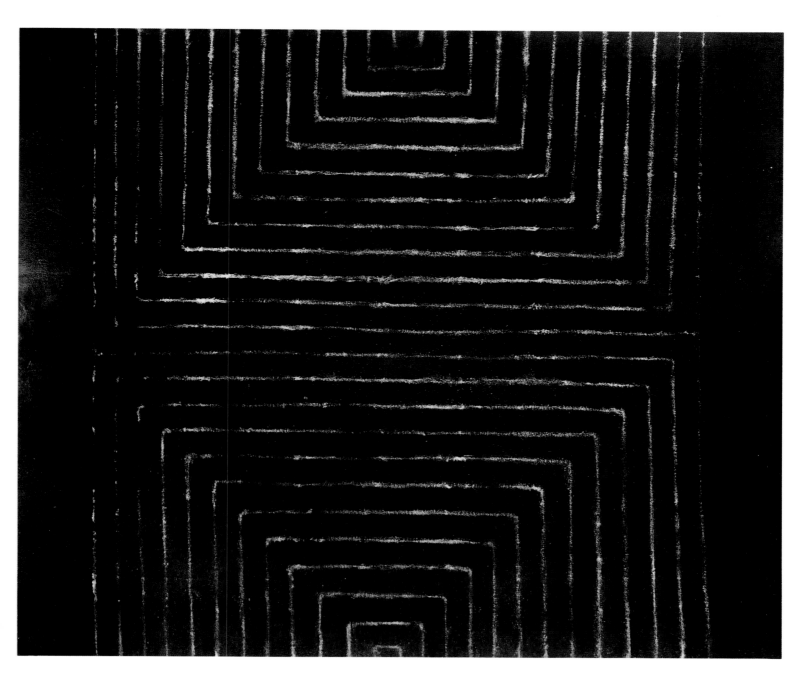

Morro Castle, 1958
black enamel on canvas, 84⅝ × 107⅞"
Kunstmuseum, Basel.

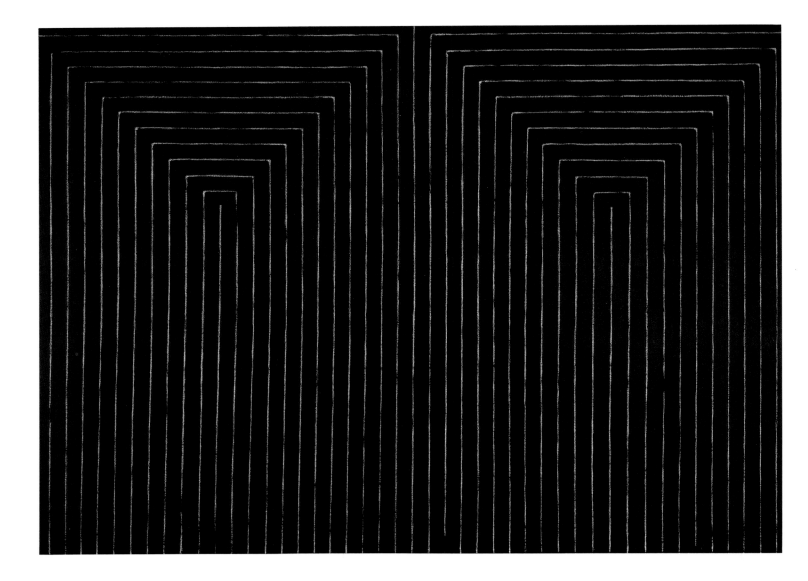

*The Marriage of Reason and Squalor
(second version)*, 1959
black enamel on canvas, 90¾ × 132¾"
The Museum of Modern Art, New
York. Larry Aldrich Rockefeller Fund.

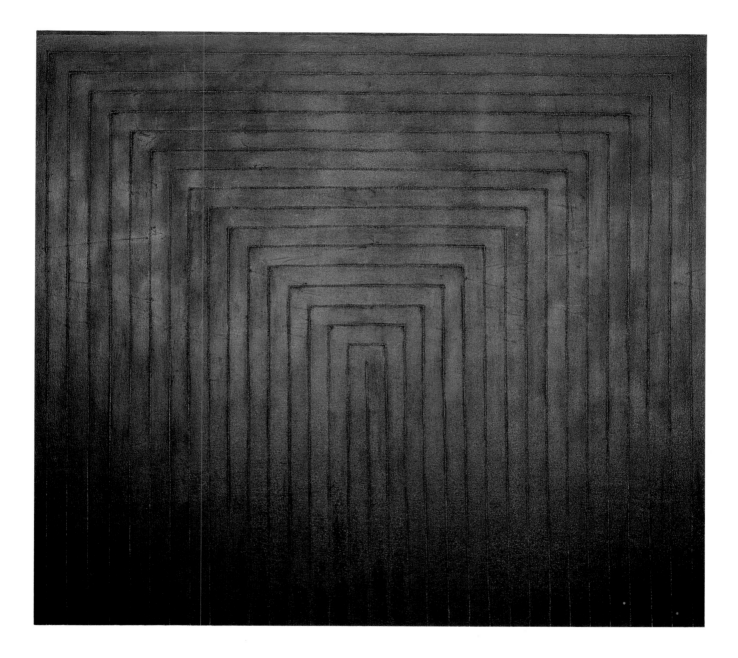

Getty Tomb (first version) 1959
enamel on canvas, 84¾ × 96½"

4

ALUMINUM, BARBARA ROSE, COLORADO, COPPER, PARIS

When Carl Andre came to New York to live in 1957, he had looked up Michael Chapman, an Andover classmate and the only person Andre knew who was likely to be able to provide him with a place to sleep until he could get some income. Chapman, who was living with Barbara Rose, a twenty-year-old graduate student at Columbia, did offer a bed and helped Andre find a job as a sub assistant editor in a publishing house. Right off the bat, Barbara admired Andre's refreshing outsider's slant on things and began touting him to the members of her circle. They had become good friends about the time that Andre was hacking away at huge pieces of wood in Stella's studio. Carl Andre admired no one more than Constantin Brancusi and spent a lot of time trying to figure out what the next major step in sculpture would be. Once, as Andre was working on one of his massive logs, Frank walked by, rubbed his hand across the untouched back of the piece and said, "You know, Carl, that's sculpture too." Andre was probably miffed at the time, but he thought about what Frank had said. As Calvin Tomkins put it, "It turned out to be a moment of revelation for Andre, who from that day to this has been using his materials (wooden beams, bricks, metal plates) in an untouched state—using them as 'cuts' in the space that surrounds them, shaping the space itself."[1]

Andre saw Barbara Rose from time to time, usually for lunch at the cafeteria in the Central Park Zoo. That fall, in the weeks preceding the opening of *Sixteen Americans* at the Museum of Modern Art, he brought Frank. As Barbara has told a great many people over the years, her first view of Stella was of a short, unshaven boy missing his front teeth. He had paint on his pants and holes in his T-shirt.

Opposite: detail of *Six Mile Bottom*, 1960.

Below: Hollis Frampton and Barbara Rose in 1957.

In early 1960 Frank showed Darby Bannard, who now ran The Little Gallery in Princeton, the rough sketches for the next series of paintings and complained that in the case of each image there were left-over pieces which he didn't like. Bannard is glib but thoughtful. He looked at the sketches for a while and said, "Well, if you don't want them, then just take them away." That comment would lead directly to Stella's first shaped canvases. Frank returned to New York and drew up the eight distinct shapes for the Aluminum paintings and proceeded first to make the working drawings, with a straight edge and pencil, on grid paper and then to build the stretchers. From the working drawing for the stretcher for *Six Mile Bottom*, one can see that the four long, narrow, vertical indentations in the stretcher itself permit the satisfactory resolution of the painted canvas.

As William Rubin has observed:

Though the notches in the Aluminum pictures represent only a small departure from the rectangle when compared with Stella's subsequent more radical shaping, they constitute the beginning of this main line in his development. By moving drawing to the boundaries of the picture field he would increasingly attribute new importance to shape—an element that had virtually disappeared from much of the avant-garde painting of the late forties and fifties.[2]

When seen as the only color of a large abstract painting, the burnished silver of the Aluminum paintings might seem exotic or at least far from the ordinary. The color was in fact very common at the time since it was used for millions of radiators in houses and apartments. The silver paint represented half of the crucial change that went on immediately after the Black paintings. Rosenblum writes:

Stella chose a tone far more chilly, reflective, and achromatic—the factory coldness of commercial aluminum paint. In Stella's hands the effects of such a metallic medium were far more immutable and inorganic. Now the stripes, again defined by the white rivulets of bare canvas that separate them, became a kind of gleaming, impenetrable pictorial armor.[3]

If a handful of observers found the Black paintings "mysterious" or "deep and brooding," Stella made sure that so passionate an association could not be established between a viewer and any of the Aluminum paintings:

The aluminum surface had a quality of repelling the eye in the sense that you couldn't penetrate it very well. It was a kind of surface that wouldn't give in, and would have less soft, landscapelike or naturalistic space in it. I felt that it had the character of being slightly more abstract. But there was also a lot of ambiguity in it. It identifies as its own surface, yet it does have a slightly mysterious quality in one sense. You know it's on the surface, but it catches just enough light to have a

shimmer. That shimmering surface has very much its own kind of surface illusion-ism, its own self-contained space. You can't quite go into it. And it holds itself in a nice way on the surface as far as painting problems are concerned.[4]

" And now," comments Rosenblum, "even more than in the Black paint-ings, the internal design became so closely related to the configuration of the framing edge (or central void) that the container and the thing con-tained became inseparable, each being a function of the other."

The titles of these twelve canvases in eight distinct shapes are diverse and personal. For example, *The Marquis de Portago* was a romantic figure, an aristocratic race car driver who died in a wreck that killed a number of spectators as well as himself. *Luis Miguel Dominguin* was a matador and a friend of Ernest Hemingway. Stella describes the titles of the Aluminum series as "sort of literary or glamorous—like Arabic philosophers, bull-fighters, and racing drivers."

As cold as they are reputed to be, the "ripple effect," where the stripes jog and then jog again, is a pleasant optical sensation. It serves to engage the viewer—the eye *and* the brain—and I find that it manages, in spite of protestations by Michael Fried and others, to create a feeling of shallow depth.

Before Frank completed the Aluminum paintings he decided to take a little time off. He called me in April 1960 to see if he could come out to Colorado for a visit. I urged him to do so and he finally showed up around May 25. Not long after he arrived, we took off in my Volvo for the southwest corner of Colorado.

Telluride is now a chic resort, summer and winter. In 1960 it was a ghost town, its only paved road the state highway. Besides Telluride, we passed through Ophir, Ouray, Pagosa Springs, Creede, and Lake City, mostly unexciting ghost towns. But Frank's driving of my four-speed, stick-shift car made up for any lack of stimulation. He didn't have a dri-ver's license but as I have pointed out, he is a very quick study. We played pool in Montrose and ate pancakes in a diner in Sagauche in the Sangre de Christo range and headed on back. The day after we returned to Colorado Springs, Frank left for New York, but not before buying a pair of lavender frontier pants with mother-of-pearl snaps for Terry Brook, his girlfriend.

It looked like my days as a retailer were over. With fifty dollars and a carton of Camels, my Volvo and I headed west to Sacramento and Jean Manly. Before I left I wrote letters to twenty private schools around the country offering my services as a teacher and coach. By the end of July, in

Guberman/Stella poem written in Colorado Springs, 1960.

```
dialogue

st. cuthbert: are women in that time allowed
in the Getty Tomb?
theodore of tarsus: no
st. cuthbert: do the ostrogoths celebrate Eas ter
according to the roman or maygar custom?
theodore of tarsus: yes
st. cuthbert: how soon after washing may a
man enter the Getty Tomb?
theodore of tarsus: no
st. cuthbert: for we are ignorant in these
matters how soon after washing may a woman
enter the Lincoln Tunnel?
theodore of tarsus: sic et non
```

Sacramento, where I was making pretty good wages as a draftsman, I had received nineteen courteous letters declining my services and one firm offer from South Kent School in Connecticut.

In the first week of September I showed up at 366 West Broadway with our friend Bardyl Tirana, a Columbia Law School student and a Princetonian. After a couple of beers Frank said that he had a girlfriend for me. Bardyl drove us up to 210 Central Park South. It was a Sunday afternoon and there with the *Times* were Terry Brook, Barbara Rose, a cat, Mignonne, and a large black painting on the wall, an Ad Reinhardt which Frank said he was buying on time. I liked Barbara and Frank had been right—she did become my girlfriend for a month or so.

The fall of 1960 was golden and agreeable—a true Indian summer. The prospect of a late afternoon drive down winding country roads in western Connecticut, New York Route 22, and the lovely and quaint Sawmill River Parkway to Frank's first New York City opening was appealing and I was looking forward to it. But the opening at the Castelli Gallery was on a Tuesday and I had three classes Wednesday morning and finally decided to forgo the festivities. Of the evening of September 27, Barbara wrote that the show was grand, not a mob scene, however, mostly just the usual circle, which, thanks to Barbara and Terry, had grown to a dozen or so.

Most critics did not appear to notice the elegant show of Aluminum stripe paintings at the Castelli Gallery, but *The New York Times's* big gun, John Canaday, wrote on Sunday, October 2:

Western Union telegraphic money order for Stella from Ivan Karp, 1960.

Stella, who last year painted parallel white lines on black (or was it black on white?), this year paints enormous canvases covered with broad stripes in silver paint, leaving pencil-thin lines of white canvas showing. At various points the stripes turn corners like battalions of soldiers. Then he neatly cuts away a corner of the canvas here, a broader area there. Stella was at the gallery when I saw the show, and I thought it might be helpful to talk to him. But you feel a fool asking the man who does this sort of thing for an explanation. I decided that "What is your intention?" would be a safe enough opening gambit. "To make a flat picture," he replied. "Why do you cut notches out of the canvas?" I pressed further. "To keep it flat," he said. Later I talked with his dealer, who exclaiming over the pictures' beauty and purity and the time it took to make them (six months), mused, "Don't they make you think of old-fashioned silver cash registers, the kind that had the parallel tracks for the keys?" It was a curious association.

When Stella got back from Colorado in early June 1960, he had to finish the Aluminum paintings which he did in his usual businesslike way. At the same time, he was doing the drawings for the paintings named after the towns he and I had seen in southwest Colorado in May. They are painted in metallic copper and the color seems consistent with the way many people think about Colorado. The red sandstone shimmers copper in the setting sun. But in using the copper paint, Stella was playing a card that had been in his hand for a lot longer than the few days since he had first seen the rugged, unpopulated but much filmed part of my state.

In Ipswich every spring Dr. Stella would put his boat up on sawhorses and scrape and paint the bottom. The paint of choice, which is supposed to keep barnacles off the bottoms of boats, is copper metallic paint. As his father's principal assistant, Frank had been using the copper paint for years. It was natural for him to think of it for the paintings. And it was a perfectly logical step after the aluminum paint. It had the same, impersonal quality that seemed to keep the viewer from getting "into" its surface.

Stella with Terry Brook, 1960.

While working on the Copper paintings, Stella began a series of square paintings which he would call the Benjamin Moore paintings. There were six colors: red, yellow, blue, green, orange, and purple, the three primaries and their complements. All paintings in this series, large and small alike, were painted with Benjamin Moore alkyd house paint. Most house painters will tell you that Benjamin Moore paint is one of the best, if not the best, commercial house paint. This is important because in less than two year's time he had gone from using the cheapest paint he could find, frequently in colors nobody else wanted, to the Cadillac of paints.

The two main issues at this moment in his career were the continued radicalization of the shape of his paintings and the reconsideration of color for the first time since he had begun the first all-black painting.

October and November 1960 were as mild as the winter ahead was going to be brutally, record-breaking cold. For a few weeks I received letters from Barbara Rose which were very affectionate and full of admiration for my monklike existence in the outreaches of the Housatonic Valley. Her letters also made regular references to the brilliance of Frank Stella and the loudmouth aggression of Carl Andre. Barbara wrote in October, "Be well and do not let that dandy F. Stella outsmart your so smart wardrobe as he is obviously trying to do, what with those many houndstooth jackets from Langrock [a clothing store in Princeton] hanging in rows in his starving artist's garret."

I was incredulous but it was true. Frank was deep into deficit spending, buying an Ad Reinhardt painting and two-hundred-dollar jackets. By then Carl Andre had gone to work as a freight brakeman on the Pennsylvania Railroad, but Frank was supporting Hollis Frampton as well as paying for film and other photography equipment.

I saw less and less of Barbara Rose, as I began to understand that I was expected to be on campus, even when I wasn't teaching. When I did get

down to the city, I would usually meet Frank at my parents' apartment on Park Avenue. Frank always had a small, square canvas with him and a bag with a jar of paint and a brush. He would sit on the floor in front of the television and work on the twelve by twelve inch paintings in the Benjamin Moore series, in their six configurations. We spent a lot of time there. It was a perfect meeting place, between 36th and 35th Streets, a ten-minute walk from Grand Central Station.

Several times in January and February in the Housatonic Valley the temperature hit twenty-five below. In the city it was frequently below zero. The silver radiators at 366 West Broadway could raise the temperature inside by no more than thirty or forty degrees over the temperature of the air outside. Frank used to joke about burning Carl's sculpture to keep warm.

By the spring of 1961 Barbara and Frank were a couple. Barbara used to say, "What Frank wanted was a blonde Smith girl with a camel hair coat and that was me." A few months earlier Barbara began working part time at the Castelli Gallery as the "gallery girl." She knew all of Leo's artists and encouraged them to drop in when she was there. Frank would often work his way up to 77th Street to see her. She and Frank undoubtedly were able to exert some influence on Leo and Ivan Karp, the gallery's manager. They lobbied for Donald Judd, minimalist sculptor, and were able to convince Leo and Ivan to take his work. They also touted Darby Bannard, but, at least with Leo, unsuccessfully. By 1965, Barbara was taking the credit for getting Darby together with the Tibor de Nagy gallery.

Barbara and Frank had applied for Fulbright fellowships, she to Spain and he to Norway. They agreed that if only one got a grant, both would go. Barbara did get her Fulbright and Frank did not, but things were definitely looking up for both of them.

By mid-March 1961, Frank's fortunes had improved and there were signs that spring would arrive in New York. I had a spring break at South Kent and told Frank that I intended to go to Orlando to visit my grandmother. Jasper Johns had invited Frank to Isle of Palms near Charleston, South Carolina, so it would be easy for him to get down to Orlando. I encouraged him to do it. Granny Cook knew Frank from graduation, wasn't put off by his lack of teeth, and was fond of him. The highlight of the trip was our visit to the campus of Florida Southern College in Lakeland which had been designed by Frank Lloyd Wright. I had been raving about Wright for years and for me it was a pilgrimage. We weren't disappointed.

Writing of art-historical references in Stella's work, Rosenblum points out:

And in the 1963 Dartmouth Paintings, *in which many paintings are named after cities in Florida, it is not hard to find an instant confirmation of Stella's enthusiastic visit, in March 1961, to the buildings at Frank Lloyd Wright's campus for Florida Southern College in Lakeland, whose kaleidoscopic interlockings of diamond-shaped and triangular modules (especially in the Annie Merner Pfeiffer*

Chapel of 1938) find immediate responses in paintings like Dade City, Plant City, *and* Tampa.[5]

One of Frank's enthusiastic promoters from the time of the *Sixteen Americans* show was William Rubin, then an art-history professor at Sarah Lawrence College. His brother, Larry, owned Galerie Lawrence in Paris at 13, rue de Seine. He offered Frank a one-man show opening in November, which meant that by his twenty-fifth birthday, 12 May 1961, Frank's studio contained not only the paintings for the Copper series, but also a batch of the twelve by twelve inch Benjamin Moore paintings and variations, and the stretchers for the large, square paintings in Benjamin Moore, which would go to Paris.

By summer, Stella had decided that the studio at 366 West Broadway was much too small. He also needed to get to Europe in the fall to be with Barbara and to be present at the opening of his show at Galerie Lawrence on November 7. He also hoped to visit Michael Fried who was living in London.

He found a studio in a large loft building at 84 Walker Street, exactly six blocks from 366 West Broadway. He would be in the same building, one floor higher, as Niki de St. Phalle and her husband, the Swiss sculptor Jean Tinguely. The move took most of the month of September.

Frank didn't have much help. A trucker transferred the paintings and other belongings too big to carry, but most of the things he moved from West Broadway to Walker Street on foot. When Frank wrote to me in the spring 1959 that he had rolled twenty-five paintings it may have been close to the truth. He would reuse the stretchers after the paintings had been rolled. One of the rolled paintings, *Gavotte*, was the seventeenth of the Black paintings, according to Brenda Richardson's catalog. It lists *Gavotte* as ninety by one hundred twenty-two inches with the note "Painting no longer extant; destroyed by artist, 1961." Counting the unpainted canvas which wrapped around the sides and back of the stretcher, *Gavotte*, impregnated with five or six coats of cheap enamel, was nearly twelve square yards. Maybe thirty pounds in a long, unwieldy roll, slung over his shoulder on a hot, late summer afternoon. Stella managed to bend the roll in three and cram it into the wire trash container on the corner of Canal Street and West Broadway. By the next day it was gone.

Also casualties of the move were several of the new Copper paintings. Frank leaned them against the side walls at the front of the spacious loft. When he returned from Europe early in 1962, four of the paintings had been badly damaged by the low winter sun pouring in through the tall windows.

Stella and Barbara Rose, 1960.

Barbara left for Spain at the end of September. Frank agreed to complete the Benjamin Moore paintings and join her. The six large paintings were shipped to Paris by air, but the artist carried the thirty-six babies in his luggage. To each puzzled inspector he explained that they were studies—works in progress.

The Black and Aluminum paintings had a handmade look to them due in large measure to the unevenness of the stripes caused by the irregularities of the artist's strokes and the bleeding of the paint. With the Copper paintings, Stella began using commercial quarter-inch tape which he would put down over the drawn lines, trying to keep the tape centered on the lines as much as possible. The copper paint, like the black and aluminum, and the purple which was to follow the copper, was oil based and tended to bleed under the tape. When he began using flat, alkyd house paints for the Benjamin Moore series there was very little bleeding.

All the small paintings in this extended series were made by first drawing the diagram and then painting in the color as close to the pencil line as possible. The bare canvas showing through was about an eighth of an inch, or half what it was with the Black, Aluminum, and Copper paintings, but because they were small, the feeling was comparable. He also reduced the bare canvas to an eighth of an inch on the six large paintings for the show at Galerie Lawrence. The net effect of the new, narrow space between stripes, the no-bleed alkyd paint, and the quality of the surface of the matte colors, was startling. In each case there is no variation in color, hue, value, or tonality across the canvas. There is no shimmer, no visible brush stroke to evidence the passage of the human hand. Stella said in a radio interview in 1966 that he "tried to keep the paint as good as it was in the can." In discussing these paintings Rosenblum says, "No less primary [than the colors] was the design of these canvases, which, continuing themes of the 1959 black paintings, measured out the square territory of the picture surface like an archetypal surveyor."[6]

Stella finished the small paintings in a hotel room in Pamplona. He liked the bustle of the principal plaza and the sound of Spanish all about him even though, he says, the only word he understood was "cerveza." Barbara was working in the archives of the cathedral, while Frank walked around town or made drawings in the room. His inspiration increased after he and Barbara spent a few days in Morocco. The colors and patterns, as well as the architecture, appealed to him tremendously.

They had been planning on getting married in Pamplona, but it turned out to be impossibly complicated. Instead they got married in London on November 3, with Michael Fried as best man.

A few days later, in Paris, Frank helped Larry Rubin hang his show of six large square paintings and thirty-six small ones. The young gallery owner had been told by the building's owner that he was not allowed to make a single hole in the pristine, stucco walls of the gallery, that the paintings would have to be hung from wires attached to molding hooks.

That worked well for the six large paintings, but the thirty-six small ones presented a challenge. Rubin came up with a hook imbedded in double-sided tape. During the *vernissage* a couple of the paintings fell off the wall.

F. Stella, the title of the exhibition at Galerie Lawrence, appeared as an enlarged reproduction of the artist's signature on the cover of the eight-page brochure. Inside the cover there was a color reproduction of one of the thirty-six small paintings (*Island No. 10*, small version, green). There were also a black-and-white photograph by Hollis Frampton of Stella perched out on a girder, black-and-white photographs of two of the show's six large paintings (*Island No. 10* and *Delaware Crossing*), and on the last page, "BIOGRAPHIE." It was three sentences long:

Frank Stella was born in Malden, Massachusetts in 1936. He studied painting with Patrick Morgan at Phillips Academy in Massachusetts, and subsequently with William Seitz and Stephen Greene at Princeton University where he received the Bachelor of Arts in 1958. Since 1958 he has been living and painting in New York.

In Paris, a city of about two million in 1961, a hundred people might have been familiar with the name "F. Stella."

Geelhaar indicates that Stella's notes designated the six configurations and their associated names as follows:

M = maze	=	*New Madrid*	orange
D = Diagonal	=	*Sabine Pass*	purple
S = square	=	*Island No.10*	green
X = cross	=	*Delaware Crossing*	red
H = horizontal	=	*Palmito Ranch*	yellow
A = angle	=	*Hampton Roads*	blue

The colors here refer to the original six large paintings that were in the show at Galerie Lawrence; each configuration was painted six times, once in each of the colors listed. The titles of the paintings in the Benjamin Moore series refer to Civil War battles. *Delaware Crossing* refers to George Washington's dead-of-winter crossing of the river at what is now known as Washington Crossing, near Pennington, New Jersey, upstream from Trenton and about ten miles from Princeton.

Joseph Hirshhorn was in Paris on November 7 and attended Stella's *vernissage*. It would be a few years before he would buy the first of many Stellas, but when Larry Rubin mentioned to him that Frank and Barbara had been married less than a week, he took out his wallet, peeled off a one hundred dollar bill, and handed it to Frank as a wedding present. Barbara says she used the money to buy a winter coat.

None of the paintings in the show sold. But Rubin liked Stella and was committed to his work. From time to time he would buy a painting out-

Galerie Lawrence brochure for the 1961 exhibition in Paris. The painting is the small *Island No. 10* and Hollis Frampton took the photograph of Stella sitting on the girder.

right, even though by the end of 1965 he had sold only one of Stella's paintings. At the time of the Paris show, he too began advancing the artist two hundred and fifty dollars a month. On 7 November 1961, Frank Stella's only fixed expense was the two hundred dollars a month studio rent at 84 Walker street. But that was about to change dramatically.

Six Mile Bottom, 1960
aluminum paint on canvas,
118⅛ x 71¾"
The Tate Gallery, London.

Marquis de Portago (first version) 1960
aluminum paint on canvas,
7' 9" × 5' 11¼"

Pagosa Springs, 1960
copper oil paint on canvas,
99¼ × 99¼"
Hirshhorn Museum and Sculpture
Garden, Smithsonian Institution, Gift
of Joseph H. Hirshhorn, 1972.

Dade City, 1963
zinc chromate on canvas, 82 × 94".

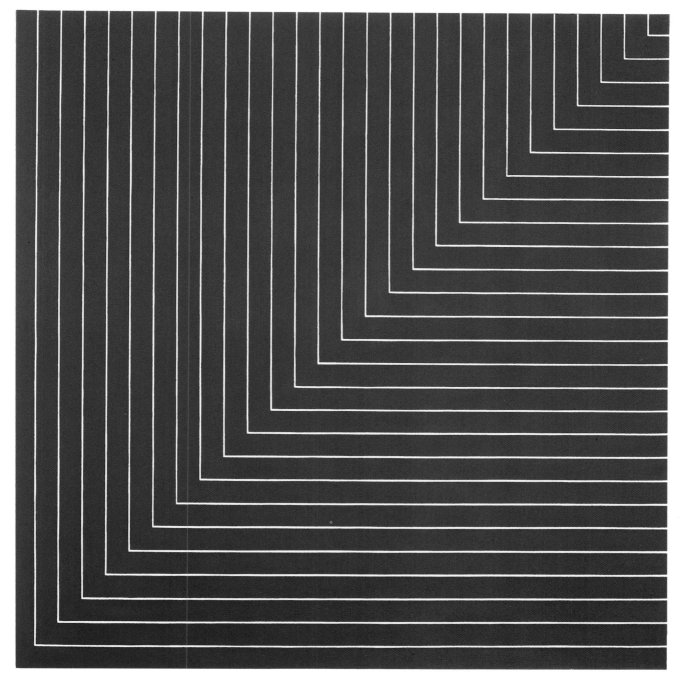

Hampton Roads, 1961
alkyd on canvas, 77 x 77".

COPPER AT CASTELLI, RACHEL, THE PURPLE
PORTRAITS, IRREGULAR POLYGONS

After Paris Frank and Barbara returned to Pamplona. She wasn't feeling well most of the time, and they were not prepared for the cold weather of sunny Spain. They had gone through a lot of money in Paris and the prospects for their return to New York were less than rosy— no place to live, a baby due in June, and assured income which was less, by half, than what they would require to live on. Frank was anxious to sort things out at Walker Street and begin painting again.

They returned to New York in January. Barbara may have left things rather badly with the Fulbright people, but she had been so miserable in Spain it didn't matter to her. Back in the city they found a small walk-up apartment on Madison Avenue, just south of 34th Street. In February, on his way to Washington to meet Barbara's parents, Frank stopped in Philadelphia where I was an architecture student at the University of Pennsylvania. He was very dapper in gray flannels and a Langrock tweed jacket. And he had brought me a present from Spain in the form of a yellow, wide elastic webbing belt with elegant leather fittings.

Stella's second one-man show at the Castelli Gallery opened on 28 April 1962. The Copper paintings were the most dramatically shaped to date because they were no longer rectangles that had been notched away at the edges and/or the corners. They were far more striking. Even though some of the configurations could be found within the Black paintings, these were distinct and innovative works. As Rosenblum has written, "The Copper paintings had now broken so far from the traditional rectangle that the shapes unbalanced completely the sense of an enclosed area of pictorial illusion."[1] The titles of the paintings were inspired by the names of Colorado towns: *Ophir, Telluride, Ouray, Pagosa Springs, Lake City, Creede.*

Opposite: detail of *Tampa*, 1963.

The working drawings for *Ouray* and *Creede* reproduced in Geelhaar's catalog are not to any scale, even though they are drawn on grid paper. From these two drawings it appears that Stella could arrive at the overall dimensions and the width of the legs (or arms, as in the cross-shaped *Ouray*) without using a conventional inches-to-feet ratio, which would have yielded a far more informative diagram. Clearly, though, in both cases, Stella *began* by drawing the perimeter of the shape with a sharp pencil and a straight edge. Then, freehand with a soft pencil, he drew in the stripes, following the grid lines of the paper. For *Creede* the firm size of the stretcher was established by marking the darker squares on the graph paper 1" x 1", each crossed nine times by vertical and horizontal lines. It is clear from the note on the drawing that he wanted the height to be seven feet, which he drew as exactly three of the large squares. And he wanted each leg to be one-third as wide as the leg was high, or 28 inches. That indicated to him that the painting could be ten stripes wide. A given was the width of the commercial masking tape at one-quarter inch. All ten stripes would be the same width, which in *Creede* worked out to a small fraction over the width of his brush of choice, i.e., two and one-half inches. The inboard and outboard stripes would go to the edge, meaning no canvas would be showing at the very edges of the paintings, leaving in turn nine quarter-inch spaces. The width of the stripe plus the width of quarter-inch tape was the determining factor of the actual size of these paintings after Stella had established how high and wide he wanted them to be. For at least a couple of centuries the common brick has been the determining unit for the size of buildings in this country. For Stella, the determining unit was comprised of the two-and-one-half-inch stripe and the space masked by quarter-inch tape.

Leo and Ivan Karp suggested to Frank that he make a few "baby" versions of the Copper paintings for quick sale in the thousand dollar range. At first the request seemed fair enough, but when the first painting was completed he was well aware that something had been lost. He painted small versions of *Lake City*, *Telluride*, *Ophir*, *Pagosa Springs*, and *Ouray*, none larger than twenty-seven inches high or thirty inches across, and brought them up to the gallery. Castelli and Karp were happy with the pieces but Stella was not. He refused to let them be hung in the main room with the large paintings. If they were going to be hung at all, it would have to be in the back

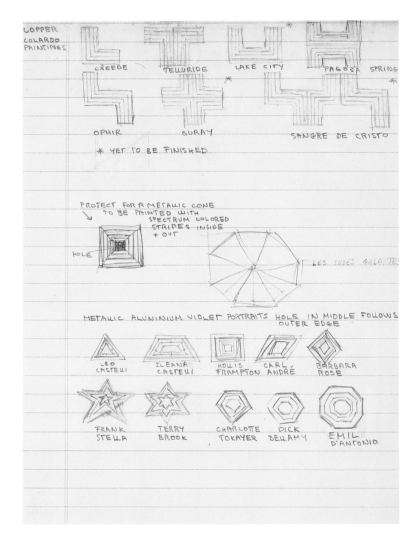

Sketches for the Copper Paintings, Metallic Cone, and the Metallic Portraits, also known as the Purple Series, 1961, pencil, 10¾ × 8½". Kunstmuseum, Basel.

room, or the hall. Almost twenty years later Stella told Calvin Tomkins, "I guess because I'm a little man, a little bigger than life size seems about the right size for me. When you're hoping for things to sort of open up, you need room for them to do it in."

Rachel Stella was born on 20 June 1962. By then Frank and Barbara were seeing all of their old friends as well as some new ones. And by then they had moved again, this time to a much larger, brighter apartment on 16th Street, west of Union Square. Frank painted the apartment and built some furniture, including a crib and a desk for Barbara. When mother and child came home from the hospital, there was a stream of visitors including Andy Warhol, Jasper Johns, and Henry Geldzahler.

The same week that the show of the Copper paintings opened at Castelli, *Art Since 1950*, an exhibition directed and curated by Sam Hunter, opened at the Seattle World's Fair. *Getty Tomb* had been selected by Hunter for the show. Increasingly, Stella was gaining the attention of the people who mattered, but he still was not selling paintings. Not one of the paintings in the Castelli show sold. Fortunately, Andy Warhol commissioned Frank to do the six paintings in the Benjamin Moore series in the twelve-inch format for him. Otherwise there were few sales.

Barbara says of their life in the winter and spring of 1962 in the little apartment on Madison Avenue, and later in the larger one on 16th Street, "Henry [Geldzahler] was there all the time. Henry worshipped Frank, and got a lot of ideas from him—and sometimes he'd come over just to watch Frank watch TV. Don Judd lived around the corner. Our apartment became a sort of meeting place."[2] Indeed, aside from the regulars such as Hollis Frampton and Carl Andre, parties at their place might include Robert Rauschenberg, John Cage, and Merce Cunningham.

Henry Geldzahler had graduated from Yale in 1957 and went on to work toward a doctorate in art history at Harvard. But in 1960 he left graduate school to join the staff of the Metropolitan Museum of Art. He quickly became involved with the art and artists of the sixties, and in particular with Frank Stella and Andy Warhol. Unlike Leo Castelli and Frank, whose relationship had always had a bit of uneasiness to it, Henry and Frank were comfortable in each other's company. Henry was fond of Frank and kept him engaged. They had much in common and Henry, like Yorick, was "a fellow of infinite jest, of most excellent fancy."

Emile de Antonio, the film maker, also came on the scene with some frequency. He was a friend of Steve and Sigrid Greene and had visited them in Princeton. He first heard of Frank Stella in 1957 from Steve who spoke glowingly of him. De, as he was called, was more than a gadfly, in as much as J. Edgar Hoover regarded him as a communist sympathizer and a threat to our American Way of Life. He was a superb and original film

maker and his *Painters Painting* is what it says it is: "A candid history of the modern art scene, 1940–1970." Barbara and Frank made the match of De and Terry Brook who were married in 1965 and stayed together until Terry's death from cancer in 1984.

For the better part of three years, Stella had done away with the problem of color in his own work. As he had made clear in the Pratt lecture, what (color) to put where and what (color) went with what was a problem. But in 1961, probably in Spain, he had begun to think about paintings in which he would put colors together again—the paintings in the Benjamin Moore series were single color.

As the basis for two extended series of paintings that would carry his investigations of colors and values, Stella used the configurations of two of the paintings in the Benjamin Moore series, *Island No. 10* and *New Madrid*. The former became the Concentric Squares, and the latter, the Mitered Mazes.

After a decade's worth of sermons and texts that preached the gospel of the necessity of "flat," Clement Greenberg's dictum, Stella's new paintings were nevertheless illusionistic. Typically, in his exhaustive method, Stella set out to examine the possibilities of combinations of six colors on one hand and of a ten-stop gray scale ("a scale of achromatic colors having several, usually ten, equal gradations ranging from white to black") on the other. There was definitely the illusion of depth. These paintings looked like they were receding into the canvas. Given the configuration of *Island No. 10*, the addition of just one other color of a different value, even randomly, gives the optical effect of a receding space. Works based on the structure of the lined-up, diminishing squares accentuates their illusory character. In paintings based on *New Madrid*, the mitered corners produce in each case a pair of diagonals, one continuous and the other broken, which create the sensation that we are seeing, as Rosenblum puts it, "These fictive ziggurats, protruding or receding, become still more complicated when adapted to the earlier maze form."

Perhaps the most appealing works in these two series are the paired mazes. Rosenblum continues:

In other variations on this theme, Stella pairs two of these mazes to produce an even more vibrant optical effect in which two points of focus compete for attention. And at times these diptych-like structures, already heralded in the binary forms of many of the Black paintings, join grisaille and color mazes. A dazzling case in point is Jasper's Dilemma, *where, with topical reference to Johns's own problems of color versus grisaille, Stella sets into unending competition a colored maze and, so to speak, its own black-and-white reproduction.[3]*

Alfred Pacquement, the French art historian and author of *Frank Stella* (1988), is more sympathetic to the "spatial" development than most American critics at the time:

Up until that point he [Stella] had insisted on the flatness of the surface, opening a new epoch in turning his back upon the heritage of Cubism (as indicated by his derisive title, The Last Post Cubist Collage, *from 1959). Coming to grips with the use of color, just as every painter must do (is it chance that the first sketches of the Concentric Squares were born during a trip in Europe, in Spain, quite precisely?), he rediscovered without much diffi culty how to appropriate the effects of illusionism. The multicolor Concentric Squares are, nevertheless, premonitions of his evolution toward volume.*[4]

In the last week of October 1963, Stella gave me a batch of pencil drawings and asked me to make precise working drawings so that he could order stretchers for his latest series, which would become the Purple paintings. Although the stretchers for the Copper paintings, which Stella had built himself, appeared to be extremely complex, each one had only right angles. Seven of the eight Purple paintings would have no right angles, and suddenly the carpentry had become too difficult for the artist to handle.

While the aluminum and copper paints which Stella first used had wide commercial application and consequently were relatively inexpensive, the light purple paint with metallic particles suspended in it had to be made to his specifications.

The eight shapes of the Purple paintings and the friends of Stella whom they represented are as follows:

Equilateral triangle	Leo Castelli
Square	Hollis Frampton
Rhombus	Carl Andre
Pentagon	Charlotte Tokayer
Hexagon	Sidney Guberman
Octagon	Henry Garden (Geldzahler)
Decagon	D (Emile de Antonio)
Trapezoid	Ileana Sonnabend

In the center of each painting is a void whose shape repeats the shape of the painting and whose sides are exactly parallel to their counterparts.

"Frank Stella and a Crisis of Nothingness" was the headline of the review of the Purple paintings exhibition (Castelli, January 4–February 6) in *The New York Times*, 19 January 1964, by Brian O'Doherty. With the title of the piece to set the tone, the critic labeled the artist, "the Oblomov of art, the Cézanne of nihilism, the master of ennui." In Emile De Antonio's 1970 film, *Painters Painting*, Stella talked about his response to criticism:

I don't know how to get at it, and I'm not sure I want to say it . . . I guess I don't mind saying it: for critics who are not first-rate, there is a tremendous assumption of artistic humility, which I don't seem to have: too much success and being too smug about it. There is no suffering. There is no feeling. There is no questioning. I just keep doing it, and I don't have troubled periods, I don't have crises, and anxieties. All that is documented on the canvas. Basically what they're after is that it's too easy for me, so, therefore, it couldn't be any good.

In July 1994, Stella talked some more about the critics and the anxiety of influence:

I was always in it so I never worried about it [critical abuse] too much, you know, and the journalists are in and out. Over the forty years the artists stay the same but there's a new generation of journalists every ten years. They have relatively short careers. They get bored with it.

One of the things that's real hard to explain, especially when you're young, is that there's a tremendous investment in going against the grain and the fun of competition and sort of competing with your betters and elders and, you know, making fun of them and arguing with them and everything and there's a kind of interchange in that way, but the thing of that is partly to succeed them and partly to equal them and partly to accept the commitment of pursuing that enterprise for the rest of your life. So if you're going to do something and it's what you do, and it's what you're always going to do, you don't need to be particularly reverential. A little bit of healthy disrespect for the people who are supposed to be so good doesn't hurt.

Between 1962 and 1965 Stella made a great many sketches for paintings, always working in series, and at times, drawing on tracing paper so that he could repeat the same configuration as often as he wanted, changing the colors each time. A great many of these were published in Geelhaar's catalog and in *Frank Stella Working Drawings 1956–1982 from the Artist's Collection*, published by the Kitakyushe Municipal Museum of Art in Japan in conjunction with their exhibition in November 1982.

The four examples from this period illustrate the very loose quality, not only of the drawing, but of the forms and their composition. One series bears the names of other artists, some who are friends or acquaintances, others who are famous, such as Magritte and O'Keeffe. I will call this series, which includes more than one group, the Homage series. The first

group was for a series of six paired concentric squares, each square with only three divisions. The titles with Stella's exact color designations are as follows: *For Picabia*, R&B; *For Kenneth Noland*, O&G; *For Frank Stella*, Y&V; *For Delauney*, Spectrum; *For Jasper Johns*, B-W-B; and *For Alfred Barr*, O B.

In 1963 he had begun drawing the group of eccentric shapes with color inlays, most with one or more curved lines. These would lead to the drawings for the Irregular Polygons, but before that came the "Art on Art" sketches, again documented in Geelhaar. Particularly informative and revealing of Stella's mind is the project list written in pencil on a sheet of three-hole, gridded notebook paper and headed "Winter-Summer."

> Item 4.: Fall show for Leo
> Art on Art, (2 each) EPOXY
> - Judd's Pillar
> - Clem's Hurdle
> - Ken's Cross
> - Kupka's Diamond
> - Larry's Dot
> - Magritte's Easel
> - Dick's Fan
> - O'Keeffe's Patio
> - ? Darby's Screen

Of the drawings reproduced in Geelhaar's book, *Magritte's Easel* is very much like the paintings in the Irregular Polygon series.

Castelli arranged for Frank to be invited to Dartmouth College for the summer of 1963 as an artist-in-residence. The idea of getting out of town into the cool, fragrant countryside of New Hampshire with its clean air and crystal lakes appealed to him and to Barbara. They were given a little frame house on the edge of the campus and it turned out to be almost as idyllic as they had imagined. At Hanover, Frank did the first six paintings of the Dartmouth series. In August they were included in a two-person exhibition at the Hopkins Art Center beside the sculpture of Tal Streeter, who was also an artist-in-residence.

The six paintings done at Dartmouth are part of a series of thirteen. The first four are painted with zinc chromate paint, and the last two are red lead paint. They are named after towns in Florida not far from Lakeland, home of Florida Southern, which he and I had visited two years earlier. With a loose description of their configurations they are:

Dade City	connected V shape (pointing out)
Polk City	connected V shape (pointing in)
Plant City	eight-pointed star (diagonal stripes)
Port Tampa City	eight-pointed star (vertical/horizontal stripes)
Tampa	cross shape (diagonal stripes)
Haines City	cross shape (vertical/horizontal stripes)

"I had the local university carpenter do them," says Frank of the stretchers for these paintings. "At first they were very skeptical. Then they did a very good job. They thought it was stupid, I mean they couldn't believe that I wanted them. I had to keep insisting that they build them."

Following the Dartmouth show, the paintings were trucked down to New York, crated, and sent to Paris for Stella's second exhibition at Galerie Lawrence, slated for spring 1964.

Henry Geldzahler was invited to travel in Iran in October 1963 as a guest of Mr. and Mrs. Stanley Woodward, directors of a foundation whose mission it was to locate and place modern American art in our embassies. He invited Frank to join him.

When Stella returned to New York from Hanover in late August, he completed four more paintings in the Dartmouth series and produced the sketches for the Running V series and the Notched V series. Then he was off to Persia, and as usual he was inspired by what he saw as well as by the sounds of the Middle Eastern dialects and by the names of places. The Persian paintings of 1965, a relatively small series, were named after cities in Iran, *Bam, Bafq, Baft,* and so on. The following two amusingly cryptic paragraphs are from Larry Rubin's catalog raisonné:

The group of works known as the Persian paintings originally consisted of four large and four small canvases painted in 1965. The titles refer to names of cities in Iran. Each of the four large pieces had a smaller version; however, only six works are recorded here because two of the small paintings have vanished without a trace.

These paintings have never been exhibited as a group. In 1966 they were sent to Europe for an exhibition that was to be held in Stuttgart, but the show never took place.[5]

Bam. Fluorescent alkyd on canvas. Eight by nine feet. Big, bad boy of a painting. It can be seen in Louisiana, the museum of contemporary art outside Copenhagen. Stella incorporates the violent juxtapositioning of fluorescent colors borrowed from the Moroccan paintings with the banded circuitry and terrific pace of the Running V's. In this very powerful painting, he had, through a perfectly logical combination and development of two earlier ideas, come up with some more completely unexpected pyrotechnics.

Rosenblum, so taken with the joyous dynamics of *Bam* and its companions, writes:

The synthesis of these two movements, one visual, one nearly physical, creates a pictorial field whose teeming activities are almost unbearably constricted within the triptych clarity of the frame, whose central panel, so to speak, seems forced to a diagonal axis by the insistent pressures of the color stripes in the lateral fields. Again Stella

holds the conflict between the frenzied and the frozen at a fever pitch. A rapidly oscil- lating surface of abrupt jumps in color and tonal value; a streamlined velocity so compelling that the spectator almost loses his balance at the shift in direction—such frenetic energies are held in check by the insistent, flaglike clarity of the tripartite design, which, in turn, provides yet another opposition, that between the total flat- ness of evenly painted stripes and the illusion of oblique foreshortening in the central, diagonal field.[6]

Significantly, Stella's trip to Iran inspired the paintings in the Protractor series, 1967–70—more than ninety immense canvases named for ancient cities in what was once called Asia Minor.

By Christmas 1963, Frank, Barbara, and Rachel had moved to a new apart- ment at the northwest corner of 73rd Street at Madison Avenue, a move prompted by the notion that it would be good to live near Central Park for Rachel's well-being. The three hundred dollars a month rent was twice what they had been paying on 16th Street, but their fortunes were improv- ing. Leo had raised Frank's advance to four hundred dollars a month, Frank continued to receive a stipend from Larry Rubin, and Barbara was earning a little money writing for *Art in America*, and *Artforum*, a new mag- azine from Los Angeles edited and published by Philip Leider. She quickly became a contributing editor of *Artforum* and was responsible for getting Darby Bannard and Donald Judd on the masthead as well.

In 1964 Barbara's "salon" was at its height, and Frank seemed to enjoy it. Most Saturdays and Sundays people would drop by in the afternoon for a drink. They were two blocks from the Whitney, less than five blocks from the Castelli gallery, and never very far from the heart of the New York art scene. Barbara's gatherings included gallery owners and artists, critics and students, curators, and assorted other friends.

About this time Frank began to feel out of shape and was determined to get some regular exercise. His first thought was to start playing lacrosse again. He had heard of a league of teams in north Jersey and in the sub- urbs north of New York City. He still had his sawed off attackman's stick and a pair of leather lacrosse gloves. Having heard that a team was form- ing and that there would be try-outs on a field in Red Hook, New Jersey, he made his way over with only the stick and gloves; no helmet, no pads. He could not find the field. That was the end of Frank's lacrosse career.

Jogging had never appealed to him. But with Central Park a block away there were not as many excuses for not running as there had been when they had been living on 16th Street. Three or four times a week he would walk over to the park, run the mile and a half mile course around the reservoir a couple of times, and walk home. He hated it.

Stella on the tennis court, 1967.

Not long after they had moved to 73rd Street he passed by the old Armory on the corner of 34th Street and Park Avenue. A banner announced the availability of tennis lessons and courts to rent by the hour. Inside, the courts—a hardwood floor covered with tautly stretched canvas—were badly lit and grubby. But the lessons were inexpensive and he improved quickly. In the beginning he wasn't friendly with any tennis players, but he would take two or three hour-long lessons a week. He picked up the fundamentals easily and before long, typically, was trying to beat the pro. As soon as his game was presentable, he found players at the Armory who would give him a game. Between 1965 and 1975 he played tennis with the same intensity he brought to solving the problems of painting. About that intensity, Larry Rubin said to me, "It's winning. Winning. Frank loves winning. He wants to win. He doesn't play for the fun of playing. He plays to win. And that's the way he plays art. That's the way he plays the horses. Not always with success, but he wants to win."

In the years 1962 to 1965, Stella was moving at a dazzling pace. The seven paintings of the Running V series, whose titles were Spanish words or phrases, began as freehand pencil sketches and were painted in 1964–65, each a single color of metallic powder in polymer emulsion. The largest of the group, *De la Nada Vida a la Nada Meurte* (from the nothingness life to the nothingness death), is seven feet tall and more than twenty-four feet wide. Even though each is painted a single color, there is a velocity to these paintings. The eye speeds from one end to the other, jogging as the bands do—slowing and picking up speed again—while at the same time experiencing a gentle lift from and return to the picture plane as the joggings generate shallow space. It appears that all seven paintings were completed by summer 1964 and four of them were shown at Kasmin Ltd. in London in October. John Kasmin would remain Stella's London dealer until he closed his gallery and retired thirty years later.

On 12 May 1964, Frank's 28th birthday, the show of the Dartmouth paintings had opened at Galerie Lawrence in Paris. Larry Rubin remembers, with considerable pleasure, just how the work arrived:

They were very big paintings. Really big, and the regular delivery trucks couldn't take them. So they brought them from the airport on a truck for mirrors and great sheets of glass. They opened them in customs and they must have thrown away the cases. And I had no idea when they were going to get there. Then at one point there was this tremendous commotion and honking and screaming and what not and I went out to see what it was and there was this truck with all the Stellas on it. Thank God it wasn't raining. And there they were, strapped on the sides of this truck. They were taking them off. Rue de Seine is a very narrow street and they had it blocked up. Of course, I almost fainted when I saw that they were not only not crated, they weren't wrapped. So they had uncrated them, strapped them to the sides of this thing and brought them to the gallery. And amazingly enough they weren't damaged.

They weren't damaged and they weren't sold. The provenance of each painting indicates that it returned to New York where it eventually was sold by either Leo Castelli or Larry Rubin.

But by the end of 1964 the Dartmouth paintings must have seemed old to Stella, who was at work on four distinct groups of paintings including the Moroccan paintings, inspired or at least motivated by colors and geometries he had experienced during his 1961 trip to Morocco with Barbara. In truth, he wasn't yet finished with the square and would continue to ring the changes on that "least arbitrary of all shapes." They were painted in Day-Glo, fluorescent colors, and were shamelessly optical. They were done fairly quickly since the fluorescent quality of the paint is at its maximum when the application is but one coat thick.

With these paintings, whether the canvas is divided into two, four, or eight zones, the bands are mitered and color A, which travels along between two bands of color B also runs into color B at the diagonal. The usual first reaction to one of these large paintings is to wince. Yellow predominates in all but three in the series and is made to collide against and jar the otherwise normally sedate greens, blues, and reds.

The Notched V paintings of 1964–65 were named for the great English clipper ships of the last century. According to Rosenblum, "The basic unit of this new series was a vector of concentric chevrons, analogous to the V-shaped thrusts of color in Kenneth Noland's chevron paintings of 1963–64. Characteristically, Stella defined this new motif as a single unit, as in *Slieve Bawn* and *Slieve More*, and then elaborated it in variations that combined from two to four of these restless forms."[7]

These Notched V paintings, made up of modules of chevron groups, never completely succeed as paired or grouped units except in the two prints made at Gemini G.E.L. in Los Angeles in 1967, *Star of India I*, and *Star of India II*. In these, six of the modules, each a different color, are put together to make a hexagon with six notches. As in the best of the Black paintings, they practically crackle with their own electricity and, at the same time, declare their own dignified resolution. But Stella never made

Above: detail of *Bam*, 1965.

the two *Stars* into paintings, perhaps because using the regular chevron patch module, they would have been 12' 10" x 14' 10", enormous even by Stella's standards, and he was unwilling to reduce the size of the module.

In 1964 Frank Stella was included in ten museum exhibitions including the Whitney Annual for the first time, and at the Venice Biennale as one of a group of four younger artists including John Chamberlain, Claes Oldenburg, and Jim Dine.

Dr. Franz Meyer, former director of the Kunstmuseum in Basel, was a member of the international jury at the 1964 Biennale. He told me that a number of influential Europeans had decided well before 1964 that Stella was going to be a very important artist. When he saw *Tomlinson Court Park*, for the first time, he said of the experience, "I knew that this was important, those Black paintings. It was a mystery for me but very, very important."

By 1965 Bill Seitz had quit teaching at Princeton and returned to curating. His exhibition at the Museum of Modern Art, *The Responsive Eye*, was all about Op art in which much of the work was based on modern *trompe l'oeil.* Stella's painting *Line Up* was included although he and Barbara felt it didn't belong there. Still, the painting remained very much a part of the exhibition.

In April 1965, Harvard University's Fogg Art Museum opened a significant exhibition, *Three American Painters: Kenneth Noland. Jules Olitski. Frank Stella.* Michael Fried, who had earned a Ph.D. from Harvard and was now a contributing editor to *Artforum* and *Art International*, curated the exhibit

and wrote the catalog. The show, scheduled to travel to the Pasadena Art Museum in July, included six paintings from six different series by Frank Stella: *Die Fahne hoch!,* Black; *Union Pacific,* Aluminum; *Lake City,* Copper; *Cipango,* Concentric Squares; *Illeana Sonnabend,* Purple; *Tampa,* Dartmouth. Though these paintings were but a small sample of what Stella produced between 1959 and 1964 (Lawrence Rubin's catalog raisonné lists two hundred and thirteen paintings from *Delta* to *Tampa*) Fried's selections represent one of the best examples—if not the best—from each of the six series.

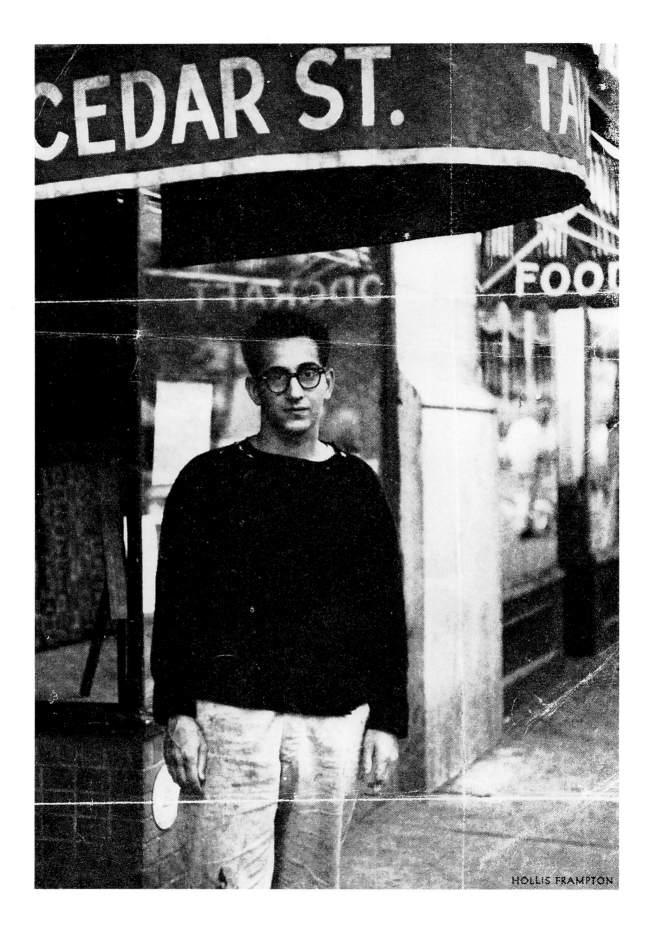

Frank Stella photographed by Hollis Frampton for
a 1965 *Vogue* article about new and promising artists.

Creede II, 1961
Copper oil paint on canvas
82¾ × 82¾"

Jasper's Dilemma, 1962–63
alkyd on canvas, 77 × 154".

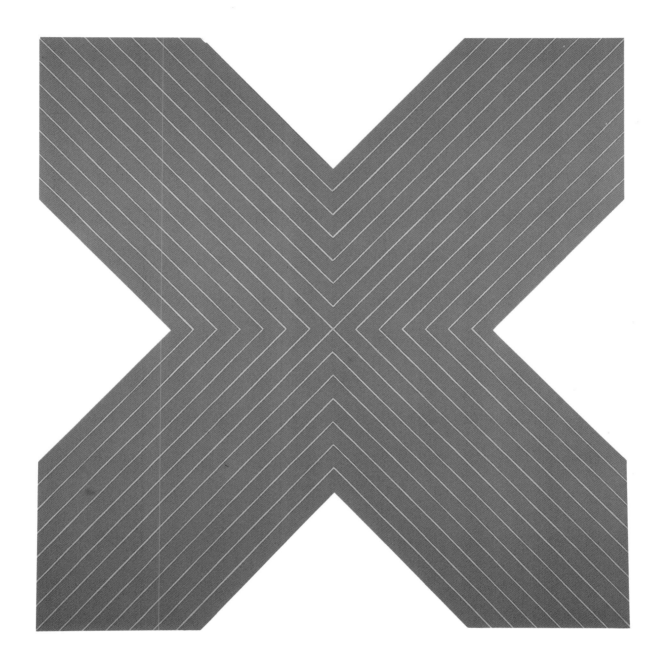

Tampa, 1963
red lead on canvas, 99⅜ x 99⅜".

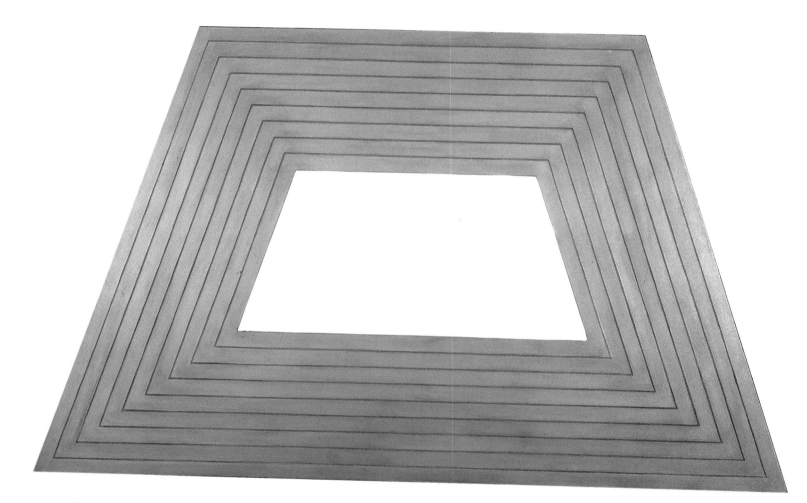

Ileana Sonnabend, 1963
metallic oil paint on canvas,
72¾ × 128".

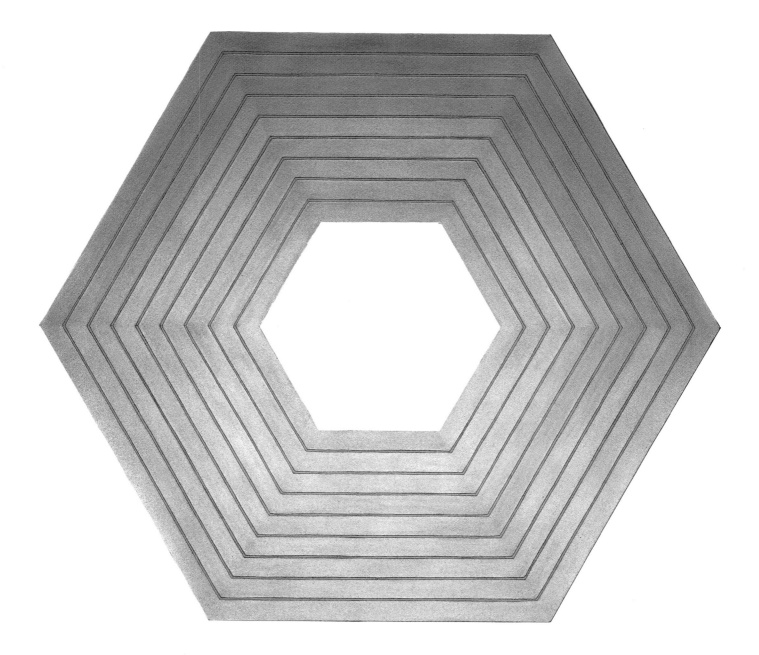

Sidney Guberman, 1963
metallic oil paint on canvas, 77 x 89".

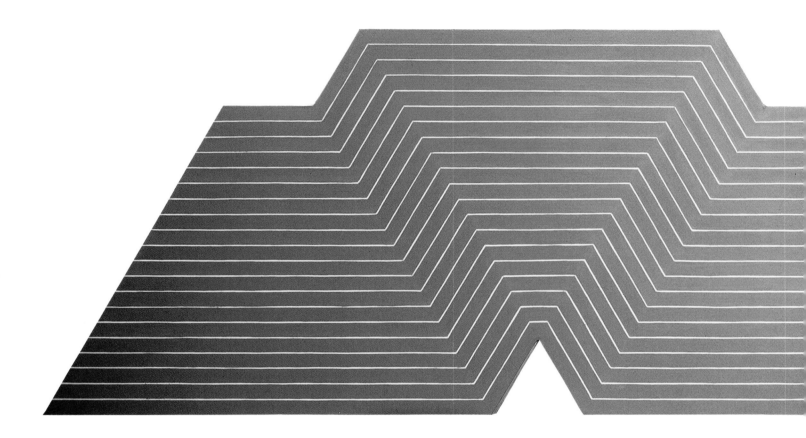

De la Nada Vida a la Nada Muerte,
1965
metallic powder in polymer emulsion
on canvas, 84⁵⁄₁₆ × 293"
The Art Institute of Chicago,
Ada S. Garrett Prize Fund.

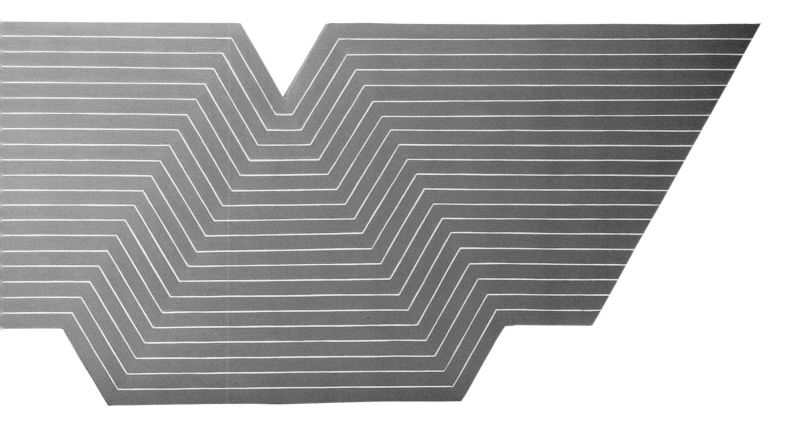

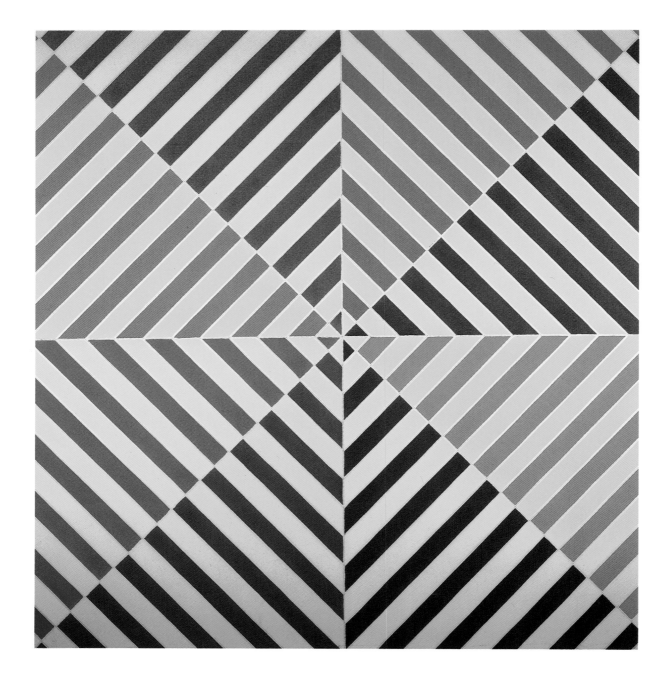

Sidi Ifni I, 1965
fluorescent alkyd on canvas,
88 × 87¾".

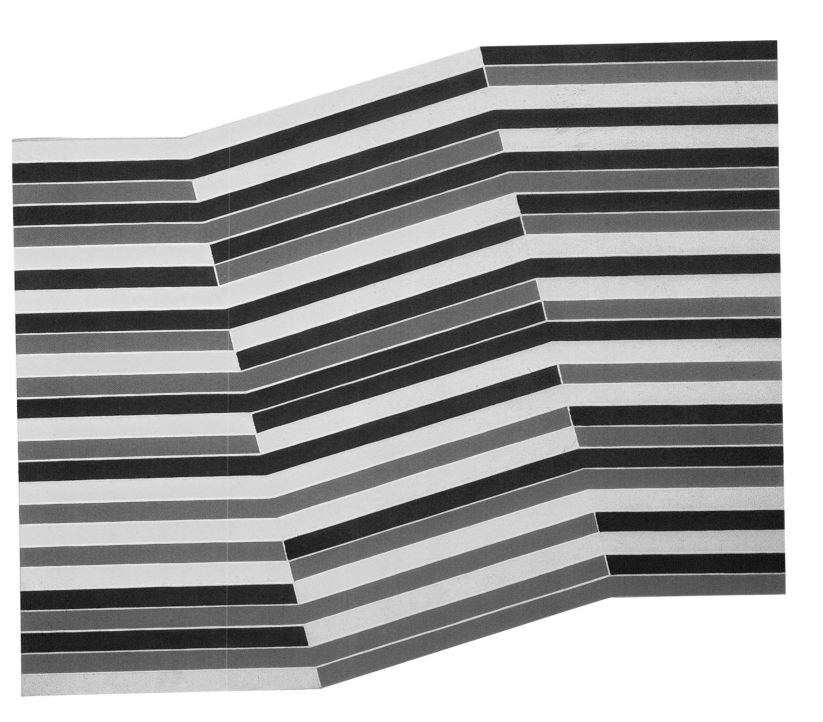

Bam, 1965
fluorescent alkyd on canvas,
96 × 108"
Louisiana Museum of Modern Art,
Humlebaek, Denmark.

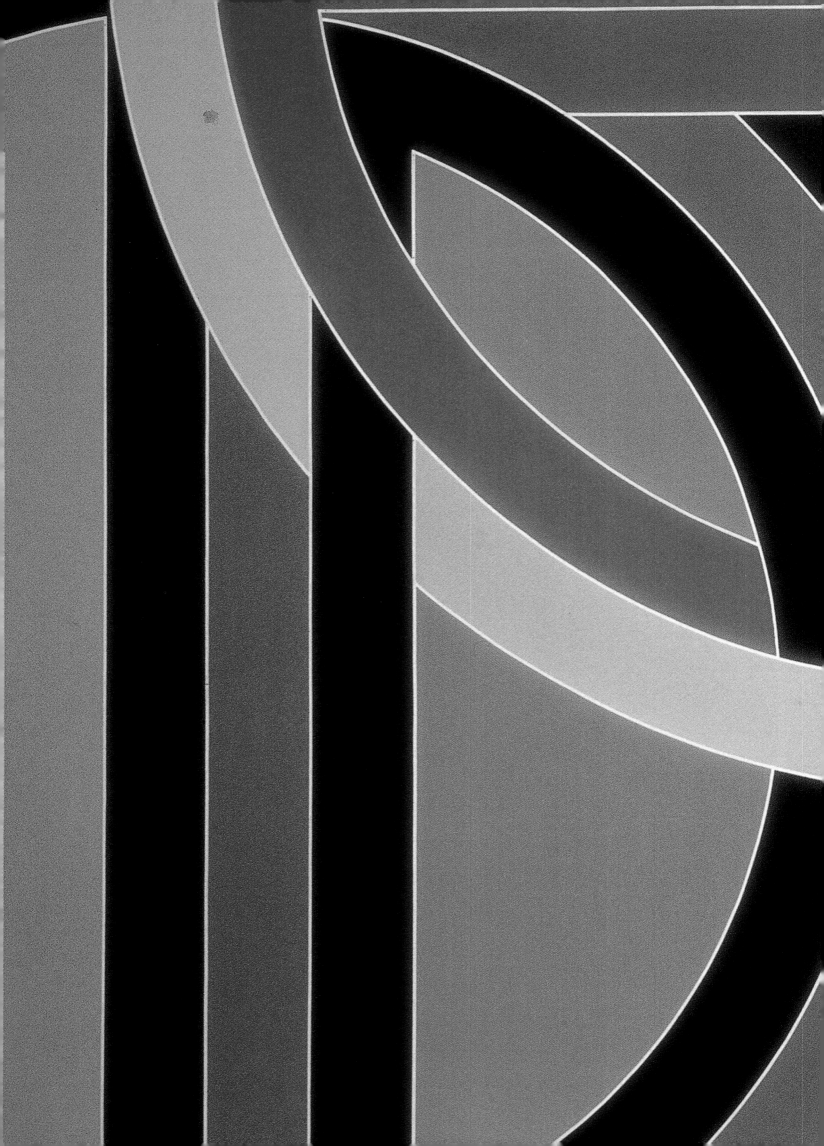

6

IRREGULAR POLYGONS, CALIFORNIA, PROTRACTORS, 17 JONES STREET

During an interview with Larry Rubin in September 1994 I started to ask a question which I never got to complete.

SG: *When was the first time you went to the studio and you saw something of Frank's which you just thought was . . .*

LR: *Awful. Yes. I made a tremendous mistake when I saw the Irregular—I had liked everything of Frank's, unfailingly, until the Irregular Polygons. And I just didn't know what to make of those when I saw them and I thought they were lousy. And I told Frank. And he was really very nice about it and he said, "Well, if you don't want them, just take a few and I'll sell them to somebody else." And that's what he did. And not very long after, I realized that I had completely misjudged those pictures and changed my mind about them.*

The stretchers for all the paintings prior to the Irregular Polygons were symmetrical on at least one axis, with only three exceptions: from the Running V series, *Abajo* (green), *Abajo* (flesh), and *Claro que si* were asymmetric. Even in the case of *De la Nada Vida a la Nada Meurte*, if you were to draw the longest diagonal, from lower left point to upper right point, well over thirty feet, you would observe that thus divided in two, the top is a reverse mirror image of the bottom.

In one group of paintings Stella made a major structural shift by leaving the relative security of symmetry to the seemingly random outlines of the irregular stretchers. And for the first time since he had painted houses in Queens, he was laying in great zones of flat color instead of painting stripes. Once again, a new series was greeted with stunned amazement by

Opposite: detail of *Raqqa I*, 1967.

Stella and Barbara Rose at 17 Jones Street, photographed by Sidney Guberman, 1967.

Stella's fans, a few hundred people in the country who felt he could do no wrong, and with boos and catcalls by a number of the critics.

Barbara was working toward a doctorate and writing reviews and articles (and frequently letters in Frank's behalf) almost weekly. They were both busy, enormously stimulated, and going at full throttle. There still wasn't much money, but based on the recognition they were getting, it was only a matter of time before the real recognition from the collectors would come.

As a critic, Barbara was already regarded not only as important, but as something of a power-broker. Stephen Greene tells the story of an opening of his in the fall of 1966, which fell on his birthday. Helen Frankenthaler came to congratulate him and he invited her and her companion to a birthday party after the opening. She declined but asked, "Oh, where is it, by the way?" "At Frank and Barbara's," said Steve. Helen and her friend walked around the gallery and returned to tell Steve that they could make it after all.

It was in the spring of 1965 that the entire family tangled with the law. Barbara and Rachel had walked over to Central Park where Barbara liked to stretch out on a park bench and read while Rachel would play nearby. It was a moment in the period of the great Vietnam protest and Barbara, because of her festive attire, probably looked to a passing cop like another lawless hippie. His suggestion that she take her feet off of the park bench prompted her, without missing a beat, to suggest to him what he could do with the idea.

Enraged, the cop arrested Barbara and was trying to get her and Rachel, who was sobbing, to move in the direction of his squad car. By wonderful coincidence, Frank showed up in his paint covered clothes and shoes, saw the cop with his hand on Barbara, and grabbed him. The policeman turned his attention to Frank, started beating him with his nightstick, and in the scuffle, Frank bit him on the hand. The arrest took place late in the afternoon of 30 April, 1965. Jerald Ordover, Frank's attorney at the time, gives an account of the aftermath:

Ivan Karp called me at home at 9 pm. I went right over to night court in Manhattan to await Barbara's appearance. Her case was finally called after midnight. She was charged with interference with a police officer in the performance of his duties and paroled until the trial. Frank was held overnight because he was

charged with the more serious crime of assaulting a policeman. I secured his release the following morning on fifty dollars bail. The charges against him were felonious assault and interference with a police officer in the performance of his duties. At the trial on May 25, 1965, Stan Lotwin [the lawyer Ordover got for the Stellas] negotiated a reduction of the charge against Barbara to disorderly conduct, to which she pleaded guilty. The felony assault charge against Frank was dismissed and he pleaded guilty to the misdemeanor charge of interfering with a police officer. Both received suspended sentences.

Ivan Karp and Henry Geldzahler had been in court to act as character witnesses if needed, but they were not called.

Around the first of June, a few days before I was to marry Jennifer Glidden in New Canaan, Connecticut (Frank was an usher), I came east. When I got to the Stellas', there were drawings everywhere—magic marker and crayon studies for what became the Irregular Polygons. Barbara commented, "Frank's been going crazy trying to reinvent painting." By "going crazy" perhaps she meant that he was trying to keep too many balls in the air at one time, that there were just too many distractions. In *The Nassau Herald*, the record of the class of 1958 at Princeton, Frank's writeup concluded, "After graduation, Frank plans to continue painting in New York, Norway, or wherever there are the fewest distractions."

Stella with his daughter, Rachel.

The summer of 1965 was full of distractions, especially in comparison to the end of 1958, when Stella began the first Black painting. In 1958 he built the stretchers and made the paintings. He messed around some with Frampton and Andre, but the only serious distraction was when he would run out of money and have to paint apartments for a few days. By 1965 he was living uptown in comfortable surroundings and his trip to the studio could take an hour each way. He was a loving and attentive father. He played tennis several afternoons a week. He and Barbara had many social demands. He was looking for a building to buy so that they could move back downtown, nearer the studio. The distractions were considerable and would remain so until the family moved to California in January 1967.

Walter Hopps, a curator at Washington's Corcoran Gallery of Art, had selected Stella to represent the United States at VIII Bienal de São Paulo, with six paintings from three series, Dartmouth, Notched V, and Running V. When Stella left for Brazil in October 1965, he had finished the group of paintings named for cities in Iran. While he

Preceding pages: sketches for the
Irregular Polygon series 1962–63
pastel and colored pencil, 6 x 4";
sketch for *Tuftonboro*, 1966,
pastel and ballpoint pen, 3¾ x 4¼";
sketch for *Pipe Grainer*, 1965
pastel on graph paper, 6¾ x 9"
Kunstmuseum, Basel.

was gone, working on planes and in hotel rooms, he began sketches for a series of paintings which would be known as the Protractor series. As soon as he returned he began painting the Irregular Polygons.

Some ideas for the Irregular Polygons had begun to appear as sketches as early as 1962. In the summer of 1965 Stella took eleven sketches with dimensions to his stretcher builder LeBrun and ordered forty-four stretchers, four of each configuration. The wood he chose was first grade, absolutely clear (no knots) white pine. The bill for these great, braced forms was ten thousand dollars. The sketches indicated that the paintings would be named after the small towns in the White Mountains of New Hampshire Frank knew from summer fishing trips with his father.

The crayon sketch for *Conway* in Geelhaar's catalog shows that it was a very loose, freehand drawing with filled-in colors. From there he redid each drawing on graph paper. The proportions of each would tell him how high it felt and how wide it felt. Essentially, his intuition told him how big each of the paintings in the series wanted to be.

The Irregular Polygons were a great departure for Stella: they were open and spacious; they were far more concerned with color and the interaction of color than any of the work since the paintings of the summer of 1958; the drawing was inventive and less dependent upon strict geometry; and they appeared to offer almost limitless possibilities for development into subsequent series. The move was courageous and it is understandable that he carried the sketches over to Ellsworth Kelly, probably the most prominent of the hard-edge abstractionists, to see what he thought. Kelly urged Stella to get busy and paint them.

From the time Stella began building stretchers that were more complex than mere rectangles with butt joints, he showed an understanding of structure, not only in the smaller sense of how you put things together, but in the larger architectural sense. He quickly developed the confidence that anything he could draw (and later make a model of) could be built.

Structurally there were no great problems with the Irregular Polygons. Stella decided that the stretchers for this series of paintings needed to be four inches deep. The surface of the painting would be four inches from the wall. With all painting stretchers greater than a certain dimension, there has to be interior support, that is, bracing inside the perimeter members. The bracing keeps the stretcher bars at the perimeter from bowing as the canvas is stretched taut and keeps the stretcher in its intended configuration. The interior supports or bracing is invariably shallower than the outside pieces, so that even if it sags somewhat the canvas will not touch it.

If the artist did away with his two-and-one-half-inch brushes and the stripes they made, he kept the quarter-inch masking tape. He said that by using a cheaper brand of tape, he was able to achieve a bleeding of the

paint into the unsized canvas. This bleeding was not regular or even. Stella felt that the breathing spaces, the ragged lines of off-white canvas, were essential. As he told William Rubin:

Without them, the Irregular Polygons would have become hard-edge paintings. Leaving them out would have killed the space, and made the pictures snap around a lot. It would have given them a kind of hard, brittle space, I'm almost sure. I was afraid of such a mechanical quality. They might have become too much like geometric drawing and like conventional geometric and hard-edge painting. I think what I had in mind in connection with these spaces was the example of Matisse—in something like the Red Studio. *It's perhaps an obvious device, but the necessity of separating the colors, that breathing, that soft line, and that identification of [color with] the ground seemed very important to me in those pictures.*[1]

Robert Rosenblum writes, "What Stella had come up with in this group of paintings, this grand departure from rigid constructions with a preordained schedule of color(s) and a timetable of stripes, their departures and arrivals, was a series of his 'most unexpected inventions.'"[2]

Heretofore, once the stretcher had been built, the surface structure of each painting was pretty much locked in. The color or colors had been established by the sketches and their notations.

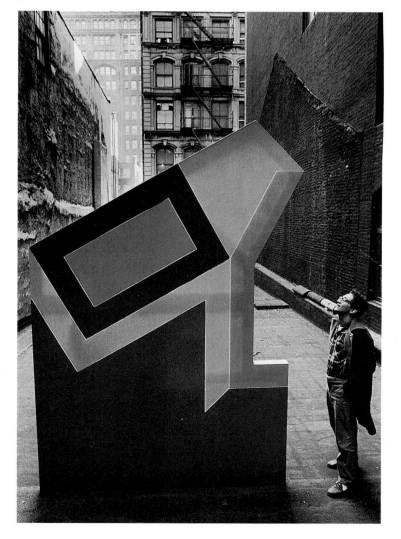

Stella with *Moltonboro* on the roof of his studio, 1968.

And in every painting since the first post-transitional Black painting there was a density of concept and execution that kept the viewer at a distance. In the new paintings, the change was immense. As William Rubin puts it, "The Irregular Polygons carried Stella into an area of openness, variety, and freedom of choice."[3]

In his book of Stella's working drawings, Christian Geelhaar, in fewer than a thousand words, was able to explain the nature and spirit of the drawings, the paintings, and how the evolution from drawing to painting took shape:

Stella limits himself to two, at most three, geometric figures which are tangential to or penetrate each other. Great value is placed on the clarity of relations. The fundamental rule that one must see, "the whole idea without any confusion," retains an undiminished validity.[4]

Geelhaar deals quite specifically with the connection between studies and finished picture, demonstrating that the sketches and working drawings were a key part of the oeuvre and essential to a full understanding of the Irregular Polygons:

The forms were allowed to retain their identity but were also intended to be released from their isolation and melted into a new, unified shape. Through the joining together of these geometric figures, a decisive mediating function was assigned to the eight-inch-wide color-contrasted bands that surrounded and accompanied the figures. A comparison of some of the preliminary studies with the definitive pictures can provide clarification about this. A preliminary drawing on graph paper for Effingham, *here still titled "Dukla" formed, according to a statement by the artist, the point of departure for the series of Eccentric Polygons. Stella here combined two figures which were special favorites for him. A chevron angle, which is familiar from the Dartmouth pictures (see* Dade City *and* Polk City*), and a diamond.*[5]

Of the Irregular Polygons, David Bourdon wrote in *Life* magazine in 1968, "These paintings antagonized many of Stella's admirers, who thought he was surrendering to old-fashioned illusionism. As a result of his switch in styles, the earlier works are now looked on as a classic body of work, vastly important and influential. Once selling—and not very frequently—at around $900, they would now change hands at around $15,000."

Stella was not so happy that people, and in particular Fried and Rosenblum whom he respected tremendously, were seeing so much illusion. He commented to William Rubin:

The paintings are pretty frontal. I don't see twists in them. I want to see them flat. I see the planar ambiguities, but I minimize them as much as I can. I feel that this is the right way, the way I want to look at these pictures, and I feel that it is possible to do this without forcing oneself to see the paintings in a manner that really distorts them and their intentions.[6]

Philip Leider may have had the last, best word on the Irregular Polygons:

By 1966 Stella had been under the gun for five years. In the Irregular Polygons he accomplished a major change of style without having to give an inch of his position in the center of advanced art in New York and without managing to repudiate any of the meanings which literalism attached to his work. The strain shows in the paintings, many of them the most explicitly violent Stella has ever made. Forms interpenetrate as if by naked force; spiked, sharp edges abound; colors often verge on the hysterical. It is astonishing that even as these paintings are being made the vision of a monumental decorative muralism is taking form in the artist's mind.[7]

In the spring of 1966, after the birth of Michael Stella, the apartment at Madison and 73rd seemed too small and Frank began the search for a larger place to live. On Jones Street in Greenwich Village, Frank found a three-story brownstone big enough for a family dwelling, two cars, and a

ground-floor studio (the building is thirty by one hundred fifty feet). The asking price was $200,000. 17 Jones Street appeared to be the perfect solution for the family.

Richard Meier, the architect and a good friend of Frank's, offered to design the interiors and oversee the renovations gratis. Stella asked Leo Castelli for the money to make the down payment on the building but Leo said he didn't have it. Frank then went to Larry Rubin, who gave him twenty thousand dollars in exchange for existing and future paintings. Larry had sold the Galerie Lawrence in Paris to Ileana Sonnabend and was frequently in New York working on plans to open a gallery on 57th Street.

Besides being able to move his family to a larger space, the cash-for-paintings deal strengthened Frank's position with Larry Rubin. Frank's request for money made Larry take a stronger position with regard to Frank's painting than he normally would have. Also, the arrangement prompted Frank, in 1967, to tell Leo that henceforth half of his output would go to Larry Rubin. As Calvin Tomkins put it:

Castelli accepted the decision with the grace of necessity: Stella would have a show at Castelli's one year and at Rubin's the next. With a less productive artist, this might not have worked out, but as a result of Stella's enormous energy and rising prices the two-gallery arrangement put him in a much stronger economic position.[8]

Energetic is a good word to apply to the production of the Irregular Polygons. Frank began painting them in the fall 1965. Five were included in the 30th Biennial Exhibition of Contemporary American Painting at the Corcoran Gallery of Art in Washington, D.C., 24 February– 9 April. A batch of eight or ten were reserved by Castelli and were shown at the gallery, 5 March–6 April. A third were shown at the David Mirvish Gallery in Toronto, 15 April

Frank was selling the paintings as making as much as a thousand [dollars a month] Castelli and Rubin increased each month as they increased. As David Bourdon pointed out, Frank's work commanded substantial prices see approach to the Irregular

In the fall 1994 one of [the New] School for Social Research was [celebrating] the couples was Frank Stella and [...] make it through the sixties. Although [...] rise—few months passed without [...] work, to speak, or to teach—the guess [...] them was not to last long.

One of the teaching invitations the couple received came from the University of California at Irvine, an exurb southeast of Los Angeles. Frank was asked to teach a studio course to the advanced painting class, and Barbara was invited to lecture on trends in contemporary American art. The jobs were for the spring semester, beginning in January 1967.

On 1 January 1967, Frank was nearing the end of his thirty-first year and had never owned a car. But when you move to Los Angeles, you have to have a car, unless like Thomas Mann, you are able to live and work in the same place (Pacific Palisades) and have people bring you what you need.

The Stellas chose to live in Newport Beach because of its proximity to Irvine. Barbara, Frank, Rachel (now four) and seven-month-old Michael Henry—named after Michael Fried and Henry Geldzahler—settled into their rented house on the beach in the first week in January. Given the circumstances—a major relocation, two new jobs, living in a rented house with two babies in an alien culture (Southern California) and the usual money pinch—the pressure the Stellas experienced was inevitable. The soundest marriage in the world would have shown the stress. And the Stella marriage was already showing a few fault lines even before they got to California. Things hardly improved when they read in their contracts that, as employees of the State of California, each was required to sign a loyalty oath. Even though it was 1967 there were still vestiges of McCarthyism in the groves of academe.

In 1967 the town of Irvine was little more than the sprawling campus of the University of California. Founded in 1964, U.C. Irvine would eventually accommodate 20,000 students. But it was not to accommodate Frank, for whom there was never any question about signing the oath. Barbara, however, had come to teach, to make a little money, and she would sign the oath if she had to.

Tennis had become Frank's great passion and he usually managed to play wherever he went. That January, standing in back of the house in Newport Beach looking west, two or three Wilson, Jack Kramer, gut-strung wooden tennis rackets under his arm, Frank saw things in a much less rosy light than they are supposed to be in Southern California. He was, for a few days at least, like a beached creature.

It was worse for Barbara. The things she cared about seemed to have become more difficult to attain. She was trying to complete her book, *American Art Since 1900*, but even the task of correcting the page proofs seemed impossible given so much disruption. (Most of their belongings and furniture had been put in storage while work went on at 17 Jones Street). But she did complete the book, and it was published in 1967 with the dedication "To Frank."

Barbara had known Robert Rauschenberg and Jasper Johns from the early days of the Castelli Gallery. They were her good friends, her pals. Both artists were making successful prints and Rauschenberg was working

on print projects with Kenneth Tyler, the master printer from Tamarind, who had set up Gemini G.E.L., a print workshop in Los Angeles. Barbara had met Tyler on several occasions in New York and she contacted him as soon as they arrived in California.

Ken Tyler, whom I have known since 1969, is one of the most relentlessly positive people on earth. There is nothing an artist can propose that he will say he cannot print or make or develop and produce. He knew he could work with Frank, but Mohammed had to go to the mountain. He drove down to Newport Beach for lunch one Sunday in January. It was Frank's lucky day. Tyler recalls:

Frank told me he couldn't draw and why should he make prints if he couldn't draw? All his contemporaries were draftsmen, not him. At that time Johns and Rauschenberg were extremely famous in terms of print work. And Frank thought they really had the whole stage. In a funny way I think he admired what they were doing but didn't think much about being involved because he didn't know the approach. So I came back later with a felt tip pen filled with tusche and told him, "Here, draw." So he came in and he drew the "V" to the Star of Persia, *with that felt tip pen.*

The rest is history because he started to draw away and his first concept was to make albums of his imagery. The Black Album, The Copper Album, Silver and Purple, and so on. And go through the series, and this would be in a black naugahyde folder with acetate sleeves and the prints would be slipped in, they'd all be 11" x 17", and we'd sell them very cheaply. Absolutely the opposite of what Jasper and Bob were doing. And what everybody else was doing, actually.

We published the prints in a series, and we had the portfolios made but nobody wanted them and, of course, nobody kept them in portfolios. Everybody took them out and framed them.

In that period, he was involved in working on the Eccentric Polygons but really didn't conceive of color prints yet. The first prints we came out with were Star of Persia, *and the Notched V series and after the V series, which was colored metallic inks, we moved into the black inks, but the amount of work he did in the first few years was immense. He created a lot of prints. But he really didn't have a feeling for layered printing. This happened with the Eccentric Polygons, in the seventies, and that series, I think, opened the doors to*

Below: Stella and Rachel with Ken Tyler at Gemini in California, 1967.

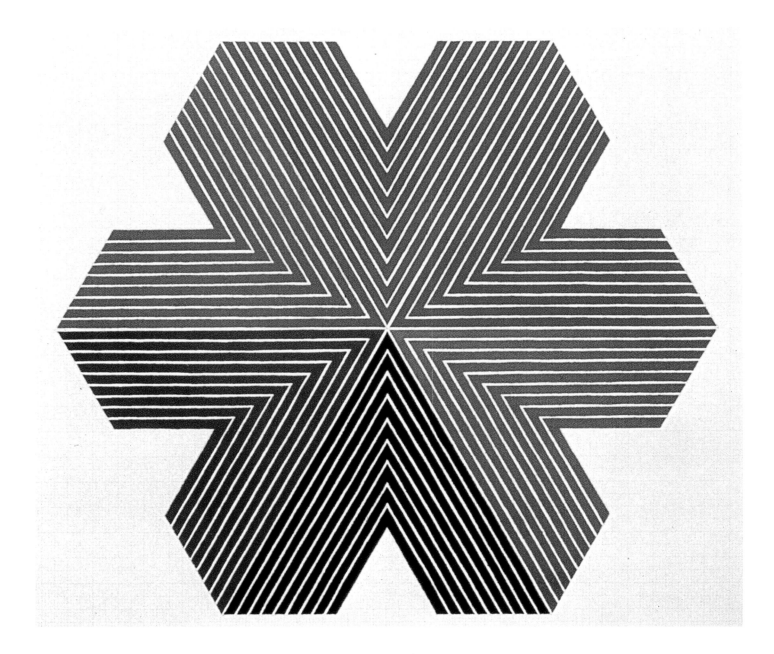

Star of Persia I, 1967
7 color lithograph on English Vellum
graph paper, 26 × 31".

The extent to which that is a grand understatement will become clear when one looks from the vantage point of 1995 back over the almost overwhelming body of work—two and three dimensional—that is the result of the close collaboration between Frank Stella and Ken Tyler.

Besides his family, Gemini and Ken Tyler were responsible for keeping Stella in California as much as possible in the early part of 1967. The first two prints, *Star of Persia I* and *Star of Persia II*, were completed in the spring, both images in editions of ninety-two. In the fall there was an ad in *Artforum* offering them at two hundred fifty dollars each. (In 1990 *Star of Persia I* sold at a Sotheby's auction for twelve thousand dollars.) Both prints were sold out by the end of the year. Suddenly the money to be made from prints had become a real consideration for the artist.

That winter and spring, out of necessity, Stella went back to New York two or three times each month. In the studio on Houston Street he completed the Irregular Polygons and watched as the cavernous space began to fill up with the stretchers for the next group of paintings, the Protractor series. There was plenty to occupy him including the renovation of 17 Jones Street in which, according to Richard Meier, he was quite involved.

When Frank was in Los Angeles, he would go to Gemini every day, always finding time to get in a game of tennis in the afternoon, frequently at the Beverly Hills Hotel. And he still needed one painting to finish the Copper series. As laid out originally, there were to have been six paintings named after the small towns in the southwest corner of Colorado and one enormous painting, *Sangre de Cristo* (blood of Christ), named for the reddish color of the mountains along the front range of the Rockies in southern Colorado.

A friend of Ken Tyler's had a four-car garage in Costa Mesa, just a few miles east of Newport Beach. He agreed to vacate it for as long as it would take Frank to stretch and paint *Sangre de Cristo*. The forty-two-foot stretcher had been made by a woodworking company in L.A. and trucked out to Costa Mesa in three pieces that were bolted back together. The canvas was stretched and stapled to it and then set up on sawhorses. Frank did not use copper boat-bottom paint as he had done with the first six paintings in the series. Instead he painted with gallons of copper ink which Tyler had made up by Imperial Ink Company in L.A.

"It is astonishing that even as these paintings are being made the vision of a monumental decorative muralism is taking form in the artist's mind," wrote Phil Leider of the Irregular Polygons in his 1970 article in *Artforum*.

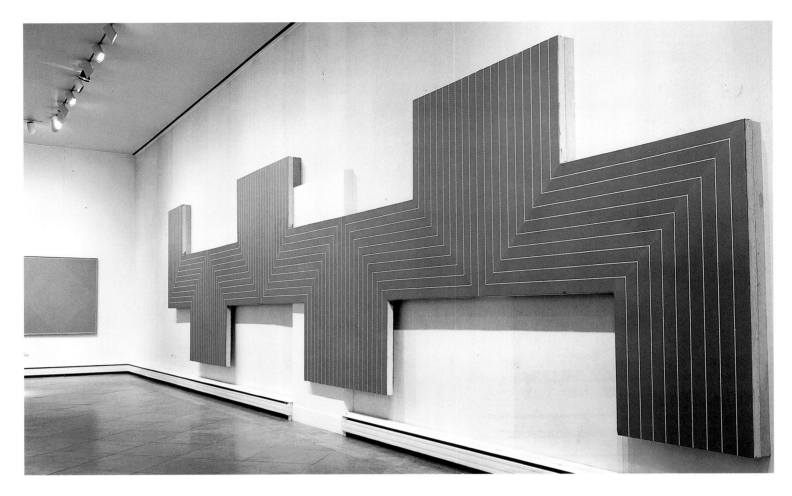

Sangre de Cristo (1967), installed at the Castelli Gallery.

The "monumental decorative muralism" he refers to are a group of over one hundred enormous paintings known as the Protractor series.

The paintings in this series are architectural in size and scale. They are mostly ten feet tall, and a number are fifty feet across. Muralism is an appropriate description since each effectively covers the wall in front of the viewer, filling up the field of vision. And because the width of the bands is at eight inches the scale itself becomes more heroic than the gamut of paintings whose band width was two-and-a-half-inches.

How did Stella make circular stretchers? In order to make the strip of wood take on the shape of a part of a circle, it is sawed into on one side, at right angles to its longitude, over and over until the saw-cuts, about five-eighths of an inch deep into the three-quarter inch thickness of the board, render the board fragile and structurally delicate. Practically half of the mass of the board has been removed. The saw-cuts are filled with glue, and it is then placed with cuts inward against a semicircular form of the desired radius. When the glue has dried the curved board can be attached with staples or screws to the rest of the stretcher.

The considerable amount of mass production in the fabrication of more than one hundred stretchers for the Protractor series was full of endless repetition, including, literally, nearly a million five-eighth inch saw-cuts. By the time the final stretcher for the Protractor paintings had been delivered to the studio on Houston Street the total bill came to over fifty thousand dollars.

The white areas of unsized canvas between the bands of color were the result of a diagram drawn on the taut canvas, its lines then covered with the quarter-inch masking tape. The curved elements are drawn with a beam compass, a ten-foot length of quarter-inch lath with holes drilled to accommodate a pencil. The end of the lath—the center of the arc—was nailed to the canvas so that the stretcher beneath and the compass would turn about the nail. With as much practice as Stella had had, he was able to start the tape wherever he chose, and with a couple of feet extended from the roll in his left hand to the surface of the canvas, he could make the tape follow the curve, keeping center over the line while at the same time, smoothing down onto the canvas and continuously let more tape unroll.

When he was traveling around Persia with Henry Geldzahler in 1963, Stella made a list of the Islamic names of ancient cities with circular plans. Variations on these names became the titles of the thirty-one configurations of the ninety-three-plus paintings in the series.

The module common to every one of these paintings is five feet, the radius of the protractor shape used repeatedly. He made three separate and distinct paintings for each shape he came up with. They are easily identified by the designations Protractor (I), Interlace (II), and Fans (III). By looking at the illustrations of *Raqqa I, II,* and *III,* the difference among them is clear. The Protractors work better than the other two probably because the structure of the drawing on the canvas reflects most faithfully the shape of the stretcher.

Alfred Pacquement says that with the Protractor series, Stella modified the rhythm of his production, pointing out that he had been working on three separate and quite different groups of paintings in the same year (in 1965 Stella completed the Moroccan paintings, began and completed the Persian paintings, and began the Irregular Polygons.) By contrast, he would spend over three years working on the Protractor paintings and the related Saskatchewan and Newfoundland series.

Most of the Protractor paintings are wonderful to look at because the colors are so rich and exciting in their interactions, the geometries are compelling, and the great arching compositions have a tremendous sensual appeal.

Stella spoke of their impetus to William Rubin:

My main interest has been to make what is called decorative painting truly viable in unequivocal abstract terms. Decorative, that is, in a good sense, in the sense that it is applied to Matisse. What I mean is that I would like to combine the abandon and indulgence of Matisse's Dance *with the over-all strength and sheer formal inspiration of a picture like his* Moroccans. *Matisse himself seems to have tried it in the* Bathers by a River, *and that's as close as he seems to me to have come. Maybe this is beyond abstract painting. I don't know, but that's where I'd like my painting to go. Anyway, it seems to me that at their best, my recent paintings are so*

AMERYKA

Frank Stella
przeciwnik iluzji
malarz
geometrycznej
rzeczowości
i prostoty

GRUDZIEŃ 1968

Above and opposite: Stella and the Protractors as featured in a Polish magazine, 1968.

strongly involved with pictorial problems and pictorial concerns that they're not conventionally decorative in any way.[9]

The renovations at 17 Jones Street were more or less completed sometime in the spring of 1967, and Frank, Barbara, Rachel, and Michael were able to move in when they returned from California. They took up formal residence in the fall after spending the summer in Western Canada. Frank taught the advanced painting studio at the Emma Lake Workshop at Regina, a summer extension course of the University of Sasketchewan.

Before he brought his family back from California in May, Stella completed work on a set of twelve lithographs at Gemini using the images of the Black paintings and began a second set of eight, which would complete the lithographs of the Black series. Financially, he was still not in the black but was getting closer. The grand and quick success of the *Star of Persia* prints had been a bonanza, especially given his grim outlook at the beginning of the year. And Barbara had been offered a full-time teaching position in the art history department at Sarah Lawrence College as an associate professor starting in the fall.

The front door to 17 Jones Street has always been painted dark green. It is made of steel set into a thick wall of old, weathered brick. Beside it there is a wooden garage door with a couple of "No Parking" signs nailed to it. The garage is large enough for two cars, one behind the other. On the first floor there is a long, fairly narrow office, and some forty feet into the building, there is a space roughly eighteen by sixty feet which at first was used as a second painting studio. It was later converted into a printing studio with an immense lithography press and finally in the late 1980s into a huge playroom and gym.

On the second floor there are offices looking out over the street, a large all-purpose room behind them, and at the back of the house is the master bedroom with bath and dressing room.

The living room on the third floor is the full width of the building and a hundred feet deep. Its walls are covered with paintings by Poons, Hofmann, Olitski, Noland, Schwitters, and other twentieth-century artists. Originally there was a stepped, square, carpeted pyramid about four feet high roughly in the middle of the room—a piece of sculpture by Richard Meier doubling as a play area for Rachel and Michael. Also on this floor are four bedrooms, two at the front of the house and two in the rear with

the kitchen, where a circular staircase connects to the master bedroom on the floor below.

In the fall 1967 Jennifer and I went to visit the Stellas in their new house. We admired the space and the renovations. I took some photographs including one of Frank in his LeCorbusier chaise in front of the Larry Poons painting with Barbara seated on the floor beside him. We took a walk in the neighborhood, then stopped for a coffee where Barbara announced that Bill Rubin, now chief curator at the Museum of Modern Art, had invited Frank to have a one-man show there in the spring 1970. He would be thirty-four years old.

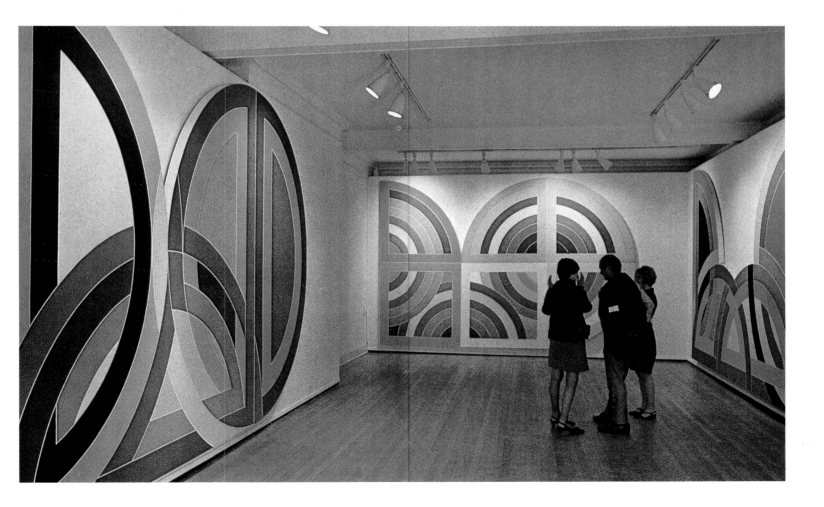

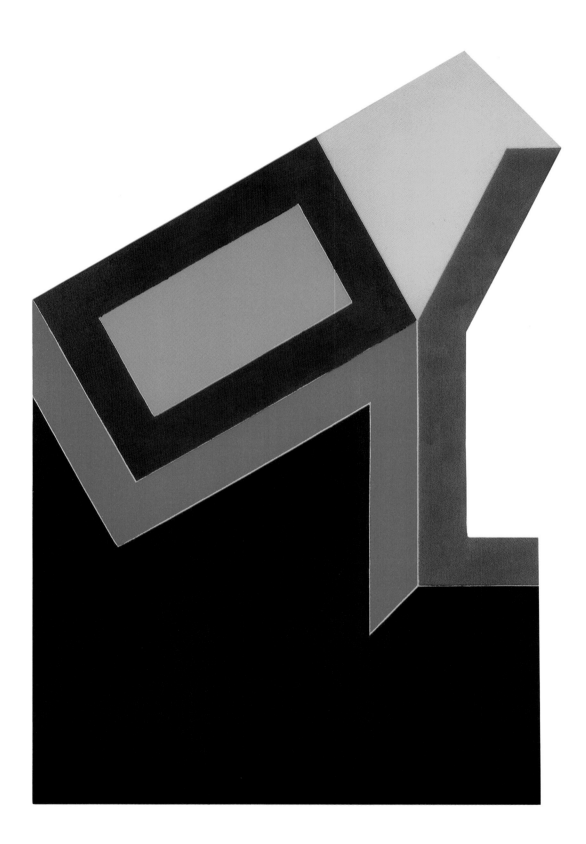

Moultonville II, 1965
fluorescent alkyd and epoxy paint
on canvas, 124 x 87½".

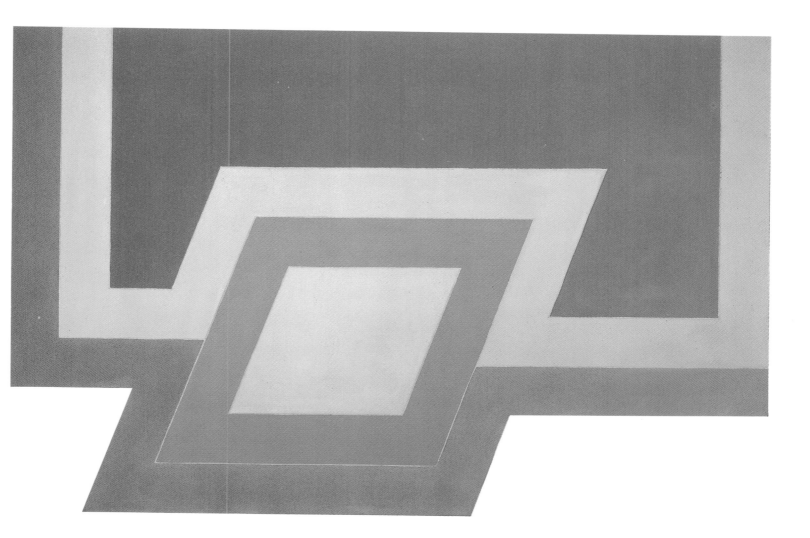

Conway I, 1966
fluorescent alkyd and epoxy paint
on canvas, 80½ × 122¼".

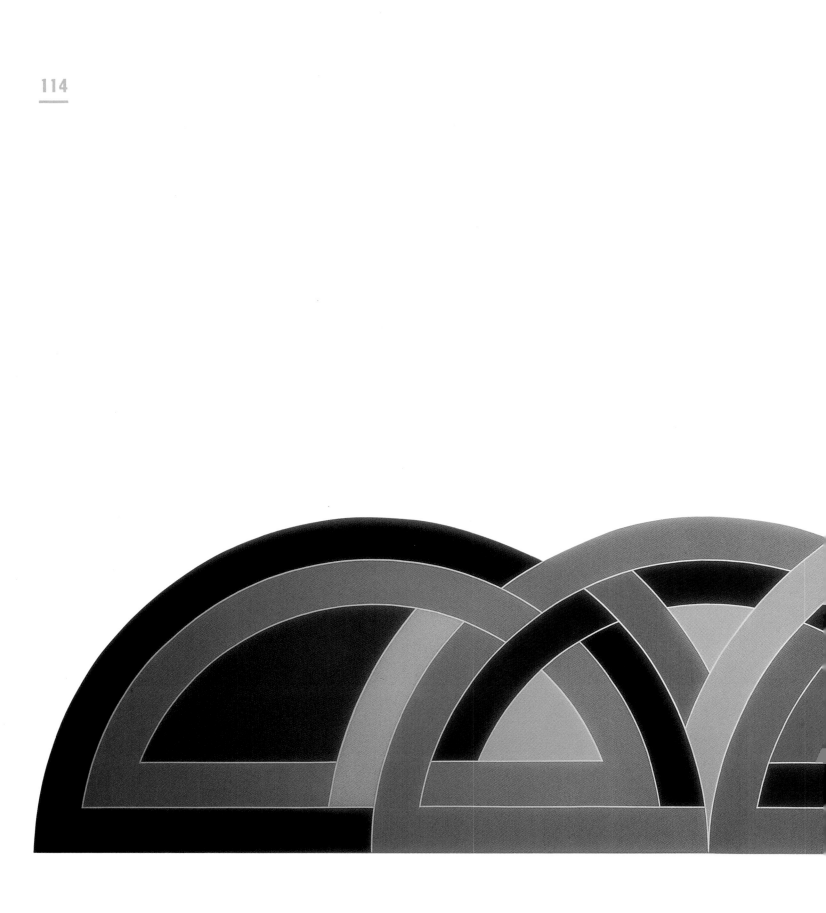

Raqqa I, 1967
fluorescent polymer on canvas,
120 × 300"

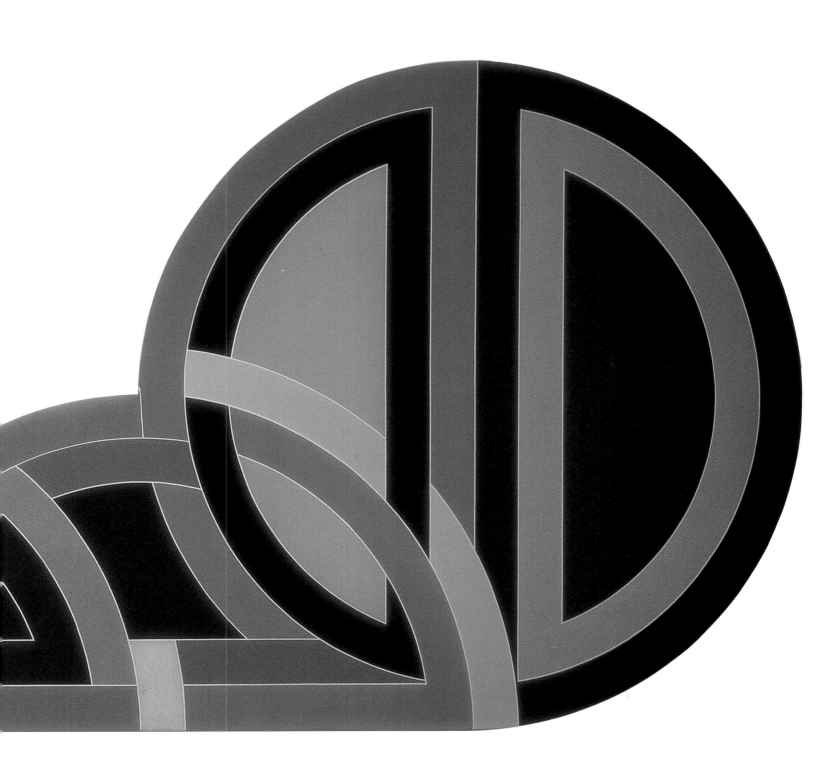

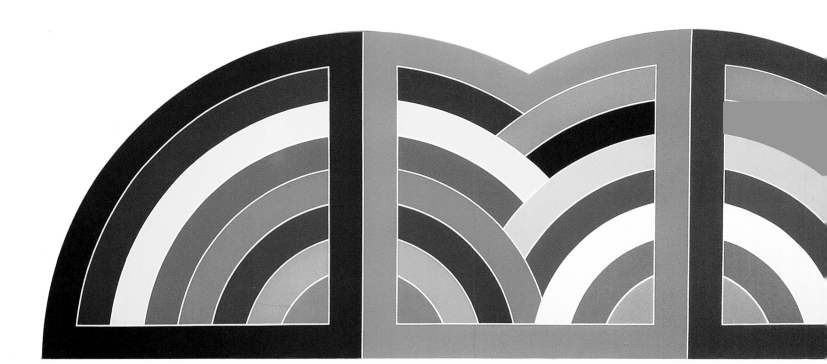

Raqqa II, 1971
fluorescent synthetic polymer on
canvas, 120 x 300"
North Carolina Museum of Art,
Raleigh, North Carolina, Gift of Mr.
and Mrs. Gordon Hanes.

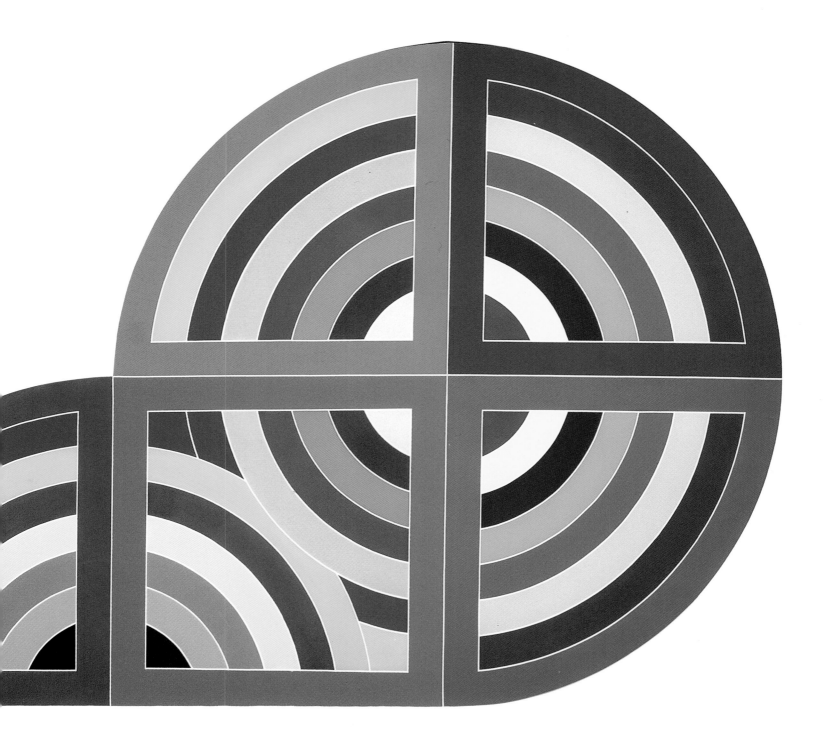

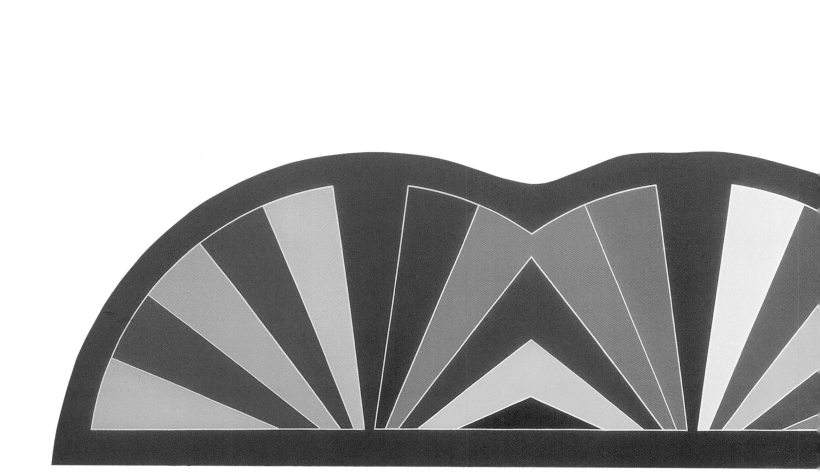

Raqqa III, 1968
fluorescent polymer on canvas,
120 × 300"
Museum of Modern Art,
Wakayama, Japan.

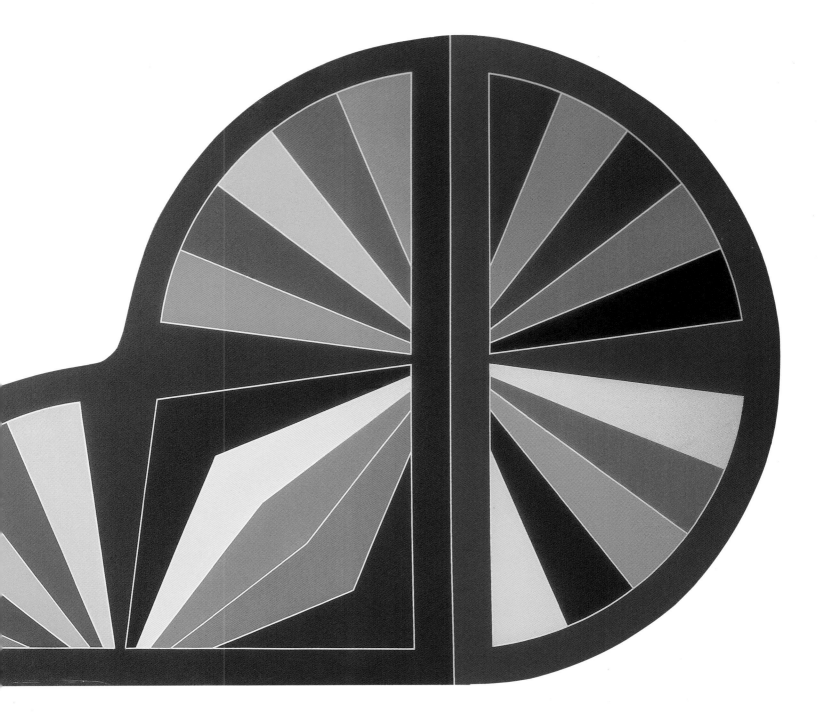

KAY BEARMAN, MOMA RETROSPECTIVE

When she graduated from Smith College in 1960, Kay Bearman did not intend to return home to Memphis. She had studied art history and expected to find an art-related job. That summer she began working at the Metropolitan Museum of Art as a curatorial assistant in the twentieth-century department. In 1964 she was interviewed by Leo Castelli and Ivan Karp and was offered the position of assistant to the gallery director, which included everything from writing letters, serving drinks and returning slides, to talking to unhappy artists and scheduling appointments for Leo and Ivan. She was to remain at the Castelli Gallery until Henry Geldzahler brought her back to the Metropolitan as his assistant in 1968.

In New York's world of art galleries, good manners are not necessarily a prerequisite for the people who have contact with the public. But Kay Bearman, trim and chic with short dark hair, and with a refined, slightly southern accent, was steadfastly polite. It was not long before Barbara Rose was leaving Rachel at the gallery while she visited other galleries or did errands. It was not in Kay's nature to object to the imposition, and she became quite fond of Rachel.

By 1967 Kay was handling much of Frank's business, including helping him keep track of his ever increasing flow of offers and invitations. She also oversaw a list of collectors who wanted to buy Frank's paintings. The order of the names on the list reflected, in part, Leo's estimation of each collector. The list represented a remarkable turn of events.

The Protractors were first shown in New York at the Castelli Gallery, December 1967. Collectors who weren't already on Stella's bandwagon, but who had been watching the sale and resale prices of the early stripe paintings, figured the time had come. The show at Castelli's was sold out

Opposite: detail of sketch for
Ile de la Crosse, 1958.

Above: sketch for the print
Grid Stack, 1970
ballpoint pen on graph paper, 17 × 14".

Opposite: sketch for
Ile a la Crosse III, 1968
marker, pencil, colored pencil, and ball-
point pen on graph paper, 9½ × 12"
Kunstmuseum, Basel.

before the doors opened. In the 19 January 1968 issue of *Life*, David Bourdon wrote, "The eccentric newer works too were snapped up. Stella's latest show of circular-shaped canvases was an immediate sell-out at prices as high as $7,500. Buyers queued up for these works, and though the series of 42 [sic] paintings is only half completed, all have been sold or reserved on the basis of preliminary drawings."

For each of the forty-four Irregular Polygons Stella made a scale drawing in which he would indicate the colors with magic markers. None of these paintings has more than six colors. But the Protractor paintings were far more complex and subtle, and it would have taken a thousand markers to indicate all the colors and tonalities and chroma variations he was dealing with. After completing a few of the Protractors that had been based on color drawings with lots of letter indicators—for example, WRO, WYG, WYO—he abandoned that practice. As he told William Rubin, "After a while I stopped making those thorough color drawings, because it was as much trouble to make them as it was to paint the picture."[1] Once again, he was changing his process, changing the rules. Previously Stella had strictly adhered to the drawing on paper when transferring onto the canvas. Now he discarded that practice and relied on his intuition to tell him what color to put next to what color. Ironically, he had resurrected the old problem of having to figure out what went with what.

More than in any of the previous series, the titles of these paintings—Islamic names of ancient cities—contribute to an "ambiance generale" (Pacquement) or the feeling of the entire group. In other words, there is a strong connection between the geometry, color, and architecture of the Protractor paintings, and the ornamental and architectural proportion and design of Islamic conventions.

Stella's intuition for all aspects of painting is extraordinary, from color and proportion to a feeling for architectural structure. But it is also true that his knowledge of the history of art of the last five hundred years is probably as great and as well considered as that of any living artist.

Frank Stella's generosity and gentleness are endearing qualities. But like most geniuses he has an intensity about his work that frequently leaves little room or time for the person he is living with. Not long after I took the photograph of Frank and Barbara in the Jones Street living room, the stresses in their marriage had become strains. Barbara, now a member of the Sarah Lawrence College faculty, continued to write articles and books and traveled a great deal. In 1969 they were formally separated, then divorced. It was a stunning blow to both of them.

If Frank had been battered emotionally, his resilience was ingrained. The need to keep working and to take care of his children did not leave time to feel sorry for himself even had he been so inclined. In early 1969 he came to Philadelphia with Kay Bearman. We played some men's doubles, watched the pros play tennis in the Spectrum, and went to a party. He was obviously comfortable and happy around Kay, and in spite of his shyness, seemed at ease. They would hold hands a lot, and Frank had a happy, goofy look. Kay told us that she was taking up tennis — Frank had given her tennis clothes and a racquet, and she was getting lessons.

He came back a few weeks later to speak at the Institute of Contemporary Art at the University of Pennsylvania. Given the changes his own painting has undergone in the last twenty-five years the talk seems particularly prescient:

The current emphasis on hard- and soft-edge geometric abstraction distorts the situation of painting in the 1960s. It gives the mistaken impression that painterly painting has lost its viability and has become formally retardataire. The simplest argument against painterly painting attacks its underlying romantic or open-handed sensibility as out of step with the times and alien to the basic formal concerns of the best painting today. The first part of the argument seems to me to be only assertive, simply declaring a preference for one kind of sensibility over another with an attempt to justify it by assigning a positive value to a contemporary situation, which is again at best only another relative preferential situation. The second part of the argument presents more of a problem but is equally mistaken, and on a number of different counts at that, if we amplify that argument to say that not only does painterly painting have a sensitivity alien to the basic formal problems of the best contemporary abstract art, but also that it actually fails in dealing with some of these problems, most notably the spatial ones.[2]

Using as examples the best mid-sixties paintings of Morris Louis and Jules Olitski, whom he refers to as "the two painterly painters of excellence," he makes the case for a painting which is not only gestural, but which permits space into the equation.

The implications of this are significant. While Stella was carefully laying down a web of quarter-inch tape over precisely drawn lines, while he was wielding his ten-foot long beam compasses and laying in great, flat arcs of color, he was dreaming of big, free paintings, as rambunctious, say, as *Funeral for Mrs. Beck.*

In 1969 Bill Seitz, who had become Director of the Poses Institute of Fine Arts at Brandeis University, in Waltham, Massachusetts, named Stella the Maurice and Shirley Saltzman artist-in-residence for the spring semester. Stella had

also been awarded the Brandeis University Creative Arts Award. In connection with both honors he had a show of eight paintings, six from the Newfoundland series and two from the Protractor series, at the Rose Art Museum at Brandeis in April. The huge paintings, four squares, two rectangles, and two shaped canvases including *Basra Gate I* (eight by thirty-two feet) filled up the small museum. It was definitely an eye-opener for the art students, as well as a teaching tool for Frank and others on the art faculty. There were four of the *River of Ponds* paintings. Anyone who has taught painting understands that, besides the importance of commitment, one of the most difficult messages to get across is accepting process—the continual doing and redoing—as one of the key elements of creativity. Four paintings with the same geometry to the drawing but painted differently deliver that message with volume and clarity.

Two studies for *Basra Gate*, 1966–68, marker on graph paper, 11 × 8½"
Kunstmuseum, Basel.

The Barnes Foundation on Latches Lane in Upper Merion, Pennsylvania, has in a discreet, hermetically sealed building on Philadelphia's Main Line a collection of Impressionist and Post-Impressionist paintings, and of Matisse and Picasso, which is amazing for its depth and quality. The group of first-rate Cézannes alone would be reason enough for a small museum. In 1969 the collection was opened to the public on weekends, but only one hundred people were allowed in the building in a day. During the week the paintings were kept in darkness to protect their colors.

I arranged for Frank and Kay to visit the Barnes Collection with my wife, Jennifer, and me on a Sunday in June 1969. Frank's style of looking at art is fast. There were only a handful of paintings that he had not seen reproduced, but he was still impressed. He nodded appreciatively in front of the Matisses, mentioned that Renoir didn't belong in the company of Matisse and Cézanne, and kept moving. He spent a relatively long time looking at Matisse's *Joy of Life* of which he said, "He really did it. It's all right there." I assumed he meant that not only was everything about the painting great—the drawing, color, forms, and composition—but that it was modern in every sense and portended abstraction.

He was intrigued by a Cézanne landscape with bathers in the foreground, *Bathers at Rest* because of the thickness of the paint in some places on the canvas, as though it had been frequently repainted. He examined the painting closely but his only comment was, "This painting must have been around the studio for a long time." The only other work he gave a fair amount of attention to was a curious little painting of a swan by de Chirico that neither of us had seen before. The swan floats on water that looks like a parquet floor and is without the exaggerated perspective or

Henri Matisse, *The Joy of Life*, 1905–06,
oil on canvas, 69⅛ × 97⅞"
The Barnes Collection,
Merion, Pennsylvania.

the usual surreal quality of the paintings of the period. It had a very flat feel to it, very much all on the picture plane.

We walked back through the museum and caught up with Kay and Jennifer as they were finishing their first tour. A few minutes later we were standing on the perfectly flat lawn of the Merion Cricket Club, a Stanford White masterpiece, looking at row upon row of immaculate grass tennis courts. All the players were in white.

Tennis on grass is a different game. Frank had never played it and I had done so only a couple of times. Our host, Tony Crane, and his brother-in-law were members and had a great advantage. For five minutes. After that Frank had it figured out, and with his coaching I mastered the game before the first set was over. As it turned out, we won handily.

By 16 October 1969 more than half of the Protractor paintings including the Saskatchewan and Newfoundland series—over 130 paintings completed and projected—had been dispatched to their buyers, mostly in Europe and America. And the unpainted ones had been spoken for. If 130 paintings by one artist in a three-year period seems a tremendous number of pieces to sell in a short period of time, it is important to recall that the Stella bandwagon was rolling, that any museum which was serious about its collection of contemporary art had to have at least one of his paintings, and Leo didn't have to explain to his clients that the prices were only going one way.

This brings us back to Leo Castelli's famous list. At the top were the long-term, faithful customers including a few museums and a few individuals. Next on the list there would be newcomers, also museums and individuals, who were solid and, it was assumed, would develop a loyalty to the Castelli gallery. To get into this group it was understood that the painting's new home, whether a private collection or a museum, would be a distinguished one. The third part of the list included everybody else who wanted a painting by Frank Stella. If you weren't on the first or second exalted levels but were still "somebody," your chances of actually getting to buy a painting improved.

Because of its long-term commitment to post-war American art, the Kunstmuseum in Basel was at the top of Castelli's list. In his book, *Kunstmuseum Basel—A History of the Paintings Collection*, Christian Geelhaar reports that:

Franz Meyer justified the preference for American artists in his purchases with the conviction "that in the period 1950–1970 the most essential artistic achievements stem from them, and so a logical collecting policy should keep to these American 'originals' and not so much their European echo."[3]

Every year Leo Castelli would go to the art fair in Basel and dine with Franz Meyer in one of Basel's great restaurants. Castelli would describe Stella's newest paintings and offer Meyer first pick. In an interview with

Installation of the 1970 exhibition *Frank Stella* at the Museum of Modern Art, New York.

Opposite: Stella and William Rubin discuss the installation.

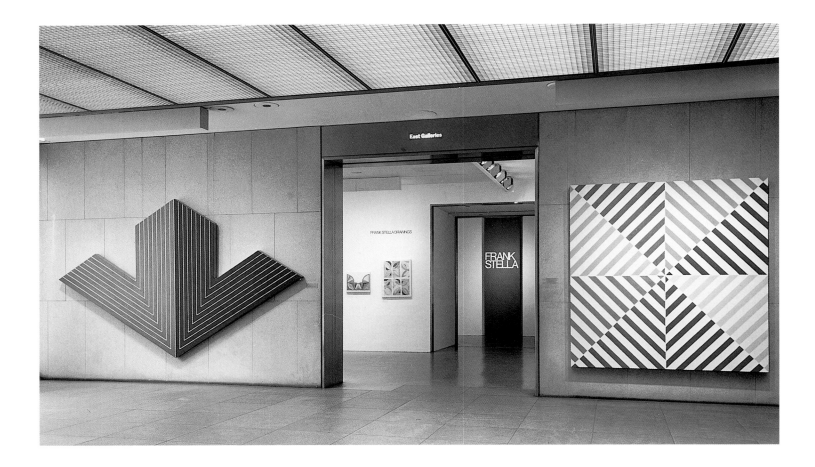

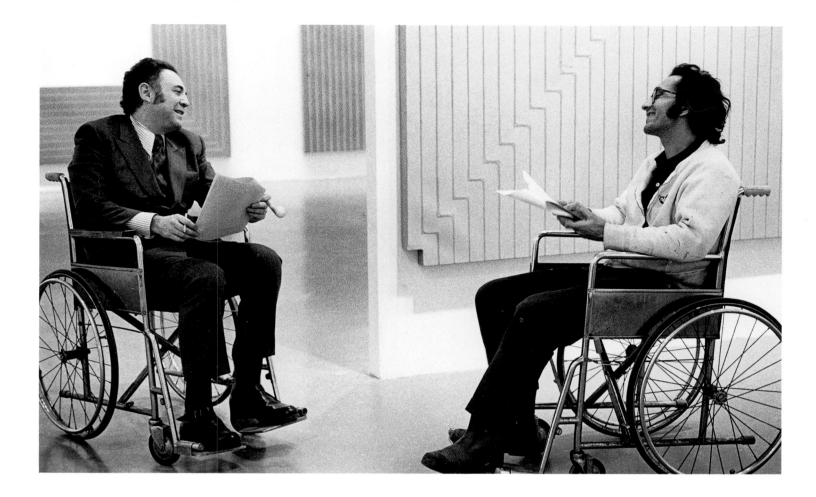

Art & Auction in 1983, Frank Stella was asked which collectors had displayed a continuous interest in his work. He singled out the Kunstmuseum in Basel as "the most convincing patron I've had in the past few years."

As soon as word was out that there would be a Stella retrospective at the Museum of Modern Art in 1970 to be curated and with a catalog by William Rubin, the artist's stock headed toward the stars. But before the MOMA exhibition, *New York, New York,* opened at the Metropolitan Museum of Art. Part of the museum's one hundredth anniversary celebration, "Henry's Show," as it was called by his friends and enemies alike, after its architect, Henry Geldzahler, included 408 works by 40 artists. Nine were by Frank Stella and of those, three were Protractors—*Hagmatena II* (1967), *Sinjerli Variation IV* (1968), and *Ctesiphon III* (1968).

The 20,000-square-foot installation was spectacular, but most of the art press found fault with it, as did many of the artists who were left out, most notably Louise Nevelson. Everybody with an ax to grind—and there were thousands—wanted to know how the "40" were chosen. Thomas Hoving answered the question with a straight face in *Making the Mummies Dance,* when he wrote, "The truth is [Henry] had made the list in consultation with critic Clement Greenberg, artist Frank Stella, art historian Michael Fried, and curator friend Walter Hopps." Stella says that the statement is false and that he had nothing to do with it, and he doubts that the others did.

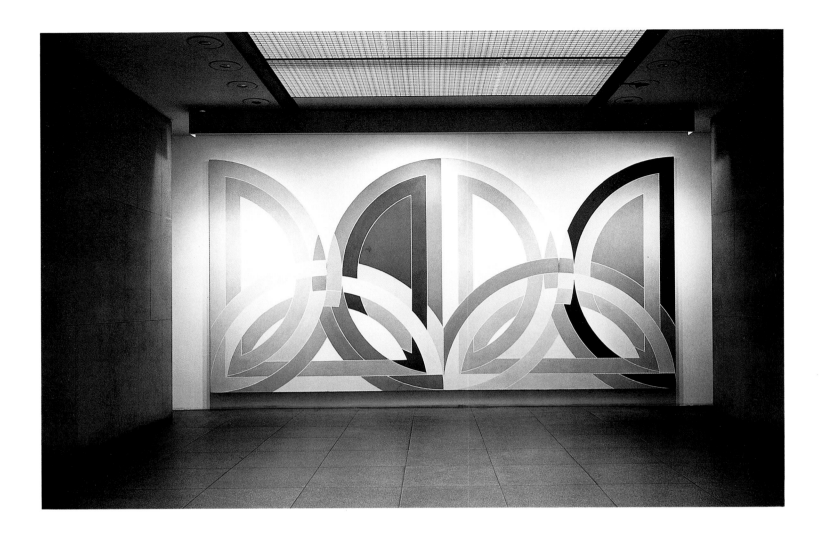

Installation of *Takhi-i-Sulayman I* at the Museum of Modern Art.

New York's Museum of Modern Art on 53rd Street, just west of Fifth Avenue, was quite a different place in 1970 than it is today. Its architecture still retained some of the original 1929 design by Edward Durrell Stone even though a number of changes, notably by Philip Johnson, had been effected over the years. The membership was much smaller—the great art appreciation boom had not really arrived—and the scale of the building was very different. Then, it was a place where a few hundred visitors a day would browse through the galleries. The sculpture garden was a place you might take a date or find one—and lunch in the member's dining room was a bargain. A nonresident membership was fifteen dollars.

Frank Stella consisted of seventy-three paintings from *Astoria* (1958) to *Flin Flon III* (1969). Of the works, roughly one-third were owned by museums and about one-third of those belonged to European museums. (In 1970 the Japanese had not yet begun their buying up of American art of the sixties.)

Just as there was grumbling in 1959 that a twenty-three-year-old was included in a prestigious show at the Museum of Modern Art, predictably there was grumbling that a thirty-four-year old was having a retrospective at the same august establishment.

But no one among the nearly four hundred guests at the opening was grumbling. The exhibition was perfectly hung and everyone I spoke to—maybe thirty people—was in a state of euphoria with the possible exception of Barnett Newman, an elegant man, dean of the postwar abstractionists, who was as reserved and dignified as ever. Those of us who had been fans since the Princeton days—Rosenblum and Holderbaum, Steve and Sigrid Greene, Fried, and I—were feeling especially gratified, confident that this was no better than Frank deserved.

Frank was making the rounds with his big sideburns and an unlit cigar, holding hands with Kay, speaking to all the guests. The only person who stole the slightest bit of Stella's thunder was Bill Bradley, the great white hope of the about-to-be World Champion New York Knicks. Bradley towered over everybody else except Carl Belz, who had gotten the basketball player and the artist together in 1968. The two had hit it off and Bradley, a fledgling collector of contemporary American art, had acquired many of the prints Stella had done at Gemini G.E.L.

Port Tampa City was the cover image of the April 1970 issue of *Artforum*. Inside was a long, laudatory review of the retrospective that was more a summing up of the first ten years. "Abstraction and Literalism: Reflections on Stella at the Modern," by Philip Leider concluded:

But the character of the artist! Of all the artists in America who might *have decided to risk the possibilities of letting loose the decorative id beneath the abstractionist ego, Stella was surely the least likely. The identity he had declared, the identity he had imposed on American culture, was coiled, tense, arrogant, lean, ungenerous, unremittingly rational, self-denying and unsensuous. From whence was to come the openness, generosity, spontaneity, lyricism which an art of freely accepted decorativeness was to be made?*

In the same issue of *Artforum* there was a page-size reproduction of a large, rather somber maroon painting by Mark Rothko opposite a page-long eulogy by Max Kozloff. At sixty-six, Rothko had taken his own life earlier in the year.

Whether or not Motherwell, Newman, and de Kooning felt that there was room at the top for Frank Stella, the evidence was that there was, and furthermore that the ground under his feet was solid.

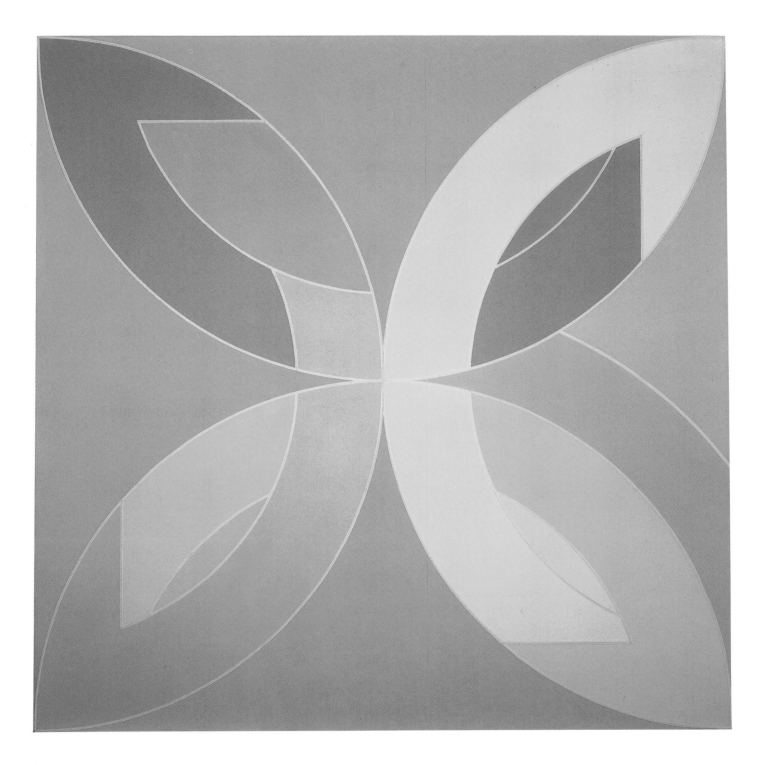

Flin Flon III. 1969
polymer and fluorescent polymer
on canvas, 8 × 8'.

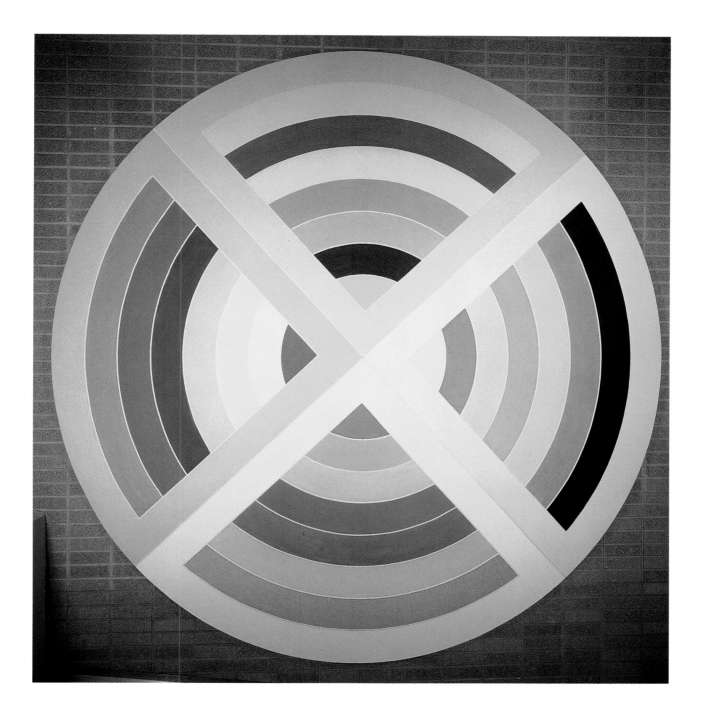

Sinjerli II, 1967
polymer and fluorescent polymer on
canvas, 120" diameter.

Sabra III, 1967
polymer and fluorescent polymer
on canvas, 120 x 120".

Gur III, 1968
fluorescent alkyd on canvas,
120 × 180".

KNEE SURGERY, DRAWING IN THE HOSPITAL, POLISH VILLAGES

A retrospective at age thirty-four at the Museum of Modern Art was cause for a night's celebration, but for Stella it was not an excuse to take a rest. He had to complete the Protractor paintings, and he had plenty of printing laid out for him at Gemini. And he was nagged by the fact that he hadn't really worked out what he would do when the last Protractor painting was completed. Few sketches indicate what was to come next.

William Rubin notes:

By the mid-seventies it was clear that many of the best abstract painters of the sixties were, in effect, milling about, with no idea in what direction to develop their art. Nor were any new young painters providing answers. Stella was speaking only for himself when he said he was "coming to the end of something" in 1970, but, in retrospect that was a perception about vanguard painting as a whole. And its crisis soon became apparent—as witnessed by the widespread talk of "the death of painting."[1]

Stella had a few other things on his mind, including a left knee that was bad and getting worse. His orthopedic surgeon had told him that an operation would be necessary in months if not weeks. But he kept playing tennis as hard as he knew how.

And there was the war. By 1970 the war in Vietnam was intensifying each month. Most college campuses were alive with protesters and counter-protesters. Everybody seemed to be angry; angry that the country could be involved in anything so wasteful and bloody, so stupid and immoral. Or angry that the young people refused to understand that

Opposite: detail of *Gabin III*.

America *had* to finish what it had started, *had* to save face, *had* to hang in there and save South Vietnam.

For Frank the 1970 retrospective represented a watershed, even though he wouldn't paint the last of the Protractor paintings until 1971. Each time he would complete a set of drawings to his satisfaction and project a series of paintings, he would work on the paintings until the entire series was completed. In 1970, that aspect of his personality may have been at odds with the part that was saying, "Keep moving, keep pushing, it's time for a change." One of Frank's more remarkable traits is his ability to ignore success, critical and financial, and to pay no attention to the approval of the public. The painter's instinct and the painter's dealer's say, "Keep making the same painting. It sells."

Frank Stella felt he had no choice. He told William Rubin in 1987:

When you're done with something, you can't fool yourself. . . .I didn't see a way to improve what I had been doing over the previous decade, to make it better. . . .In starting all over again I didn't know where [the sketches of] the Polish pictures would lead, but I just had to follow them. In the Protractor pictures I had been as loose as I could get within a system that I'd kept to for over ten years. Imposing that discipline on myself endowed all the early work with both benefits and drawbacks. But I felt I wasn't free enough.[2]

Opposite: Detail of *Odelsk I*, 1971.

In 1970 Stella went to Los Angeles a score of times, usually for a couple of days to a week. The Beverly Hills Hotel suited him well. Frank played tennis regularly with the hotel's pro, Alex "The Chief" Olmeda, a former U.C.L.A. star, and decidedly one of the most glamorous of the pros of his day. From the Beverly Hills Hotel to Gemini G.E.L. was no more than three miles, right down Sunset Boulevard. Frank would be there by 9:00, work on prints till 3:30 or 4:00, go back to the hotel, and play tennis for at least an hour and a half.

By the end of 1970 he had made forty-nine separate prints at Gemini including *Referendum '70*. The print was done in the late summer—an edition of 200—and all the proceeds from its sale, Stella and Gemini waiving their fees, went to aid the politicians in the national elections of November 1970 who were seeking to end United States involvement in the Vietnam war. Offered at five hundred dollars a print, the edition sold out in a matter of days.

The imagery of *Referendum '70*, a six-color screen print, is the same as that of *River of Ponds I*, one of the six Newfoundland series lithographs begun in the summer of 1970 and completed in early 1971. In this group of prints there were four large squares, *River of Ponds I, II, III*, and *IV*, and two huge double squares, *Port aux Basques* and *Bonne Bay*. The six prints were published in editions of 78, 78, 75, and 70, for the squares, and 58

for the two double squares. Every single one of these prints was sold within weeks of its offering. Four hundred and seventeen prints. The squares sold for eighteen hundred dollars, the double squares for four thousand dollars. Brisk business. In September 1994 Ken Tyler described Frank's attitude toward those prints:

He doesn't like talking about the Newfoundland series because he thinks [the prints] that are promotional. For some reason he's never liked them. I don't think he liked the flatness of them—they were part silkscreen, part lithography—and I don't believe he liked the fact that they were so successful. They flew out. They were terribly, terribly successful.

Before he could complete the prints, however, Frank's left knee caused him so much pain he had to stop playing tennis. In October he traveled to Amsterdam for the opening of *Frank Stella* on October 2 at the Stedelijk Museum. The exhibition had been at the Hayward Gallery in London and would proceed to the Norton Simon Museum in Pasadena before closing at the Art Gallery of Ontario in Toronto.

A few days after his return from Amsterdam, he checked into Mount Sinai Hospital in New York for fairly routine surgery to repair a torn meniscus, the knee's shock absorber, a lens-shaped bit of fibrous cartilage between the femur and the tibia. After what appeared to be a successful operation, Stella's surgeon left the following day on vacation. Infection set in, however, and possibly due to a reaction to the anesthesia, Frank did not convalesce as he was supposed to. Finally at the insistence of Dr. Stella, the patient was put on antibiotics and was able to leave the hospital forty days after entering.

Typically, Frank profited from his time spent in a hospital bed. Richard Meier had mentioned a book entitled *Wooden Synagogues* by Maria and Kazimierz Piechotka, documenting the buildings in Polish villages burned by the Nazis during the invasion of Poland. Based on the delicate structures in the book, Frank made a series of forty free-hand pencil drawings of jagged, multidirectional shapes. On close study a connection between these shapes and the Irregular Polygons becomes apparent. But mostly they appear to be unlike anything else he had ever done.

As soon as he was out of the hospital he had the new drawings copied onto graph paper by a draftsman using a computer. The paintings in the Irregular Polygons series all have standard angles, i.e., 90, 60, 30, and 45 degrees, with a few exceptions. These could be re-created by anyone who could draw using a T-square, a 30-60-90

triangle, and a 45-45-90 triangle. The new diagrams were much more complex.

Stella found a carpenter, David Paul, whom he hired to build the stretchers in the studio rather than send out the work. He tried to begin with these where he had left off with the Irregular Polygons, since he had learned that no matter how irregular the perimeter of the stretcher, canvas could be stretched taut across it. But his new idea was to collage canvas and other materials to the surface of the stretched canvas. Almost immediately he discovered that gluing things to a nonrigid surface doesn't work. He was still dealing with a two-dimensional surface, so instead of covering the stretcher with canvas, he covered it with a heavy cardboard called KachinaBoard thinking it would be lighter and more economical. Next the canvas was applied to the KachinaBoard, after which the various cut shapes of canvas, felt, and paper were glued down to the surface.

As he worked toward turning the forty drawings into paintings, he developed two more basic ways to build them. Instead of applying only flat materials to the surface of the overall shape, he began to apply pieces, large and small, of elements with thickness and depth, such as homosote, masonite, KachinaBoard, plywood, and so on. In this second group the surfaces of all the applied pieces were parallel to the support itself and to the wall. In the third group—and this was a great breakthrough—he began tilting the planes of the applied pieces, causing them to interlock and mesh with each other as well as with the support. Also, in the third group he began to substitute Tri-Wall for KachinaBoard, wood, and the other materials he had been using. Tri-Wall is a brown corrugated paper product about three-quarters of an inch thick which because of its lightness and strength is used for packaging large electronic gear. As a rule, Stella applied painted canvas or felt to it, but in a few of the Polish Village paintings, he left it in its natural state. The use of Tri-Wall reduced the weight of the pieces in the third series by at least 50 percent.

In order to better understand not only the complexity of these works (Stella has steadfastly referred to them as paintings even though they are mostly not painted), but also the time and expense involved in their making, here is a general idea of what went into the fabrication of *Odelsk I*, one of the least complex of the Polish Village works, with only eight colors and nine differentiated areas of canvas or felt.

Using a computer, the draftsman turned Stella's freehand, ruler-assisted drawing into a diagram to scale. In order to cut the pieces, which when assembled would be the backing for the surface of the painting, the drawing was given to a computer-operated table-saw which would make the cuts. Subsequently the pieces, when put together on a huge table, were an approximation of the shape of the painting. From this it was possible to establish the dimensions and shapes of the pieces of wood which would become the perimeter and interior supports of what had, heretofore, been called the stretcher. This bizarre, trusslike object would then have

the KachinaBoard fastened to it using glue and staples (two-inch-long staples fired from a pneumatic staple gun). Critics have faulted Stella on the fabrication, but the skill and precision with which the fabric elements were cut and applied is worthy of a Saville Row tailor.

Since his days at Andover, where there was plenty of paint and other supplies in the studios, Frank has escaped the curse of most artists, namely the fear of wasting materials. In July 1994, I asked Frank about the cost of the enterprise:

Once I made the notch, once I broke from the rectangular format and as the formats became more complicated, they become more expensive. That's in perimeter. And then you add the dimensionality to it and again it becomes more expensive. When you have an irregular perimeter and an irregular surface, by definition it becomes more expensive.

What money I made from art I put back into making the art. But the other thing is. . . .the surfaces became more complicated and so. . . .the only way things could have cost less would be to simplify which would be to make the surface flat and regular. So the whole struggle was against a regular, flat surface. A planar surface. An uninflected surface.

The first, second, and third versions of the Polish Villages are designated respectively by Roman numerals. The first thirteen drawings were executed three times each in the canvas collage (CC, I), and once each in the 3-D appliqué (3-DA, II) versions (total 52). Drawings 14 through 22 were executed in CC and 3-DA simultaneously (18) with the tilted planes (TP, III) group (9) added later. Drawings 23 through 40 were executed in all three groups simultaneously (total 54).

Besides the full-scale paintings there were models. In *Stella Since 1970,* Philip Leider explains:

Accompanying the full-size execution of each work, small corresponding models were made. . . .at least one and sometimes as many as four are known to exist. For the first thirteen works in the series the models were made out of cardboard, but with the introduction of the tilted-plane version, several other models were added. For the actual working model, a flexible maquette of Bristol board was cut and pinned, but as these rarely survived the fabrication process, a wooden model was made as a permanent record. In addition, a Tri-Wall model with a Tri-Wall background was made, as Stella wished to keep before him the possibility of using and developing the background.[3]

Stella has been very open and even scholarly in listing his influences and preferences from the history of art. Over the years he has mentioned exhibitions which have been worth seeing more than once. One of his favorites was *The Planar Dimension, Europe, 1912–1932,* which was organized for the Guggenheim Museum by Margit Rowell. It is more than likely that

when he saw the exhibition in 1979, he was familiar with the work of every artist included. His debt to Russian Constructivism and particularly to Kasimir Malevich is considerable. As Rubin put it:

> *The relationship to Constructivism has also to do with Stella's literal building up (or "engineering") of the pictorial object, an activity that now became a major preoccupation.*
>
> *The process of painterly construction that Malevich had envisioned—and, even more, its opening into large-scale work—was to remain a largely unfulfilled aspiration for the artists of the Russian painter's generation. Its enormous complexity was to make the undertaking a huge one. Little had in fact been done in the direction of the kind of constructed painting that Stella was now undertaking.*[4]

In terms of the sophistication of facture, the Polish Villages represent a big step from the relative simplicity of the Irregular Polygons. For the most part, the works were put together either by assistants in the Houston Street studio or by manufacturers.

"The Polish pictures were well designed and very tight in terms of engineering," Stella told me in a recent conversation. "We spent a tremendous amount of time with detail. Unlike the more recent metal reliefs, which were fabricated entirely in factories, they were partly handmade in the studio. I was around all the time, so that I could adjust and readjust things, deal with every decision about tilt, angle, or surface finish."

When the Aluminum series paintings were first shown at the Castelli Gallery in the fall of 1960, Stella was credited with painting the first shaped canvases. That is accurate only if you agreed that the definition of a shaped canvas was a large two-dimensional painting with a perimeter that was not a square, a rectangle, or a tondo (circle). Even a cursory look at *The Planar Dimension* will reveal that between 1912 and 1932 a number of artists in Europe whom Stella admired made works of art that resembled shaped paintings. These artists include Jean Arp, Vilhelm Lundstrom, Kurt Schwitters, Laslo Peri, and El Lissitzky, and their work has a common dynamism and an omnidirectional quality. While made of painted concrete and much smaller than Stella's work (about two feet square), the *Space Constructions* (1922–23) of Laslo Peri presage the Polish Village paintings.

In Arp's wonderful little painted wood relief, *Plant Hammer* (1916–17), the jagged, angled form in the top half recalls a number of Stella's specific

shapes in the Polish Villages, as well as the general feeling of *Targowica II*, which Stella owns and which hangs in his living room. Coincidentally, Margit Rowell comments, "*Plant Hammer* was executed in two almost identical versions. Apparently when Arp particularly liked a work, he made more than one version and kept one for himself."[5]

One of the drawbacks with the Polish Village series was their great weight—more than six hundred pounds in some cases. Another problem is that over the years many of the collaged elements have peeled away or fallen off. Most critics haven't been especially generous when writing about them, dismissing them as transitional. Alfred Pacquement seems to have understood their importance better than most:

Without ever turning his back on painting, Stella seeks throughout the trajectory of his own work to broaden the field of painting's endeavor. The Polish Villages constitute an essential stage in this progression, and it is difficult to characterize these works as either the terminal of the first epoch or the point of departure of the second. Most certainly they represent an essential turning point.[6]

In 1971, the combination of his intense work on the Polish Village paintings, the time lost to the hospital stay, and the complications of being a conscientious single parent curtailed his printmaking time in California. He did, nevertheless, complete fourteen prints at Gemini G.E.L. including the six Newfoundlands, six in the Benjamin Moore series, *York Factory I*, a long, pale pastel print of forty-three colors based upon the Newfoundland paintings, and a single black lithograph, *Angriff*, based upon *Island No. 10* in the Benjamin Moore series. The poster for the ninth New York Film Festival bore the image of *Narwola* from the Polish Villages series, the use of which Frank had donated.

In his catalog raisonné *The Prints of Frank Stella*, Richard Axsom writes, "The Purple Series was the second, and also the last, set of prints to be produced from lithographic stones. The men and women whose names were appropriated as titles for the Purple Series paintings (1963) and prints constitute a gallery of Stella's circle of friends in the New York art world."[7] In the late spring of 1972 Frank took Kay to California for a working vacation. In the reception area at Gemini there was a mini exhibition of the recently completed Purple lithographs. But instead of eight, there were nine. *Kay Bearman*, a decagon, had been added to the group.

Nineteen kilometers inland from San Tropez on the French Riviera is Plan de la Tour, a village of a few hundred inhabitants. At the suggestion of Larry Rubin, whose brother Bill had a place there, Frank rented a house for the month of August. In the second week Jennifer and I, along with our son Maxwell and our standard poodle Clio, drove down from

Opposite: detail of *Mogielnica IV*, 1972.

Below: Jean Arp, *Plant Hammer [Fleur Marteau]*, 1916, Collection of the Haags Gemeentemuseum, The Hague.

Lausanne where I was teaching painting at the Ecole Cantonale des Beaux Arts. We arrived at a large, low Mediterranean house set in a pine grove with a lawn in back big enough for a good-sized croquet pitch and a little guest house off in the trees.

Each morning I would walk up to the big house in search of coffee. Frank would be outside in shorts and a T-shirt drawing on a zinc plate with lithographic crayons. The work in progress was the plates for a series of six prints based on the Concentric Squares and Mitered Mazes series of 1962–63. Larry Rubin had introduced Frank to Paul Cornwall Jones, the director of Petersburg Press in London, and Jones had proposed that his firm produce prints for Frank. The demand for his work in England and on the continent was great and Frank's association with Petersburg Press would prove to be long and profitable.

By 10:00 it was too hot to draw without getting sweat on the plates and Frank would knock off to spend time with his children, Rachel and Michael and his guests, Phil Leider and his daughter, Polly. A good deal of cooking went on, requiring one or two trips to the village each day. In the afternoon we would go to the beach and play with Maxwell who, at two, was jabbering away in French. Each evening there was a croquet game and drinks before dinner. The only tape, Vivaldi's *The Four Seasons*, played over and over, the music spilling out of the house into the croquet zone and piney wood.

One morning Frank was not at his post. Kay told us he had gone to London. Once a week he would pack up his six plates in a flat little wooden box with a hinged lid and a leather belt to keep it closed, drive to the Nice airport, fly to London, look in on the printing, leave off the plates and pick up fresh ones, and return. The week we were there he got back in time for croquet.

Of this group of prints, Axsom says:

Proofed and editioned at a commercial lithographers shop (Cook, Hammond, and Kell Lithographers, London), these prints were the first of Stella's lithographs to be made on a flat-bed, offset proofing press. Stella was one of the first printmakers to adopt this type of press for the making of fine art lithographs. Pigment-rich inks were developed for the series to replace the thinner, standard inks used in commercial lithography.[8]

In 1973 Stella completed the Polish Village paintings. Groups of them were shown in January at Castelli, in the Whitney Biennial, and in November at the Phillips Memorial Gallery in Washington, D.C., in a one-man show, *Frank Stella*. He ended the year with a tour de force. *Double Gray Scramble* was the ninety-third print, including all prints made at Gemini G.E.L. and Petersburg Press, since he had made *Star of Persia I* with Ken Tyler in 1967. *Double Gray Scramble* was based on a paired Concentric

Squares image using 50 screens and 150 separate runs. Axsom explains the new level of complexity: "The color and gray-scale sequences that were independent of each other in the paintings and prints are here combined in alternating color bands in such a way that each interrupts or 'scrambles' the ordering of the other."[9] In other words, with the left-hand square, the gray scale goes black to white starting in the center, and on the right, black to white starting at the outside band.

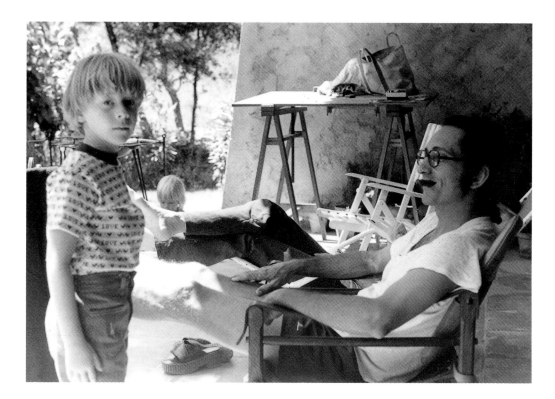

Stella with Michael in Plan de la Tour, France (right) and with Maxwell Guberman in Lausanne.

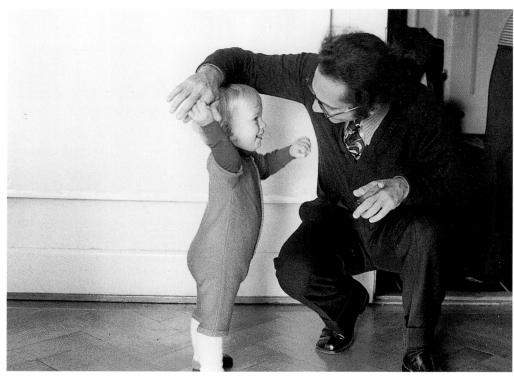

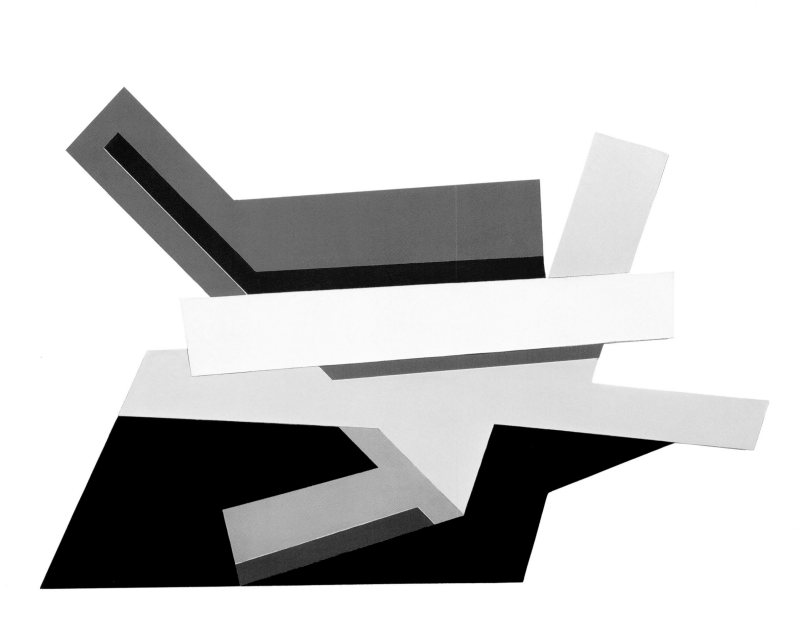

Odelsk I, 1971
mixed media on canvas, 7'6" × 11'.

Gabin III, mixed
media on canvas, 96 x 122".

Mogielnica III, 1972
relief collage of mixed media,
87 × 125 × 8".

Mogielnica IV, 1972
wood relief, 86½ × 120".

THE BRAZILIAN SERIES, EXOTIC BIRDS, HARRIET MCGURK

The Polish Village series was pivotal in Stella's development. The great weight of the individual works was a nagging problem and eventually convinced Stella to change to a lighter material—aluminum. Before the end of 1973 the last work of the series was assembled and fine-tuned and delivered to its owner. In the meantime, Stella was working on sketches for the Brazilian series, which he began in 1974. These pencil drawings have a rather tentative quality and are made up basically of long narrow bars and long slender triangles.

Not surprisingly, however, Stella took another zag before beginning the full-scale fabrication of the Brazilian series—the enormous Diderot paintings. The availability of a new industrial thickness, cotton duck canvas of twelve-foot width (the widest had been ten feet) suggested to him further possibilities for the Concentric Squares. Even though the height of the paintings was nearly twelve feet, and the width of a single band from center of white stripe to center of the next reduced to three inches, the scale felt more delicate and busier than it had been in the Saskatchewan paintings with their eight-inch sweeping arcs. A comparison between one of these paintings with their eight-inch-wide bands of color and one of the Diderot series with its busy vibration of three-inch stripes over the enormous canvas's surface reveals the difference in scale.

Working with a great many more bands, Stella began to deal with exactly twice as many colors as the three primaries and their complements and to use a more complex gray scale. In *Bijoux Indescrets* there are a total of twenty-three concentric square rings counting the small square in the center working in a double system. The interior square and the painting's outermost square ring are cadmium yellow. On his way "home" he uses

Opposite: detail of *Laysan Millerbird* (#22, 5.5x), 1977.

the three primaries, yellow, blue, and red; the three secondaries, orange, green, purple, as well as the six colors found between a primary and the secondaries that flank it on a color wheel. In other words, he introduced the color between yellow and orange and the color between yellow and green, yielding up six additional hues which, with the primaries and secondaries, gave the artist a regular system of twelve colors. After finishing half a dozen paintings, Stella felt that he had exhausted the Diderot idea, and he was ready to move on.

Kay Bearman wanted to get married but Frank, even though he disliked the idea of splitting with Kay, wouldn't budge back into marriage. In 1973 they broke up and got back together twice. During this period Frank had been traveling abroad, and when he was at home he wanted to spend time with Rachel and Michael. In addition, Kay was forced into the position of stepmother without any of the reassuring aspects of marriage. Finally the relationship couldn't withstand the stress and they made a final split in 1974.

In 1974 Stella made a series of trips abroad including, most significantly, a trip to Brazil. Through Paul Sorren, a friend from the West Side Tennis Club and an importer of South American goods, he met Shirley DeLemas Wyse in Los Angeles. They became involved and a daughter, Laura, was born in 1975.

In early 1974 at Gemini in California, Stella completed the complex printing on the eleven images of the prints of the Irregular Polygon series. Unlike the paintings themselves, all of which were made of bands and zones of flat unmodulated color, the bands and large open areas of the prints bore the marks of the lithographic crayons. They were gestural in each case. A further difference is that the zones of color are bounded by a precise, hard-edge screen outline printed in gray ink. Axsom writes of the Irregular Polygons: "Color areas achieve their special effects from vigorous calligraphic drawing and multiple overprinting of flat and transparent tones. The Eccentric Polygons thus represent a distinct change in Stella's printmaking."[1]

In early 1974 Ken Tyler moved from Los Angeles to the East Coast to be closer to the artists he considered most important. Stella, probably more important to Tyler than even Johns and Rauschenberg, had signed on early. In the rolling hills of southern New York state, Tyler put together a state-of-the-art print studio in what had originally been a Revolutionary-era farm. The property included elegant living quarters, a swimming pool, fruit orchards, a generous apartment for a visiting artist, and a

Opposite, from the top:
Moultonboro, 1974,
9 color lithograph/screenprint,
17¼ x 22¼"
Conway, 1974,
9 color lithograph/screenprint,
17¼ x 22¼"
Effingham, 1974,
8 color lithograph/screenprint,
17¼ x 22¼".

facility for fine-art printing as sophisticated as any in the world. As soon as Tyler was open for business at Tyler Graphics Ltd. in Bedford Village, New York, Frank Stella was at work on the Paper Reliefs.

"How can I get the feeling of the tilted planes of the third group of the Polish paintings in works on paper?" If that is a good approximation of the question Frank posed to Ken Tyler in early 1974, it was taken seriously and the answer was forthcoming.

The Paper Reliefs are based on the configurations of six of the paintings from the Polish Village series of 1970–73. Tyler's daughter, Kim, and his assistant, Betty Fiske, built the six molds out of brass screen and mahogany, which they had sewn together with brass wire. Paper pulp was tamped into the molds and, before they were entirely dry, the forms were removed from the molds. The artist worked with them in the proofing process which amounted to the development of color dying and paper collaging. Some of these works were hand colored with dyes and colored pulp while still wet. In addition, when they were dry each was painted by Stella with casein, watercolors, and/or dyes.

The Brazilian series of paintings begun in 1974 and completed a little over a year later seemed to be as decisive and crisp as most of the Polish Villages seemed bulky and unwieldy. And there was something going on which Stella had rediscovered making the Eccentric Polygons

Above: Stella at Gemini studios.

Oppostie:
Grodno I, Paper Reliefs, 1975
26 × 21½ × 1¾"
Bogoria VI-8, 1975
22¼ × 29½ × 1¾".

prints: the return of drawing. Marks. Painterly stuff.

Stella's paintings had evolved from ragged, painterly compositions with rectangles and bars to paintings consisting of two and one-half inch bands of commercial black enamel, laid down in so many coats that as a rule, with a few exceptions along the edges, there was little evidence that a paint brush had been used. Recalling what Pacquement has said about the Polish Village paintings, it is difficult to determine whether they represent

a conclusion or a new departure, but they undisputedly marked an essential turning point.

There are ten pictures in the Brazilian series each executed in four versions: two full-size paintings and two maquette-size. In every zone of every painting the surfaces have a "worked" look to them, which is to say, among other things, that they have painterly marks. There are brushstrokes and other marks, scribbling and scumbling—*gribouillage*—a lot of gestural evidence that gives these paintings not only a new exuberance but also a new kind of exuberance. The great vaulting arcs of the Protractor paintings were exuberant, but at the same time they were carefully controlled. Stella's new scribbling strongly suggested, after all these years, a return to a loose, from the elbow, involvement with drawing. With the exception of pencil sketches and filling in the blanks on lithographic plates, he had put drawing aside for about fifteen years. Now, with the surfaces of the Brazilian paintings, he returned to it with a vengeance.

A turning point—a sea change—for a creative individual is usually accompanied by a lot of discomfort. The complex, heavy, multimaterial paintings of the Polish Villages series had represented a colossal change, not only in the look and scale and architecture of the pieces, but also in the level of difficulty for "getting it right." By the time Stella was completing the last of the Saskatchewan paintings, the process was all too familiar. By comparison the challenges that the Polish Village pieces held were staggering. Certainly Stella was the beneficiary of the knowledge of specialists, in particular carpenters and cabinetmakers, but the tight meshing of various materials with one another, for example, or the precise gluing of dyed fabrics, which would stain if the glue were not applied with surgical precision, presented uncharted territory. Stella has admitted that he has remained disappointed with most of the Polish Village group. So many aspects of the creative process *were* trial and error. Only when he discovered Tri-Wall—two years into the production of the paintings—did he realize the proper direction he needed to take with these works, did he realize what they "wanted to be." The result was the meshing, interlocking three-dimensional pieces of the third group of the Polish Villages.

The three years spent producing the Polish Village series had been exhausting, generating far more work and investment of capital than he had expected. Stella once said, "When Mantle hits the ball out of the park everybody is sort of stunned for a minute because it looks so simple."

The Polish Village paintings had something ungainly about them. They never looked simple.

Leider refers to the Brazilian series, the first all-metal works, as "the most assured group of pictures Stella had made in ten years."[2] From the jagged outline of the Polish Village paintings, Stella returned to overall outlines which, while broken and even jagged, depended upon the rectangle as their main visual reference. The more subdued perimeter is but one of the elements of the Brazilian paintings that renders them more satisfactory to an informed observer. Perhaps the Polish Villages did not totally succeed because they dealt with so many questions and left a great many unanswered. By the same token, their raising so many issues, taking so many risks contributed to their success.

In comparing the Polish Village paintings to those of the Brazilian series, the latter series is more successful in terms of drawing, composition, form, and color. The paintings bear the names of neighborhoods in Rio de Janeiro: *Arpoador, Botafogo, Grajau, Jardim Botanico, Joatinga, Lapa, Leblon, Montenegro, Morro da Viuva, Tijuca.* Compared to the exuberance of the Polish Village pieces and the rigors of his next project, the Exotic Birds, these paintings look resolved and calm. The Brazilian paintings represented not only a great aesthetic shift but also a significant technological change. The lesson of the Polish Villages experience was that the time had come for most of the fabrication process to be taken out of the studio. Since he had decided to use aluminum as the material for the Brazilian paintings, he automatically removed himself from the cutting and fitting and putting together of the pieces. He was now dealing with the advanced technology of aircraft fabrication.

Typically, as he was working on the surfaces of the Brazilian paintings, comprehending the various methods and techniques available to him for applying colors to metal, he began making sketches for what would be the Exotic Bird paintings. On his thirty-ninth birthday, 12 May 1975, as he neared the completion of the Brazilian works, he bought a collection of French curves, boat curves, and railroad curves. These are precise drawing aids used by draftsmen in technical drawings for establishing curves in architecture, in boat design, and more unusually in the establishing of drawn, paired arcs of shallow curves in scale drawings of railroad track.

In the fifties and sixties, Sol Steinberg, a lapsed architect, made hundreds of drawings using French curves. He would use them not as drawing aids as they were intended but as significant and humorous shapes unto themselves. Many of these drawings were published in *The New Yorker*. With his sense of humor, Steinberg appreciated the jokey, baroque quality of the French curve and how readily it lent its shape to Baroque architecture, to nature, even to spacecraft.

Like Steinberg, Stella would use the various patterns, including French curves, railroad curves, and ships' curves, as shapes, complete and of a

Opposite: Detail of *Grajau I (#1)*, 1975.

piece, integrated into the composition. But while Sol Steinberg's drawings and cartoons contained drawings and tracings *of* these objects, Stella's paintings contained replicas of the objects themselves, cut out of whatever material Stella happened to be using at the time.

Stella Since 1970 was a major exhibition which opened at the Fort Worth Art Museum on 18 March 1978. Curated and with a catalog by Philip Leider, it included paintings from the Polish Village series, the Brazil series, and the Exotic Bird series. The catalog was full of specifics on the work, recalling Hollis Frampton's contention from 1959 that "people who make claims for taste should remind themselves occasionally that the arts are based upon data."

The Exotic Bird series consists of fifteen pictures, all executed in three versions. Version 1x is a maquette version, usually in the range of one to two feet square. Version 3x is three times the size of the maquette and version 5.5x is five-and-one-half times its size.

While incorporating a new, broader vocabulary of shapes, *Steller's Albatross* is relatively simple and therefore a good example of how this group of paintings was fabricated. There are three rectangles, two with cut-out centers becoming respectively the framing element and the inner portion of the piece. The third, a square slightly off center, is nearer the left than the right, nearer the top than the bottom. Each is tilted so that none is parallel to the wall. But each has top and bottom parallel to the floor. Attached to these elements—in some cases passing in and out of them—are eight specific, shaped pieces: three French curves, three ship's curves, and two railroad curves. While each of these is cut out of honeycomb aluminum, the template or pattern, plastic drawing instrument itself. In all the Exotic Birds 1x as well as in the large working drawing and the foamboard maquette, the pattern for the specific shapes is the object itself. It is the draftsman's tool.

Just as Manet's *Le Dejeuner sur l'herbe* was conventional and radical at the same time so are the paintings of the Exotic Bird series. They are rectangles, the sides are parallel to each other, and the top is parallel to the bottom. Even though the forms which join each other and careen off one another are dynamic, painted and marked up in ways that denote fast marking, these forms are finally locked into the composition in fairly conventional ways. What was astounding about these paintings when they appeared and what continues to amaze is the vigor with which Stella returned to drawing. In examining the three paintings entitled *Steller's Albatross,* the viewer is rewarded with a show of a few dozen ways of marking a surface in the name of making a painting rich and complex, textured and deep. By 1976, Stella had allowed drawing—drawing with a

charged paintbrush or crayons or anything which would leave a mark—not only a place back in his painting, but a very active part in it.

Inaccessible Island Rail has even fewer applied parts than *Steller's Albatross,* and because of its open, spacious feeling it appears quite simple. A long, close look, however, reveals a layered complexity. And it reveals the handiwork of someone who is painting and drawing—marking the various surfaces—with great buoyancy. The paintings in this group manage to be, at the same time, baroque, rococo, and significantly, mannerist. This is particularly true of the largest version of each painting, where the French curves are enlarged to seven or eight feet across, suggesting skewed proportions, scale gone wrong, and a general uneasiness about the resolution of the composition—all characteristics of mannerism. Their appearance in New York in October 1977 at Knoedler & Co.—directed and co-curated by Larry Rubin—represented yet another case of Stella's topping what had come before in terms of innovation and tough-minded, demanding, extravagant art.

Stella and Paul Cornwall Jones of Petersburg Press came up with the idea of turning the ground-floor studio space at 17 Jones Street into a printing studio. It was the width of the building and ran from the wall at the end of the garage to the end of the building, nearly one hundred feet.

Stella and Harriet McGurk..

Petersburg brought in a new German state-of-the-art commercial lithography press, roughly thirty feet long. I asked Ken Tyler in 1994 how that made him feel, how he liked the idea that Stella would also be printing at a studio in his house in Manhattan. "Shitty" he replied. "As I saw it, it would be competing against Stella with Stella. He tried to explain to me that it wasn't the same thing, but it took me awhile to see it that way. Just then it wasn't very comforting to be reminded that Frank is one of the world's most loyal people."

A huge printing press wasn't the only wonderful new thing to come Stella's way in 1975. Toward the end of the year, standing in Jones Street watching the glow of a building on fire behind his house, he struck up a conversation with a young woman whom he had seen in the neighborhood. Harriet McGurk, a resident at Columbia Presbyterian Hospital, shared an apartment on Jones Street and was neither informed about nor impressed by the New York art scene and its leading lights. She

discovered fairly quickly that her neighbor knew a great deal about medicine, exotic birds, and much else that was important to her.

Harriet McGurk is a birder and Stella is a quick study. Harriet's library included a number of books on birdwatching. Stella devoured them. He told William Rubin, "Harriet got me into birdwatching. I couldn't believe I was in the Everglades instead of being at Hialeah. Before that, my idea of an exotic bird was the Flamingo—a grade-one stake race."

The names of the endangered species that would become titles for the paintings in the series were particularly magical and musical for him: *Noguchi's Okinawa Woodpecker, Green Solitaire, Inaccessible Island Rail, Eskimo Curlew, Bermuda Petrel, Newell's Hawaiian Shearwater, Bonin Night Heron, Stellar's Albatross, Wake Island Rail, Dove of Tanna, Puerto Rican Blue Pigeon, Mysterious Bird of Ulieta, New Caledonian Lorikeet, Brazilian Merganser, Laysan Millerbird, Jerdon's Courser.*

The inventive methods of applying paint to surfaces and the use of glitter gave these paintings a rich complexity even though they were, in fact, flat and two dimensional. But the jumbled, tumbling shapes, particularly the French curves, the uninhibited brushwork, the extravagant, hedonistic use of colors gave them a baroque richness not previously seen in twentieth-century American painting.

And even though they would fit any art historian's definition of deep relief, Stella steadfastly maintained these works were paintings. In a typically wry statement, Stella said:

I can imagine getting a grasp on these figures, on what it might be like to measure a cloud or the coastline of England. It seems to me that there's some hint of this kind of chaotic, ambiguous figuration in painting, with its inherent three-dimensional illusionism in constant tension with its two-dimensional surfaces. Pictorial space is one in which you have two-dimensional forms tricked out to give the appearance of three-dimensional ones, so that the space you actually perceive comes down somewhere in-between. And somewhere in-between isn't a bad analogy for my work. I work away from the flat surface but I still don't want to be three-dimensional; that is, totally literal. . . more than two dimensions but short of three so, for me, 2.7 is probably a very good place to be.[2]

In 1976 Stella left New York for openings of two major exhibitions. In March he went to Basel for *Frank Stella; Neue Reliefbilder—Bilder und Graphik* at the Kunstmuseum, and in November to the Baltimore Museum of Art for the showing of the Black paintings curated by Brenda Richardson. In Basel, the Kunstmuseum's director, Franz Meyer, encouraged Anna Roetsler, then director of Gimpel-Hannover/Andre Emmerich Gallery in Zurich, to put together that exhibition with the museum's complete backing.

Unlike most museum directors and curators, Meyer was in the enviable position of being able to make a personal commitment to an artist's work by purchasing important pieces. If, finally, the Kunsthalle's other directors decided to pass on a work, Meyer would add it to his personal collection, as was the case with *Gabin III* from the Polish Village series.

For the Baltimore exhibition, Brenda Richardson was able to assemble the sixteen Black paintings that were part of American collections. Stella had been very skeptical when Richardson first approached him but when he saw the installation, he was overwhelmed. At first, Stella took it all in, speechless. Then, suddenly, he began running from painting to painting, talking and exclaiming and generally astonished at how good the works looked.

The exhibition of the Black paintings at the Baltimore Museum of Art was one of the twenty or so most important exhibitions of painting in the second half of the twentieth century. In 1959, when four of these paintings were seen in the *Sixteen Americans* exhibition at The Museum of Modern Art, only a handful of people liked them well enough to give them a hard look, a fair evaluation. Like so much great art ahead of its time, the Black paintings were considered by many, including some critics, a source of merriment and a cause for derision. Seventeen years later these dramatic paintings were perhaps less shocking, but still mysterious.

Seeing the sixteen paintings together was a stunning experience—each of them powerful and brooding with throbbing latent energy. This time, admiration for the work was greater. The Black paintings had achieved the status of modern masterpieces. And by the late seventies, when one would occasionally change hands, the price was six digits long.

As Brenda Richardson wrote in the catalog:

Stella's Black titles are a virtual catalog of the dictionary definition of the adjective "black," with its myriad, multilayered connotations: of the color black; having a very deep or low register; of or relating to a group or race characterized by dark pigmentation; characterized by the absence of light; thoroughly sinister or evil; very sad, gloomy, or calamitous; marked by the occurrence of disaster; characterized by or connected with the use of black propaganda; characterized by grim, distorted, or grotesque satire.

Death and especially suicide are prevalent references in the titles. For Stella to call the titles "downbeat" is clearly an understatement.[3]

The Black paintings followed a year's worth of large paintings with stripes and rectangles, often done in bright, garish colors such as chartreuse and pink. At the time they were painted, Stella was solitary, frequently cold, engaged in an enterprise which may have seemed significant to only a few dozen people in the entire country.

By contrast, when he was at work on the Exotic Bird series, he was enjoying the company of Harriet McGurk, was as warm as he wanted to

be, had an international reputation as one of the greatest living artists, and there was plenty of money. Stella was happy and the work reflected it.

Reviewing the Knoedler show in *Artforum* December 1976, Budd Hopkins, himself a fine and serious painter, wrote thoughtfully about Stella's new paintings:

One felt happy at Knoedler's whatever one's ultimate reservations. Curves—mad French curves and ships' knees and boomerangs and six-foot commas—now co-exist with huge metal rectangles, tilted in almost a parody of Cubism. The color is perhaps the most outrageous element in the entire cacophony. The colors are everything gaudy you can get in a can or a tube.

Opposite: Detail of *Khar-pidda (#8, 5.5x)*, 1978.

During 1976 and 1977 the Petersburg Press boys, Bruce Porter, James Welty, and John Campione, were busy on the ground floor of 17 Jones Street producing the six prints of the Sinjerli Variations series. Each image was a circle made of two protractors, stacked, their flat sides together, and inside each, the familiar entwined bands of color, placed off center to the left on a horizontal sheet of Arches paper. Sinjerli was a Hittite city, 1900–1200 B.C., which Stella had learned of in Creswell's *Short Account of Muslim Architecture.*

Sinjerli Variation III, 1977, color lithograph and screenprint, 32 × 42½"
Courtesy of the Petersburg Press.

In 1977 Ken Tyler and Frank produced the six complex prints in the Exotic Bird series with the assistance of John Hutcheson and Kim Halliday. Richard Axsom explained just how ground-breaking they were:

Although these prints were the first to emerge from a metal relief series, they are perhaps more directly related to the original working drawings on graph paper for the paintings and to affiliated smaller-scale, flat, mixed-media paintings that incorporated graph-pattern backgrounds. The Exotic Bird series marks the first instance of an active merging of lithography and screenprinting, the use of glitterflex (paralleling similar textures in the paintings), and the adoption of liquid tusche to create lithographic washes.[4]

Even as early as 1977 it was clear that Frank Stella and Ken Tyler inspired each other—Stella with his wild, seemingly uncontainable imagination and Tyler with his confidence that he could figure out a way to make into a "print" anything that Frank could think up.

In January 1977 an exhibition at the Princeton University Art Museum brought together thirty-three works by artists who had had some connection with Bill Seitz—his former students, friends, and colleagues. The opening included talks by distinguished members of the art community, an elegant luncheon, and a viewing of the new William Seitz Collection. That an "instant" collection could be assembled for the museum of one of the many institutions where Seitz had taught was testament to his reputation. He was respected not only because he was a good

art historian and curator but because he was even-handed, enthusiastic, and a friend to students.

Stella described Seitz as a teacher and the gentle way he had of communicating that a painting needed more work or a lot more work. His frequent caution, "Watch the edges," was taken to heart by many students, Frank and me included. And Stella reminded us that when a painting had a very long way to go, Bill would say, "That's interesting." It wasn't exactly damning with faint praise since what he probably really meant was something like, "It's interesting that you are content with such mediocrity and why don't you push yourself a little bit harder?"

All Stella's teachers—Patrick Morgan, Steve Greene, and Bill Seitz—stressed the importance of productivity and none of them acknowledged an excuse for not painting.

The fabrication of the Exotic Bird paintings, begun in 1976, took longer than Stella had anticipated. Even though the work was done in a factory, there was an almost continuous fitting and refitting of the various pieces. The tilted planes of the rectangular and framelike elements all went together with a precision that tolerated error of little more than one-sixteenth of an inch. No matter how fast he worked, Stella's determination to "get it right" kept his speed in check. And even though he had become successful at delegating aspects of the building of a painting, there was still a great deal that could be done only when he was in the studio. A combination of professional commitments and his new interest in automobile racing, not to mention a few hundred hours a year at Tyler Graphics, kept him away from the studio for increasingly long periods.

In October 1977 at the invitation of the Sarabhai family, Stella and Harriet visited Ahmedabad in India. For both of them the trip was not only a badly needed rest, but for Frank it was a temporary escape from his now continuous dealings with all kinds of people from museum directors and trustees to workers who needed instruction, to a large assortment of family members and friends.

Work, of course, was not entirely left behind.

The Sarabhais were generous hosts and provided Stella with all the helpers he could use. He had brought with him one foamcore model for a new piece that would do away with the strictly rectangular field/background/framing element characteristic of each of the Exotic Birds. He had assumed that there would be foamcore available in India but there was not. There was, however, plenty of thin sheet aluminum discarded by can manufacturing plants. Stella put his helpers to work cutting out the assortment of draftsman's shapes which he would trace on the aluminum (tin alloy) sheets.

Before Stella left for India he already had the notion that he would do away with the strict rectangular "background" in the hope of achieving freer paintings, but he wasn't sure how to accomplish what he had in mind. In Ahmedabad he discovered a heavy, open metal mesh that could be bent into a curved, partially cylindrical form. In the maquette for *Ram Gangra*, for example, the bent, curved "background" piece is a structural element to which the major elements are attached, while at the same time it is a nonelement because it is almost entirely nonobtrusive even though it supports all the various baroque shapes and keeps them away from the wall.

Stella began the enterprise with four helpers. Twelve days later the number had grown to two dozen. Before he left India Stella, with his team, made a duplicate of each of the twelve maquettes in the Indian Bird series so that a set could be given to his hosts. Back in New York at the end of 1977 he began work on the full-scale Indian Birds, five and one-half times the size of the maquettes.

The twelve Indian Birds were engineered, cut out, assembled, taken apart, painted, reassembled, and shipped out of the studio by the end of 1978. By contrast, it would be two more years before all of the Exotic Birds were completed.

Grajau I (#1), 1975
lacquer and oil on aluminum,
6' 10" x 11' 2".

Jardim Botanico II, 1975
mixed media on aluminum,
91½ × 126".

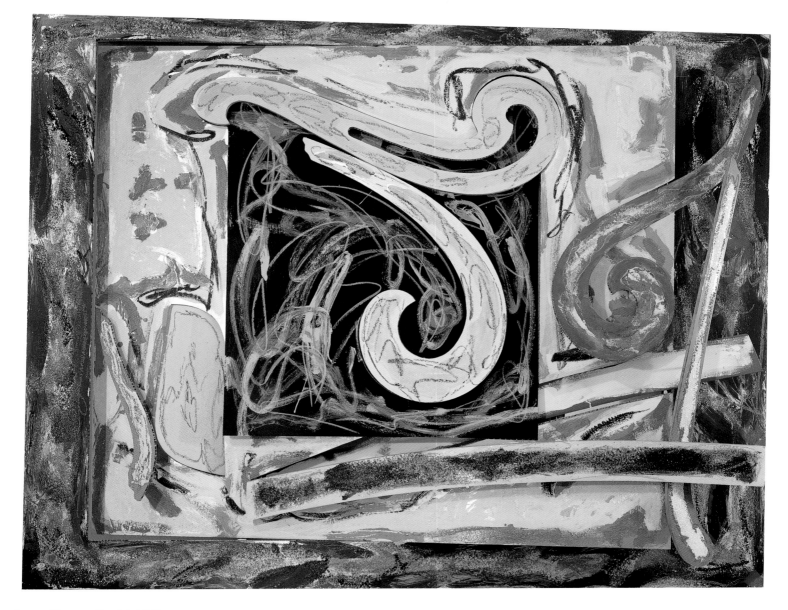

Steller's Albatross (#6, 3x), 1976
mixed media on aluminum,
65¼ × 85½ × 9½".

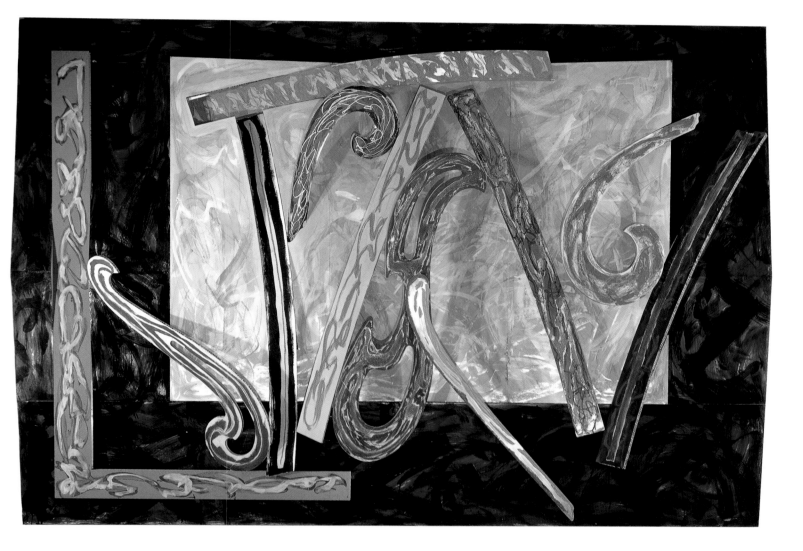

Laysan Millerbird (#22, 5.5x), 1977
mixed media on aluminum,
130 × 225 × 25".

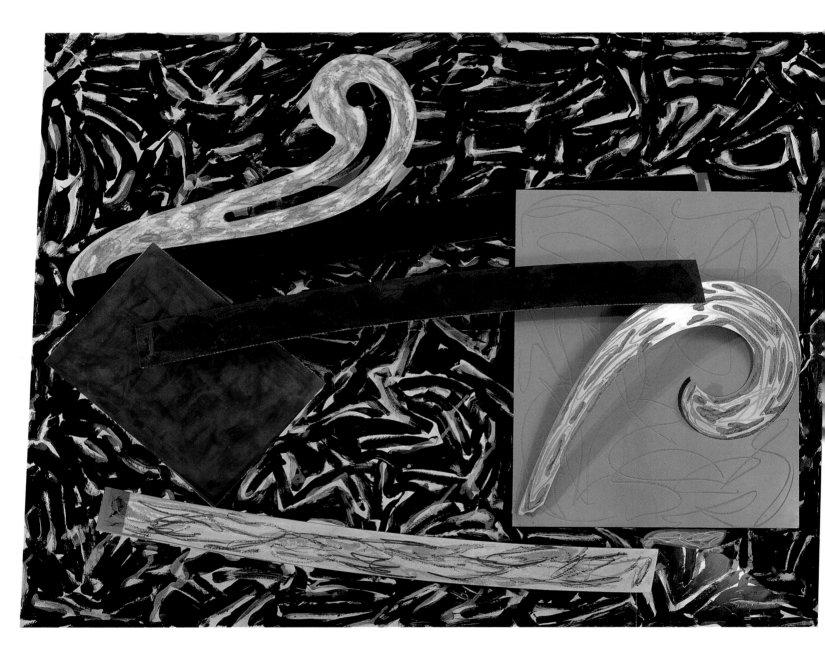

Inaccessible Island Rail (#12, 5.5x),
1976
mixed media on aluminum,
117 x 155".

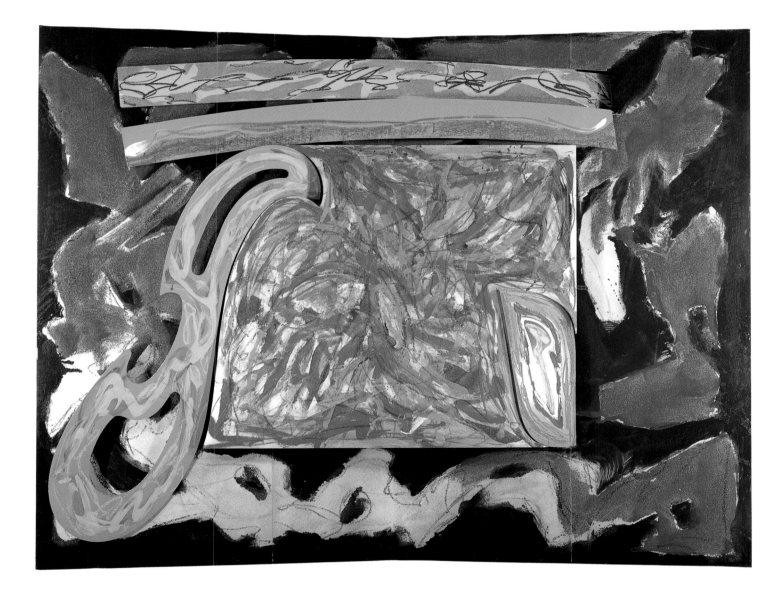

Mysterious Bird of Ulieta (#13, 5.5x), 1977
mixed media on corrugated
aluminum, 119 × 156 × 24".

Khar-pidda (#8, 5.5x), 1978
mixed media on aluminum,
122 × 88 × 35".

Kastura (#11, 5.5x), 1979,
mixed media on aluminum
115 x 92 x 30".

MARRIAGE WITH HARRIET, STELLA SINCE 1970, RACING, PRINTMAKING

Harriet McGurk and Frank Stella
are pleased to announce their marriage
in New York City on February tenth,
nineteen hundred and seventy-eight.

Opposite: detail of *Swan Engraving Square IV*, 1982.

Below: Stella and Harriet McGurk on their wedding announcement, 1978.

After graduating from Radcliffe in 1967, Harriet McGurk moved to New York, found an apartment on Jones Street in Greenwich Village, and decided to go to medical school. She had majored in sociology so she began taking the prerequisite premed courses while holding down an assortment of jobs. According to Frank, he introduced himself that fall to Harriet while a group of neighbors were gathered on Jones Street watching a fire in a building on Bleecker Street. Harriet thinks that a mutual friend got them together. In any case, in under three years, they were on their way to City Hall.

Harriet was quite nervous when the day finally came. By noon she had shopped for food for a wedding reception for forty or fifty people. She was arranging the trays—meats, bread, and vegetables—when the three witnesses—Larry Rubin, Jerald Ordover, Frank's lawyer, and Harriet's good friend Virginia Morris—showed up at Jones Street. As soon as they were assembled, they raced down and all five got into the

first cab that came along. The cabby told them that it was against the law—five in a cab—but they persuaded him to take them to the court house at 100 Center Street.

The cab made it only half a block before they were stopped by a cop. Even though Frank explained to the officer that they were concerned about getting separated if they split up, he wouldn't make an exception. They made it to the judge's chambers in plenty of time and were married by Ernst R. Rosenberger, justice of the Supreme Court of New York.

After a brief ceremony they went back to Jones Street for champagne, lots of food, and a special wedding treat. Ken Tyler arrived with a cake he had spent the night making, a cake in the form of one of the Exotic Bird series, *Mysterious Bird of Ulieta*. About an hour into the party someone noticed that the groom wasn't there. One of the guests found him downstairs watching a game on television.

In spring 1978, almost as soon has he had signed the last of the six Sinjerli lithographs (each in an edition of one hundred), Stella began a new series of prints for Petersburg—ten images called Polar Co-ordinates. These prints are based loosely on the geometry of the Saskatoon and Flin Flon paintings of 1968 and 1969. But while the paintings were made of bands of flat, unmodulated colors, the prints are alive with all kinds of marks that break up and vitalize their surfaces. The first of the Polar Co-ordinates is the first of Stella's prints in which the image covers the entire sheet. Using one hundred percent of the surface meant that Stella had decided that a print could stand on its own with very little debt to the painting that inspired it. The size of the paper and the approximate geometry of the Saskatoon and Flin Flon paintings were the only givens with these ten prints. His use of the polar co-ordinates grid was evaluated by Richard Axsom:

The variety of grid systems in the series and the title itself stemmed from the artist's playful interpretation of polar co-ordinates graph paper. Imagery is far more lively and ambiguous in the prints than in the paintings as transparent and translucent color, calligraphic scrawling, and the grids themselves disintegrate form.[1]

It became increasingly clear that Frank Stella, the painter who was dragged to print production in 1967, was now a committed, original generator of prints.

Stella Since 1970, an exhibition of twenty-six paintings from three series, opened at the Fort Worth Art Museum on 19 March 1978 and would

Opposite:

Sinjerli Variations Squared with Colored Grounds I
color lithograph, 32 × 32"
Polar Co-ordinates IV, 1980,
offset lithograph, screenprint and letterpress, 38 × 38½"
Courtesy of the Petersburg Press.

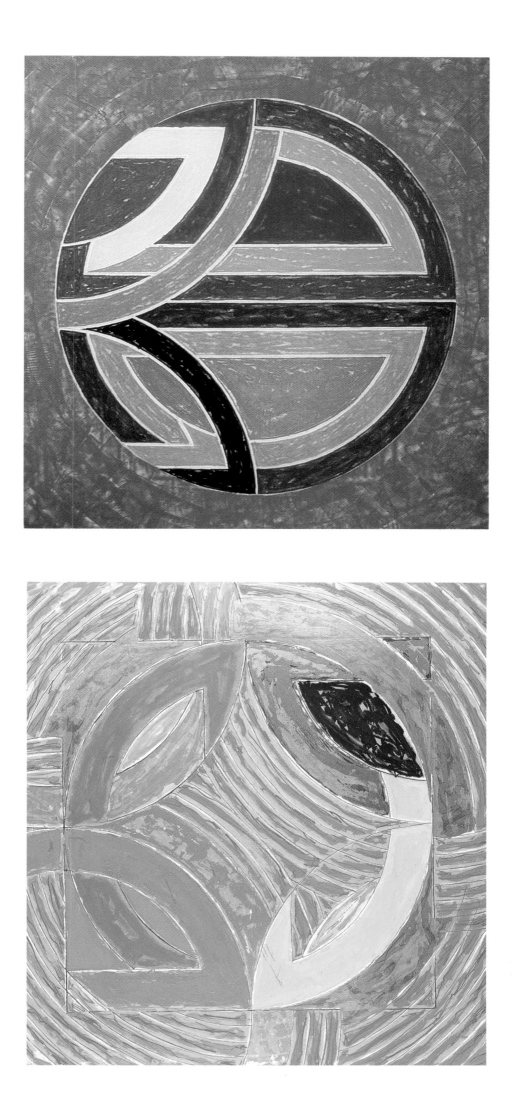

travel to four other venues including the Corcoran Gallery of Art in Washington, DC. The show included nine paintings each from the Polish Villages and the Exotic Birds, and eight from the Brazilian series. Anne Livet, the show's curator, describes the development of the catalog accompanying the exhibit:

Frank Stella's choice of Philip Leider to write this monograph was as apposite as his selection of Edward Ruscha to design the catalog; the sensitiveness toward the verbal presentation of the artistic issues involved in the work is matched in the visual presentation of this catalog.

Philip Leider had met Stella in the early sixties when Frank and Barbara Rose came to California to teach. Since Leider's first exposure to the Black paintings in 1960, he had been a steadfast admirer of Stella's. His catalog for the exhibition includes four essays (the first deals with the paintings themselves) and offers a tremendous amount of data on the three groups of paintings. The other three chapters examine the significance of these works in the greater scheme of Western art and include some brilliant and original thoughts on abstraction.

In the second essay, Leider had some thought-provoking words about Caravaggio (1573–1610) in relation to Stella's work. The parallels between Stella and Caravaggio would appear again in Stella's own Charles Eliot Norton Lectures at Harvard in 1983–84. "Changing Style," Leider's third chapter, not only describes Stella's stylistic trajectory, but also leaves no doubt about the magnitude of his accomplishment:

"Every artist of the better sort," wrote Thomas Mann, "carries within him a canon of the forbidden, the self-forbidding." A change of style of the magnitude undergone by Stella in the last two years constitutes a restatement of this canon, a shift in his view of what is possible and what is not possible to abstraction at any given time. In these most recent works (Exotic Bird series), Stella, throwing open the doors to much that had hitherto seemed to him forbidden—figure-ground dichotomies, composition, gestural paint-handling, etc.—has achieved for abstraction a renewed animation, life, vitality, that has already about it something of the sheerly miraculous. One would be blind not to see it, catatonic not to feel it, perverse not to acknowledge it, spiritless not to admire it.[2]

Ben Forgey, critic for the *Washington Star*, wrote on 21 April 1979:

In Jardim Botanico II, *each plane, as in the Polish constructions, consists of a single color, but here the modulation of brilliant tones adds notes of subtle vibrancy to the "logical" architecture of the paintings. Actually this architecture is totally intuitive; we think of it as logical only out of habit and because the artist has done his job so well.*

Frank Stella: Metallic Reliefs opened in May at the Rose Art Museum at Brandeis University. There were nine enormous paintings—five from the Exotic Birds and four from the Indian Birds—holding forth in the confines of the compact museum. Carl Belz, director of the Museum, curated the show and commented in the catalog:

Last fall, I had the opportunity to see in Stella's studio several of the latest metal reliefs completely assembled but unpainted. A multitude of curves and counter-curves swept from floor to ceiling. The clean surfaces of the overlapping aluminum planes they described were serenely ascetic, creating the dual impression of a classical drawing come to life and of a Cubist construction finally reaching its potential. I was ready to accept them without wanting more. But when I saw the reliefs completed, they seemed to have taken off and exploded, releasing impulsive painterly gestures into space and then suspending them there.

Laysan Millerbird, 1977, was by far the largest work in the show and a success on many fronts. One of the most complicated of Stella's paintings yet, it managed to be cool and contained. Compositionally it is an off-center rectangle cut into an enormous rectangle, which is a slightly folded plate. The eleven shapes within are locked together but at the same time seem to move like dancers. Other contradictions—light/dark, simple/intricate, baroque/rectilinear, gestural/crisply architectural—helped to make this one of Stella's most engagingly complex paintings.

Sometime in the mid-sixties, Stella's father started showing up at Frank's openings. The fact that Frank's first and principal dealer, Leo Castelli, was Italian, helped Dr. Stella begin to give Frank some approval. In spite of his being very hard on Frank, they were unusually close. When Frank had his prolonged stay at the hospital in 1970, Dr. Stella spent a great many of the forty days at his bedside, or pacing the hospital hall, trying to buttonhole Frank's doctors. Frank maintains that but for his father's presence he might have stayed a lot longer. They had always done a great many things together, particularly house and boat maintenance projects and fishing. Dr. Stella was only 69 when in 1979 he died suddenly of a massive coronary attack. His death was a blow to Frank.

Stella's obsession with racing and race cars, born of an encounter with BMW which resulted in his designing the paint job for a BMW racing car, would last for about five years. At the age of forty in 1976 he had never owned a car. By forty-two he was buying cars and driving them fast.

The international group of BMW drivers included Ronnie Peterson, Jochen Neerpasch, Herve Poulin, and Peter Gregg. Gregg met Stella at Nurburgring, Germany, in the spring of 1977, and by 1978 they had become close friends. Gregg valued Stella's tactical advice in connection with his races and became an admirer and collector of his paintings.

In September 1978, Frank and Harriet traveled with Peter Gregg from Milan to Bellagio for the Monza Grand Prix. They watched their friend Ronnie Peterson crash and die a few hours later. Stella was convinced that Peterson might have survived had he had appropriate and speedy care. He subsequently worked with the drivers' organization to establish and standardize the treatment for victims of violent crashes—in particular, head trauma—at hospitals near race tracks.

In the summer of 1980 Gregg and Stella rolled in Gregg's Porsche while driving to LeMans in France. Frank was unhurt but Gregg never totally recovered from head injuries, which further contributed to an already depressed personality. In December 1980 Peter Gregg walked out on the beach in front of his home in Jacksonville and shot himself in the head. He was to have been married for the second time the following week.

BMW designed by Stella in 1976. Courtesy of BMW of North America, Inc.

The Swiss curator Christian Geelhaar was about twenty years old in 1970 when he took the train from Basel, where he was at university, to Amsterdam to see the first Frank Stella retrospective at the Stedelijk

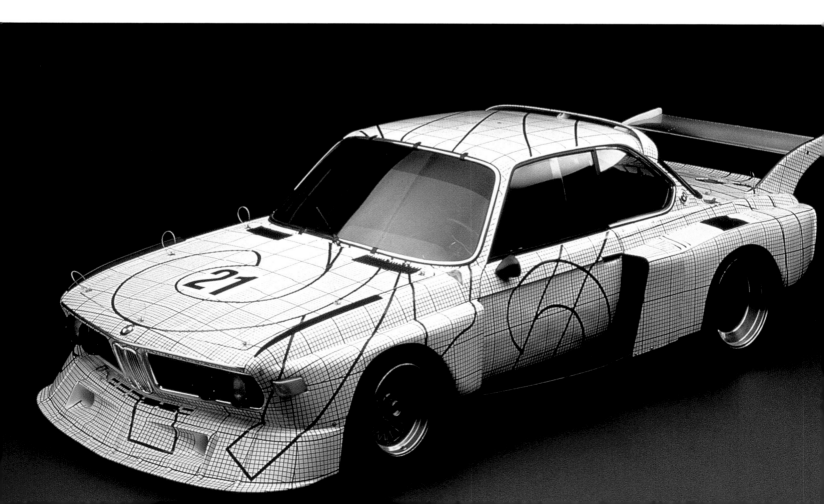

Museum. At the time he had read the available literature on Stella, and admired the 1958 painting *Seward Park* acquired for the Kunstmuseum in Basel by Franz Meyer.

By 1978 Geelhaar was curator of twentieth-century art at the Kunstmuseum. Two years later he mounted the exhibition of Stella's working drawings and produced the catalogue that reveals so much about the artist's methods and techniques. I interviewed him in Basel on 15 March 1993:

SG: In 1979 Frank told me he had made a few trips to Basel because somebody had started to collect all the drawings, the working drawings, studies and sketches. He seemed quite pleased that they were going to have a home. How did that come about?

CG: I had heard, I believe from Paul Cornwall Jones at Petersburg Press, that Frank had all these working drawings, and because of my interest in Frank's work, I ought to see them. Frank agreed and we spent a lot of time going through these drawings, trying to figure out what they were, and also how they fit into a certain chronology because there were hardly any dates at all. Then they were kept in boxes and folders and Frank was aware that they needed to be taken care of. The museum offered to have them all mounted on mats and the many we selected for the exhibition were not only matted but framed and I did a catalog. He was not that popular an artist in Europe at that time. He said to me, if the museum buys two paintings of mine I'll give you the drawings that are in the show. Of course I agreed to that. I did the show of drawings in 1980, I was still curator, not director. First I bought West Broadway *and then the large* Protractor (Damascus Gate *stretch variation) in 1981 when I was director.*

Christian Geelhaar was an extremely insightful man who was able to identify sources in the little sketches that had gone unnoticed. In connection with the Benjamin Moore series, for example, there is a sheet with six drawings and names, all quite messy and roughly drawn. The drawings and the handwriting are clearly not Stella's. They are, in fact, Carl Andre's. I suspect that it was Andre who gave Stella the six basic ways of dividing up a square.

Stella's work had taken an important and dramatic shift by 1980. He had acquired a few more drafting tools including the Flexicurve, and its presence in the Circuit series of paintings set this series apart from his earlier work. The greatest change, however, was that Stella began using his own scrap metal. It had occurred to him that the sheets of honeycomb aluminum with cut-out holes representing shapes which had been used in earlier series—the negatives if you will—were valid sculptural elements.

Kastura, completed in late 1979, was one of the last of the Indian Birds series. Even though each element, each cut-out shape, is wildly painted and otherwise colored and decorated with assorted sparkling matter, every single piece is based upon an exact, precise object (the enlarged French curve, for example). But with the huge group of paintings, the Circuits, Stella began to incorporate a whole new batch of rough-looking pieces, many with shaped cut-outs, in addition to the shapes familiar to all drafts-men, which he had been using for years. Consistent with the improvisa-tional character of the surface treatments, the fabrication of Stella's art was becoming more spontaneous, less strictly based on pre-assigned pat-terns and shapes.

If something on the floor appealed to him, he would have it copied to use in the next piece. Often a scrap would have to be downsized and then rendered in foamcore at the same scale as the maquettes.

Most of the pieces in the Circuits are so complex that it requires several minutes of study to sort out the various planes, where shapes leave off, and where they begin again. It is useful to look at one of the foamcore maquettes to understand what is going on. The scoring of the surfaces with the Polar Co-ordinates grid was not random as can be seen from looking at the photograph of the foamcore maquette for *Zeltweg.* Stella had had the Polar Co-ordinates grids printed up on sheets of foamcore.

But as head-spinningly complex as the Circuits appear, they are, at least in one respect, simpler than the Indian Birds. Even though the parts are in several planes, the planes are parallel to each other and to the wall.

Despite Stella's expenditures of thousands of dollars every month for fab-rication and production of his art and several hundred thousand dollars a year for maintenance of his Manhattan studio, he had by 1980 become a wealthy man.

Through one of his tennis-playing buddies, Paul Sorren, he had become interested in horse racing. Soon trips to the track and placing bets at OTB evolved into a partnership of Frank, Paul, Larry Rubin, and Tony Matos, a jockey's agent and a friend of Paul's. Together they bought a horse farm in Amenia, New York, near the Connecticut border. Frank is now the sole owner of the farm, having bought out his partners, one by one. Robert Kahn, an architect whom Stella met at the American Academy in Rome, has turned the existing buildings into the Stellas' weekend and summer retreat which includes a sunken squash court and a swimming pool. The farm breeds race horses and the business has done moderately well. Stella also owns Magenta Stables, a string of horses that race under his colors, magenta and dark green (*vert fonce*).

To make black-and-white prints—especially when they are as big as paintings, and manifestly as elaborate—is, for a contemporary artist, to flirt with catastrophe. Great ghosts rise, starting with Goya, Manet and Picasso, invoking awkward comparisons: Black and white is not something to toy with, it is the vehicle of tragedy (The Disasters of War) *of epigrammatic compression* (Manet's works) *of declamation* (Guernica); *and it pillories one's graphic failures.*

Thus began Robert Hughes's essay for the exhibition catalog of Frank Stella's Swan engravings at the Fort Worth Art Museum in 1984. The prints are named for the Swan Engraving Company in Bridgeport, Connecticut, where Stella started going regularly in 1973, when he began work on the Brazilian series.

In 1981 Stella was in Bridgeport working on the Circuits paintings. He switched from aluminum to magnesium as the principal material as he became more involved in the etching of the surface. Magnesium is softer and responds more quickly to the etching acid. Ken Tyler was working in Bridgeport with Frank showing him printer's techniques for coloring metal. He is still moved by his recollection of the moment:

The skins of the reliefs were etched magnesium. And as we were etching that magnesium I said to myself, "Damn, these should be prints, these should not be reliefs." And I kept proofing them, taking fragments home and printing them in black and white, and Frank suddenly one day turned and said, "God, this is pretty good. That stuff looks exciting." But he wanted the collage. He wanted it cut out and that was easy to do because the metal offered the thinness and flexibility. And by pure accident this produced the possibility for doing collaged metal prints. And Frank just went crazy. Quickly. The excitement was there, everything was there and we developed that through simple trial-and-error methods. We didn't know what we were doing. No one had ever done this kind of print before. No one had ever taken any collaged metal and worked it like that.

I said to Bob Hughes that I thought that these are the greatest black-and-white prints since Dürer. He agreed. I think they are. The Swan Engravings are unique.

Model for *Zeltweg (V)*, 1981
tycore model, 23⅜ × 27¼ × 3".

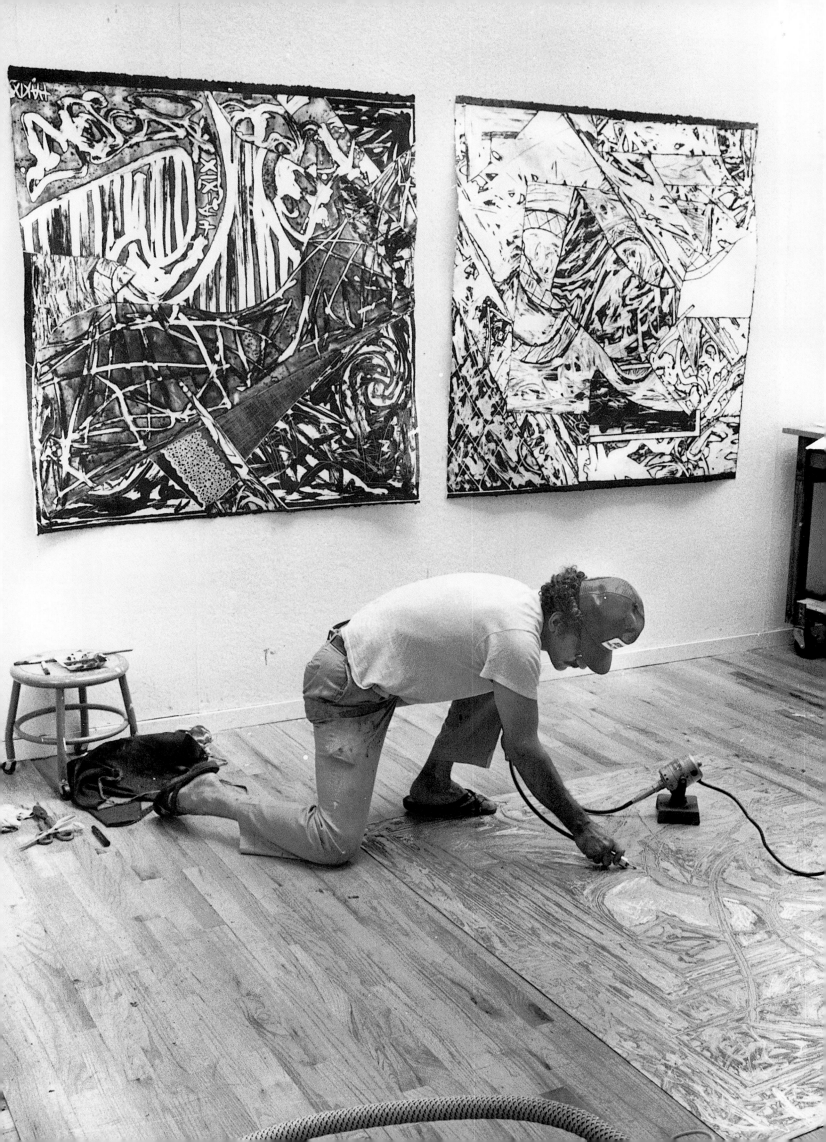

There have never been prints like them. They have a strength and a clarity and they're simply unique. No other prints in my lifetime have ever come close to that. What makes them so great is that they're naked. When they hit you in the face, they hit you because they really have this strong composition and this strong meaning and this force of imagery.

Working on a piece of three-quarter-inch plywood that was the final size of the print, Stella would choose from a nearby pile of magnesium sheet forms, snip and cut them into shapes which he liked and/or which were suggested by the etching already on the plate, and then place them on the plywood and tape them down. Eventually the surface would be covered but Stella would continue to add and subtract, cutting more pieces, rearranging until he had a composition he liked. Then, on certain pieces, he would do more etching and engraving. Finally the pieces of magnesium sheet were glued to the plywood like a puzzle. The fitting had been so skillful that there was seldom more than one-eighth of an inch of space between the pieces.

Hughes's admiration for this series of prints is practically boundless:

The Swan*'s surface is full of life. No modern artist since Picasso in the forties has given us black-and-white prints of this opulence and strength, and not even he worked at this size. Black, in Stella's hands, is not the negation of color. It is a color in itself and a substance as well. It takes on an extreme density in the deep, tarry rivulets that flow between the abutting edges of the plates. It confers on its opposite, white, a creamy or floral lushness.... Their refinement is as extreme as their vigor. With the* Swan Engravings, *Stella finally becomes as important to printing as he is to painting.*[3]

Stella engraves into an etched magnesium plate for a "Circuits" print at Tyler Graphics in New York.

Swan Engraving Square I, 1982
one color etching, 53½ × 52".

Swan Engraving Square II, 1982
etching, relief, 53½ × 52".

Swan Engraving Square III
one color etching, 52 × 54".

Swan Engraving Square IV
etching, relief, 52 × 54".

Zeltweg (V, 3x), 1982
mixed media on etched magnesium,
72 × 81 × 12⅝".

Nogaro (X4.75x, third version), 1984
mixed media on aluminum and
fiber glass, 115 × 120 × 24".

ROME, MALTA, HARVARD, PRINTS:
THE WHITNEY & PRINCETON

On 15 April 1982, Peter Alexander Stella was born. He was named for Peter Gregg. In November Frank and his family left New York for Rome by way of London. Stella had a long-standing invitation for a residency at the American Academy in Rome but had never before felt that he could afford the time. Because he had just come off a period of more than three years of the most intensive and productive (even for him) painting and printmaking of his career, he thought a change would do them all good. Furthermore he had received an invitation from Harvard to give the Charles Eliot Norton Lectures during the 1983–84 academic year. He felt that the American Academy invitation and the one from Harvard complemented each other and gave him a year to write the six lectures. Although he wasn't really sure what he would be talking about, he had plenty of ideas.

He told writer Calvin Tomkins:

I wanted to take some time off and really look at some paintings, although I didn't know then what paintings. I knew a little about nineteenth-century French painting, and a little about Spanish painting, from the time I spent in the Prado when Barbara and I were in Spain. But I didn't know much about Italian art. So I guess what I decided was that I'd try to teach myself about Italian painting, and the lecture audience would have to suffer through it. But I also knew that the lectures would really turn out to be about me.[1]

Opposite: detail of *Shards IV*, 1982.

The Academy is housed in a spare, 130-room rendition of an Italian Renaissance palazzo designed by McKim, Mead and White. It sits atop the Janiculum, the highest point in Rome. If the pace of life at the villa was

relaxed and more Italian than American in spirit, the pace of Stella's approach to learning about his subjects was business as usual.

In his second essay for the *Stella Since 1970* catalog, Philip Leider wrote:

The problem of Caravaggio is especially interesting because his case is one of the earliest in which many did in fact see what he stood for as the end of the existing paradigm, "the very ruination of painting." Driven by needs that evade explanation, the artist produces work which appears to others, and frequently to himself, inept, and in many cases the urgency of this need is questioned: might it not mask genuine ineptness? It is possible that to the day he died Caravaggio may have wondered if the charges might not be true, that the depth of his need to paint as he did could be measured precisely by his inability to paint as others did.[2]

As soon as he got to Europe, Frank began looking at Caravaggios. He sought out every painting available to the public in Italy, Antwerp, Brussels, London, Paris, and Vienna. But the painting which moved him most was *St. John the Baptist* in Rome in the Capitoline Museum.

A number of art historians have found this painting disturbing. Howard Hibbard wrote:

The youthful St. John in the wilderness was a familiar theme in the Renaissance. Caravaggio's perversion of the norm is so extreme that we are not sure that he meant to paint a St. John at all. The identification is confused by the presence of a ram rather than the familiar lamb, and there is no cross or banderole. Caravaggio painted the model in a provocatively exhibitionistic pose.[3]

But rather than being concerned with the painting's subject, Stella was moved by the space of the painting claiming that it goes far beyond illusion. He identified a *presence* which he had not come across in the thousands of paintings he had closely examined over the past thirty years. He maintained that this *presence* was beyond illusion or trompe l'oeil. He told Calvin Tomkins, "I wasn't impressed by it—I just loved it. And I realized that abstract painting could be equally real, could have that same sense of presence for me. I saw that in a very important sense painting begins for us with Caravaggio." He approached Caravaggio with the same fervor he demonstrated when approaching a projected group of paintings, identifying four tasks before him: to see as many of the paintings as possible, to read all of the available literature, to speak with and listen to the lectures of the acknowledged Caravaggio authorities, and to write his own lectures.

Stella was in residence at the Academy in November–December 1982 and again in spring 1983. The family's quarters were comfortable and they were made to feel at home. During their first stay, which included Thanksgiving and Christmas, Frank's mother accompanied them. Peter was something of a star but nevertheless was not allowed to eat in the dining room. The Stellas made friends with a number of the fellows, includ-

ing the English architect James Sterling, writer Mark Helprin, poet Mark Strand, and a young American architect, Robert Kahn, who was working on a book on Andrea Palladio, the great Italian Renaissance architect. One of the high points of the "fall semester" was the Christmas pageant organized and presented by some of the fellows for the children of the staff. Frank painted the "set", Sterling donned a fake beard and played Babbo Natale (Santa), Mark Helprin, as the fairy godmother, rapelled down the outside of the building and swung in a window wearing a tutu, and Mark Strand, an immense man, played Mamma Natale (Santa's wife).

In the spring of 1983, Frank's associate, Paula Pelosi, accompanied them on their second visit. Harriet described their apartment as glorious with enormous French doors opening onto a private garden. Each day, while Frank worked on the talks in his study, Harriet, Paula, and Peter would explore the architectural and cultural wonders of Rome. Frank made friends with Irving Leavin, the eminent Bernini authority, who was happy to direct them towards the master-pieces of the high baroque.

Installation of the 1984 exhibition at the Fogg Art Museum, Harvard University.

The six Harvard lectures start with Caravaggio and the late Renaissance and continue through to some of his own latest work. At the time of the talks, Caroline Jones, assistant director for curatorial affairs at the Fogg Art Museum, organized a Stella exhibition. The Fogg owned three works, and she uncovered more in public and private collections in the Greater Boston area; Stella loaned two large *Malta* assemblages and the original maquettes for the entire Playskool series. Jones also interviewed the artist for the Harvard Alumni magazine, prompting thoughtful answers on the painting of the last five hundred years and the future of abstraction.

Describing the development of the lectures, Stella said:

I knew I wanted to build somehow on the Picasso talk I had given at the College Art Association in 1981. Once I got to Rome, it was seeing the paintings. I had some ideas about space in general, and I wanted to work them through and see if they held up. Also, there's a slightly annoying critical tendency now, which holds that contemporary art has to

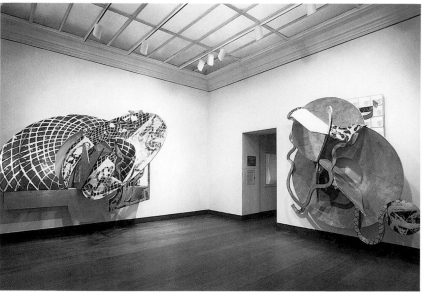

compare with the art of the past, and I wanted to think about that. I don't think it ever crossed Pollock's mind to worry about the quality of his painting compared to Titian's. It seemed like a ridiculous idea.

Frank Stella would be the first to admit that he is not a brilliant lecturer, even though he has been doing it in various forms for over thirty years. As a rule, he reads his lecture, looking up only to make sure that the pictures he is talking about are being projected. By contrast, he is often brilliant in interviews or doing question-and-answer with an audience. If the question is good, he will deal with it thoughtfully, often with wit and humor.

People who attended the first Norton lecture usually mention the size of the crowd. Every seat in Sanders Theater was taken. Although no one at Harvard expected such a turnout, there had been considerable speculation about almost every aspect of the talks. As John Russell wrote in the *New York Times Magazine* on 18 March 1985:

Speculation as to his chances of success was further heightened when it became known that his first lecture was to be concerned as much with Rubens and with Caravaggio as with the art—that of the late twentieth century—on which he long ago burned his own brand. And on the day of his first lecture last October there were very few people in the New York art world who did not wish to ride the Boston shuttle to hear what he would say.

Perhaps part of the reason that the six lectures were so successful was that Frank was taking a huge risk. But early into the first talk it was clear that the originality of his ideas coupled with the momentum of genuine and unexpected scholarship would prevail.

In these talks, Stella posed and dealt with the questions: "What did Rubens, and what did Caravaggio do in the seventeenth century to make it possible for painting to keep its place in the hierarchy of human activities?" and, "How can abstract painting keep not only the primacy but the naturalness and the inevitability that it seemed to have after World War II?"

These questions which with the work of other artists in other periods engendered discussions of what great painting was in any century.

Even after they [great painters] are gone, Stella wrote, *we sense that their work is improving and that new things are to come. Sometimes great painters slide into each other creating new forces and new possibilities, and while we appreciate the newness we are, in fact, more impressed that the echoes and resonances of those creations still embody both the past and the present. The reason we can't imagine Rubens pushing Pollock is that the Laocoon ripples through both of them.*

As for Stella's feeling toward Caravaggio and his art, he is generous with his clues. In speaking of *David with the Head of Goliath,* Stella tells

us that "the body of pictorial space actually does support the severed head of the self-vanquished artist." In conclusion, Stella commented on the direction he believed painting should take:

It has to understand its successes better, and it has to understand its sources better. With a better understanding of its accomplishments and its past, painting has to build in order to flower again. . . .It seems obvious that the future of abstraction depends on its ability to wrest nourishment from the reluctant, unwilling sources of twentieth-century abstraction: Cézanne, Monet, and Picasso, who insist that if abstraction is to drive the endeavor of painting it must make painting real—real like the painting that flourished in sixteenth-century Italy.

Some art historians even came to regard Stella as a Caravaggio authority and in connection with the opening of the Caravaggio exhibition at the Metropolitan Museum of Art in New York he wrote the cover article, "On Caravaggio," for the *New York Times Magazine*, 3 February 1985.

The Stellas were given an apartment in Eliot House and when they were in town they would attend the afternoon gatherings for sherry in the building's library, mixing with other of the University's distinguished visitors as well as with faculty and invited students. Frank vertured to New York once every week or two to keep things going at the studio. Otherwise, most of the time was spent working on the talks. Later Frank said that he thought the people at Harvard didn't receive them very warmly, to which Harriet replied, "Nonsense. It was very nice, people were pleasant, and we wanted for nothing. Maybe Frank forgot that New Englanders are reserved."

The cover of the *Times Literary Supplement* (London) of 27 March 1987 was a color reproduction of *Les Indes Gallantes*, one of the Concentric Squares paintings. John Golding's accompanying review of *Working Space* was mostly unreserved in its enthusiasm and approval:

When painters write they often do so very well and we are grateful to them for their journals, memoirs, theoretical statements, pronouncements and aphorisms. But it is seldom that a major artist is prepared to commit himself publicly to a considered, large-scale survey of the art of his time, and to relate it moreover to substantial cross-sections of the art of the past. Frank Stella has done this in his Charles Eliot Norton Lectures at Harvard, with considerable erudition, great verve and genuine originality.

In early spring 1984 the Stellas came back to New York from Cambridge. In less than a year and a half, Stella had researched and written the six lectures which make up *Working Space*. During a conversation in July 1994, he talked about his painting activity during that period:

FS: The Circuit series was a slightly different idea. That had to do with multiple-layered background. Still rectangular planes with holes punched in them. A combination of the Indian Birds and the Exotic Birds.

SG: And the Shards?

FS: That was just working with the scraps left over from production. But it was a little different. Shards had the Pantograph (a draftsman's tool which looks like an adjustable parallelogram). Shards was a cross with a variation on the Circuits.

SG: And Playskool?

FS: That's the same thing. I was working at the factory—it all has to do with the fabricating, using the left-over parts. Picking stuff up off the factory floor and seeing what goes where.

SG: And you were doing prints of these, too?

FS: Almost all these things had prints which were slightly before or after.

SG: And Malta? February '83?

FS: I did go to see the Caravaggio. I had a day to walk around the town. I got the names for the Malta pieces.

This painting, *Beheading of St. John the Baptist*, 1608, about twelve by sixteen feet, is enormous. It is unusual and "modern" in that two-thirds of the canvas is effectively empty. I suspect that the size of the painting impressed Stella as much as the drama of its subject matter.

The two most noteworthy aspects of the *Shards* prints of 1982 are the curving gridded patterns produced by the cut-up plates from the Polar Co-ordinates, and the Pantograph, a draftsman's tool for enlarging drawn shapes proportionally. Even before he had completed the prints Stella began a series of enormous, deep relief paintings based closely on the paper pieces. The difference is that they were much denser, without the various grid systems, and their markings had become wildly, exuberantly gestural, every surface of every shape covered by them. Two of the *Shards* are enormous, seventeen by fifteen feet and fifteen by seventeen feet, and both over three feet deep.

Gathering scraps and other orts from the factory in Bridgeport as well as scrapped, familiar objects—a bedpan, a length of garden hose, part of a chair, a squeegee, a ten pin—from the house and studio, he made a series of nine small mixed-media relief pieces. He called them the Playskool

series after a well-known line of children's toys. The original looked home-made and handmade; they are playful, with a wit reminiscent of Paul Klee's painting *The Twittering Machine*. While they look back to the Cubist constructions of Picasso and to Russian constructivism, they manage to look forward at the same time into the future of painting and sculpture.

Improvising yet again in large part with pieces of scrap he found on the floor of the factory, he completed a group of deep reliefs named for South African diamond mines—for example Blyvoors, Stilfontein, Welkom, Western Deep. These pieces were in early 1982 at Bridgeport, and could be considered a warm-up for the Malta series. These, according to William Rubin, showed Stella at his most challenging. They are enormous, but like the Playskool pieces they owe a debt to constructivism. The signal difference, beside their great size, is that they are without recognizable man-made objects.

And he began work on a series of unusually complex prints, *Illustrations after El Lissitzky's Had Gaya*, published by Waddington Graphics in London.

Between 1967 and 1982, Stella created 163 separate print images and each is carefully documented in *The Prints of Frank Stella*, the catalog raisonné by Richard Axsom. Every print was included in an exhibition that began in September 1982 at the University of Michigan Museum of Art in Ann Arbor and traveled to the Whitney Museum of American Art in New York before going on to twelve more museums. The final stop was the Los Angeles County Museum of Art in January 1986. It was a remarkable exhibition. For most artists it would have been one of the most important exhibitions, if not the most important exhibition, of a lifetime.

In a review of the Whitney show, Grace Glueck wrote in *The New York Times*, 14 January 1983:

The "Circuits" series is based on a recurrent Stella theme of race tracks. Their delirious cursive tangles on kaleidoscopic tonal fields were actually inspired by the serpentine laser-beam trackings left on wood when metal form were cut for the "Circuits" paintings. Monumental in size and gorgeously colored, they are technically innovative combinations of etching, engraving, and woodcut. Can the print field ever be the same?

Worth noting is Stella's explanation of how these prints came about. He was responding to a question by curator-critic Judith Goldman in his studio in June 1983:

I had etched the surface of the Brazilian paintings; and I was using magnesium skins on the metal pieces. I kept saying to Ken, "We could print these." He said yes

and I said, Let's take some home (meaning Bridgeport where they were working to Tyler Graphics, then in Bedford Village) and print them." We did. Everyone thinks a project just takes off, that it's like magic. But they looked awful. So for six or eight months the plates just sat around, until we started working on them again. I don't know where the turning point came. I guess we saw the laser drawings, the tracings left on the wood by the laser's routing. We inked one of those up, and the drawing looked so spectacular that it got me started.

Tyler's version is slightly different:

As I am a pack-rat by nature, I found myself systematically saving interesting sections from leftover offcuts of etched metal. I took these plates back to the workshop where Rodney Konopaki and I inked their etched and scarred surfaces and printed them on sheets of handmade paper. Frank was intrigued by these "scrap prints" and started selecting additional metal fragments for us to proof. These early tests were wiped as etchings and pulled on the traditional etching press. At first the results were not very interesting. Then one day we took our blackest ink, wiped the recessed areas of the plates like an etching, and inked the raised relief areas with a brayer. We then printed the plate on handmade paper in the hydraulic plated press. The printed results were stunning. Frank was impressed with the physicality of the black ink deeply embedded in the fabric of the paper, the relief effects of embossment and debossment, and the ethereal plate tone dancing on the paper surface.

A second exhibition of prints—*Frank Stella—Fourteen Prints with Drawings, Collages, and Working Proofs*—opened at the Princeton University Art Museum in November 1983, timed to coincide with the twenty-fifth anniversary of Stella's graduation. The exhibition was a distinguished one with a superb catalog that included the interview by Judith Goldman. Frank's answer to her first question, "Did you ever study printmaking?" was vintage Stella:

No. Talk about ignorance. I knew absolutely nothing about printmaking when I started out, and I don't really know anything about it now. I don't know why grease repels water, and I couldn't roll up a plate if I had to. One time out at Gemini, they tried to teach me how to roll up a plate. Even that was too hard. You really had to pay attention. I just wanted to do it and forget it. People forget that when you're making art you just screw around. Especially for me, since I didn't go to art school, not only did I not study printmaking, I didn't know anything about painting either. I just do what I want whenever I feel like it—if I think it makes sense. In all the years I've been making art, I've never been tempted to learn anything about technique.

Pergusa Three, Circuits Series, 1983
relief, woodcut, 66 x 52".

Shards IV, 1982
color lithograph and screenprint,
39¾ x 45¼"
Courtesy of Petersburg Press.

Shards IV (3x), 1982
mixed media on aluminum,
120 × 134 × 27".

SPEEDING, HAD GADYA, CONES & PILLARS, MOBY DICK, SECOND MOMA

The Ferrari Testa Rosa is considered by most race drivers to be one of the finest road cars ever made. The one Frank Stella owned in 1983 was silver. On 18 September 1983 he was finally arrested on the Taconic Parkway in Columbia County, New York. I say finally because the first highway patrolman had given up the chase and had phoned ahead for help. He had clocked the car at 106 miles per hour. Frank spent the night in jail and the next day, his lawyer, Dean J. Higgins of Albany, showed up with a plea bargain. In lieu of twenty days in jail as Judge Jutkovsky had suggested, Stella would deliver the six talks that comprised the Norton Lectures in the high school gym in Hudson, New York. The story made the national wire services, appearing in a few hundred newspapers, and Frank renamed the lectures "The Judge Jutkovsky Lectures." Unfortunately, the turnout was low. According to a friend who attended both series, Frank seemed more relaxed and even more genuine the second time around. At Harvard he hadn't taken questions from the audience but in Hudson he did.

In the spring of 1984 (his license had not been revoked), as Stella was tearing north on the Saw Mill River Parkway in his Audi with a somewhat nervous Calvin Tomkins beside him, he raised and answered a series of rhetorical questions:

What's the compelling reason for abstraction to exist?

You can see it on a spiritual level, for somebody who wants to get slightly above and beyond mere material representation. But how many people care about that? A triangle is an abstract form, but to care about it enough to go out and paint one—

Opposite: detail of *Yawata Works*, 1993.

it's not like caring enough about a naked girl. Picasso turned away from abstraction because he thought it lacked drama—he said it was "merely painting."

On 15 April 1984 Patrick Emerson Stella was born. Besides another son, that spring also brought another honorary degree. *The New York Times* of 6 June 1984 published the list of seven recipients of honorary degrees at Princeton's 238th commencement including children's book author Maurice Sendak, for "having delayed bedtimes across our land for thirty-seven years," and Frank P. Stella, for "having changed the course of art in America by rejuvenating the marriage of elegance and economy." Both men received the degree of Doctor of Fine Arts.

The year 1984 had been one of Stella's most productive ever. He completed the huge Circuit series after four years of production; he began and completed South African Mines and finished the Playskool relief multiples; he worked all year on the Malta series; and he began the Cones and Pillars, which would take three years to complete.

Compared to most of his series of two-and three-dimensional paintings, the works of these three groups, South African Mines, Playskool, and Malta, are arguably the most spontaneous Stella has ever done. Instead of working from maquettes he was taking scraps and partial sheets, and orts he would find in the factory, fabricating directly without the aid of a to-scale guide. Stella's uncanny and superb intuitive skills were hard at work. In the Malta pieces, for example, it seems clear that the fabrication involved plenty of "trying out" to see what looked good next to what and what the angle and direction of the tilt should be—a process that usually takes place when building a maquette of foamcore or cardboard. Stella had incorporated the concept and practice of process more immediately into his art.

As early as 1982 Stella was onto a new motif which would remain an important part of much of his imagery for nearly a decade: the Cones and Pillars. These images were based on engravings he had seen in a nineteenth-century book, *Traité theorique et pratique de la stereotonie* by Louis Monduit. His friend and London dealer, John Kasmin, had bought the book thinking Frank would find it amusing.

The *Had Gadya*, a series of twelve moralizing sentences (e.g. "The Dog Came and Devoured the Cat, The Stick Came and Beat the Dog, The Fire Came and Burnt the Stick, etc.") is a children's song relating to the celebration of Passover. El Lissitzky

had made a drawing to accompany each phrase in 1919. The very simplicity of the narrative made it possible for El Lissitzky to illustrate each with a single and graphically powerful illustration. And by the same token, each of the drawings, as if almost magically, took on a persona and personality which matched it up with its Had-Gadya aphorism.

Stella combined each of the twelve lines of the narrative with a complex arrangement of cones, pillars, and an even newer element, the wave. It took two years to complete the twelve separate images of the series, the exact title of which was *Cones and Pillars after El Lissitzky's Had Gadya.* Each combines lithography, screenprint, and linocut. Paper shapes that had been printed in an assortment of ways were collaged onto hand-painted rectangles of handmade paper. The elegantly shaded engravings of cones, pillars, and the various penetrations of solids in Monduit's book had inspired Stella, first to use the forms flat in the *Had Gadya* prints, and subsequently to use them as inspiration for the often enormous two- and three-dimensional objects in the forty-eight paintings of the Cones and Pillars series which he completed at the end of 1987.

In our July 1994 conversation Stella talked about the significance of the Cones and Pillars series to his career:

They represented a slightly aggressive step backwards. It meant that there was more surface to paint on. Not only because of the surface area of the big, hollow aluminum forms, but they had a canvas background, actually. A real hybrid, going backward and forward at the same time. Then there was the 3-D version of the Cones and Pillars which was quite beautiful. I was quite worried about those. But the painting was better on those completely fabricated, volumetric pieces than on the flat where you'd expect it would be better. I think that was the most successful painting I ever did in terms of painting on a three dimensional piece. The paintings work great because they're mounted on the wall. They'd be weaker as freestanding pieces. The painting has to be up on the wall and looked at as a painting.

When the public first saw these new paintings in February 1985 at the Knoedler Gallery, nearly nine years after the appearance of the Exotic Birds, there was some of the usual critical grumbling but one had the impression that the grumblers were in the minority.

In the 1 February 1985 review in *The New York Times* John Russell's admiration and praise for the seven paintings was unbridled. Early in his review, Russell announced

the point of Frank Stella is not that he is strong, but that at his best he has something important to be strong about. The pictures in question may seem for a moment to be about the aesthetics of provocation, but the longer we live with them the more we realize that they deal with a compound idiom whose time has come.

Left: detail of *Lo sciocco senza paura* (#1, 3.8x), 1985.

At the Museum of Modern Art opening in 1987, Stella (far right) is seen with Roy Lichtenstein, Robert Rauschenberg, Richard Oldenberg, Jasper Johns and Riva Castleman.

The big, rectangular painting on canvas which in each of these works served as a background, flush against the wall, was so good that it had prompted Russell to comment:

The new pictures all start, in back, with a rectangular abstract painting that is painted in an idiom that is both loose and sweet. Those paintings could stand by themselves as instances of belated Abstract Expressionism that was long on charm and quite easy to take. (Stella can be as eloquent with the brush as anyone around.)

But far less impressed by Stella and his considerable accomplishment over the previous twenty-five years was Carter Ratcliff, then as now a contributing editor to *Art in America*. The title of his piece and its blurb in the magazine's table of contents read, "Frank Stella: Portrait of the Artist as Image Administrator." Rather than radical or innovative, Stella's art is here seen as bureaucratic in its continuous reprocessing of its own materials. Stella, Ratcliff argues, had invented himself and his career and had followed a charted course from the days of cold and hunger in 1958 on West Broadway to his position, practically on the eve of his second retrospective at the Museum of Modern Art, as probably the richest, most influential American artist of his generation. His trajectory was more in line with the growth of an industry than the development of an artist. When I asked Frank about the article in 1994, he replied:

A lot of people resented me because they thought I was standing in the way of artists who were truer. A lot of people felt that my success was too easy. That I was too flip and a lot of other artists were hardworking and more deserving and didn't get the recognition. People think that I was lucky. And I happened to have one good idea. To paint those black stripes. And if they had that good idea they would have been better. I don't know, it's not rational. One of the things that's real hard to explain, especially when you're young, is that there's a tremendous investment in going

against the grain and the fun of competition and sort of competing with your elders and you know, making fun of them and arguing with them and everything and there's a kind of interchange in that way, but the thing of that is partly to succeed them and partly to equal them and partly to accept the commitment of pursuing that enterprise for the rest of your life. So if you're going to do something and it's what you're always going to do you don't need to be particularly reverential. A little healthy disrespect for the people who are supposed to be so good doesn't hurt. And that's not a bad attitude to have about yourself. I didn't spend time being enamored of my own efforts. When I finished with a series I never thought they were so great that I ought to do more of them. I always felt I could find something better. That it was worth looking for something better. I think that's important.

While drawing near to the end of the Cones and Pillars Frank had taken the idea of the wave from the *Had Gadya* prints and was working up maquettes for a new series of paintings. He had gone with his boys, Peter and Patrick, to see the Beluga whales at the aquarium in Coney Island.

But before then I already had the wave which I had used in the Had Gadyas. *After I took the boys to see the Belugas, the whales and the waves started to make sense. Then sometime after that I came across a copy of* Moby Dick. *The titles for the next series or group of series of paintings was established.*

There are 135 chapters in *Moby Dick*, each with a title, and each of these was used at least once as the name for a painting, a print, or a piece of sculpture.

Near the end of Stella's second retrospective at the Museum of Modern Art there were two paintings which I consider to be among Stella's most beautiful, *Diavolozoppo, 4x (Lame Devil)* and *Loomings, 3x*, a mostly silvery, metallic piece whose wave breaks endlessly at top and bottom, and its great baroque French curve slants down almost to the floor. Of that work

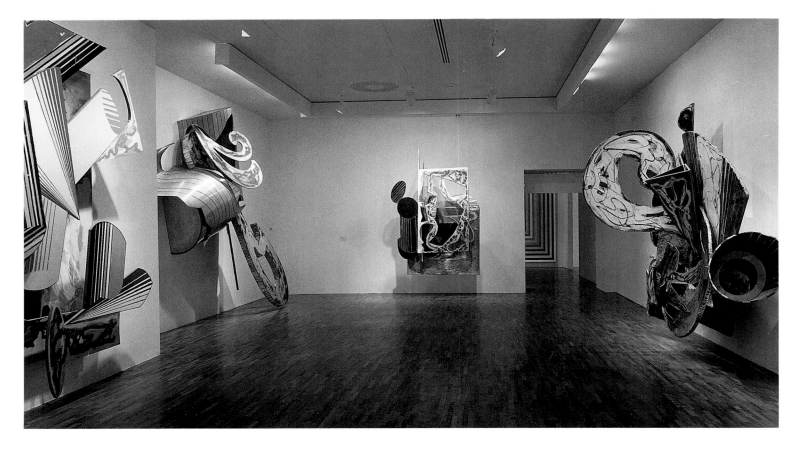

Stella says, "It was the biggest breakthrough for me. That one gave me the confidence to do the whole book. The idea was good enough to go on many times."

Of the long-time Stella watchers, Robert Hughes writes about the artist and his work as well if not better than anyone. In his review of the second retrospective he wrote in *Time*, 2 November 1987:

Stella's fearless panache and the profusion of his output refute the common idea that the possibilities of abstract painting are played out. From the fascist lugubriousness of early striped paintings like Die Fahne hoch *to the galvanic dance of fake-shadowed solids in the Cones and Pillars series of the 1980s, from the decorative pastelly flatness of the late-1960s Protractors to the wave of polished aluminum, gray as sea fog, that swells across the wall of MOMA in a magnificent piece with the Melvillean title of* Loomings, *Stella wrings more pictorial feeling from abstract art than anyone else alive.*

In his 1987 interview in *ARTnews*, Lawrence Weschler discussed *Loomings* with Stella and in so doing approached major artistic issues that span his entire career. In 1959 Stella's credo was "Only what can be seen there is there." He maintained that the Black paintings did not, indeed could not, refer to anything but themselves. But a painting made twenty-nine years later with a fabulous, billowing, baroque wave form and a title drawn from a great classic of American literature is full of associations. The painting loudly proclaims that it has been informed by the outside world. Weschler wrote:

That particular Waves piece happened to raise an issue that has been surfacing in some of Stella's more recent work: the evocative potential of some of the elements

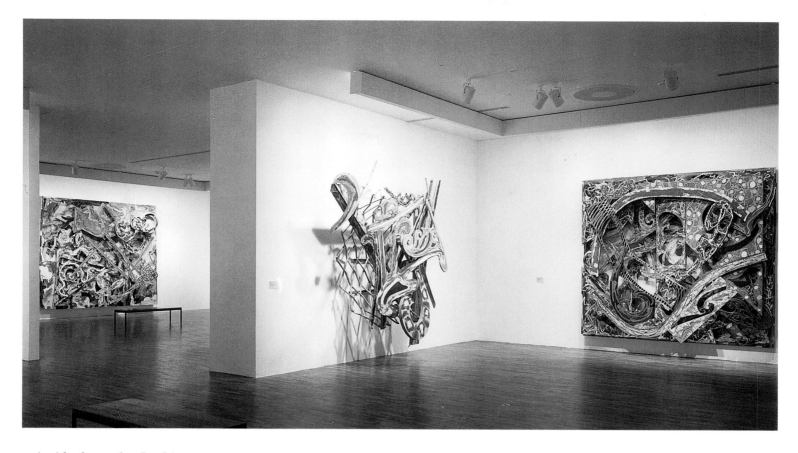

inside the works. In this case an extraordinary wave like shape breaks over the top of the painting and comes cascading down toward its center, suggesting, for one of the first times in Stella's career, neither abstract geometric shape nor anonymous draftsman's tool but rather wave, hair, brushstroke. . . . It seems to summon forth such associations but then modulate back to pure abstraction, hovering in and out of the world. I commented on the effect and Stella responded, "Perhaps, but none of those things count for anything because there's the feeling that it's a painting. It's real as a painting, and that's all that counts. I used to have to work to keep such elements out, precisely for fear of those sorts of associations. But I've gotten to the point now where I can loosen up and let them in, because they can be there and they no longer threaten the painting's reality as a painting. You like that particular element because it hovers back and forth for you. I like it because it moves and it holds the rest together. What I really like is that it moves and it catches the light, and that's what a painting is: it's got to have a sense of vitality and it's got to catch the light."

Although perhaps unexpected criteria for good painting, they apply to Stella's work as well as to the work of others. Look again at *The Marriage of Reason and Squalor* one of the Black paintings. Pulsing with its own vitality, the painting definitely catches the light with the ragged, pale line of canvas showing between the pulsing black stripes.

Between 1967 and 1974, Stella produced eighty-nine prints at Gemini in Los Angeles. Over the next twenty years, Frank and Ken Tyler generated 109 multiples including the nine wall reliefs of the Playskool series. Between 1985 and 1993 Frank was at work on the various aspects of

his *Moby Dick* series. This included the two- and three-dimensional prints at Tyler Graphics, the paintings done in the 13th Street studio, and the three dimensional pieces which came out of the Bridgeport studio.

Tyler had this to say about what went on with artist and printer during the period:

Over the last eight years, Tyler Graphics has published 24 Moby Dick *prints. As in Frank's other work, these series commemorate previous prints by incorporating many of their elements. The complicated process of reworking, shaping and fitting existing fragments into new images depends on fine-tuned collaboration between the artist and the printers. Switching back and forth between the techniques of papermaking, lithography, intaglio, relief, and screenprinting, Frank not only invested the series*

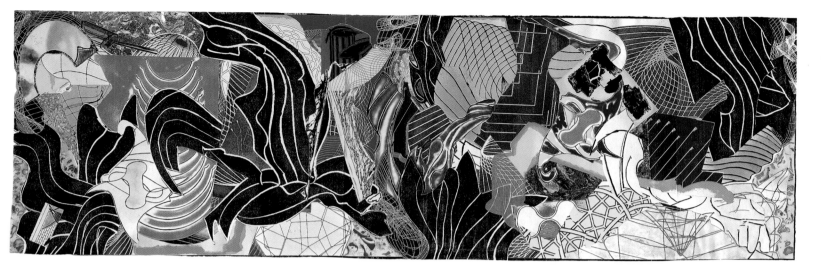

with an ever-growing repertory of images, but demonstrated the extent to which our collaborative strength has evolved over the years.

The nine prints in the *Moby Dick* deckle-edge series were completed in 1993. They were included in an exhibition in October at the National Gallery of Art in Washington, D.C., where Stella gave a lecture entitled "Grimm's Ecstasy." Paul Richard wrote in the *Washington Post*:

Nine of Stella's richest prints. . . .You've seldom seen such pictures. A quarter of a century of collaborative experience between Stella and printmaker Kenneth Tyler is apparent in each of them. Spatially and technically, and referentially as well, they're incredibly complex. . . .something in their spaces, in their unembarrassed opulence, tugs you toward the past.

And they would keep going, Stella and Tyler, Frank and Ken, continually breaking new ground.

In the last of the *Had Gadya* prints in 1989, Stella was still using the cones and pillars motif, albeit more loosely, even messily marked up. By 1990 the first of the *Moby Dick* prints, *The Symphony*, no longer bore cones and pillars, but employed a set of configurations and a new dynamics which related to the paintings Stella had been working on since 1986— with the exception of the wave. The wave, which he had hit upon early in Had Gadya, was, in many variations, going to stick around to become an ever more important player in Stella's art.

In a long article entitled "Shakespearean Fish," published in the October 1990 issue of *Art in America*, Philip Leider discussed the *Moby Dick* paintings in detail. In his first paragraph Leider traces Stella's progression:

During 1982–84 Frank Stella made a complicated series of prints entitled Illustrations After El Lissitzky's *"Had Gadya." One of the complications was that Stella introduced a variety of cutout shapes which he had separately printed in differing ways and then collaged to the print itself. Primary among these shapes were the clunky, jostling "cones and pillars" which became the distinguishing features of the troublesome 40 constructions titled after Italo Calvino's* Italian Folktales *that Stella executed during 1984–86. Sometime during 1986–87, in a group of 11 works corresponding to the end of the Calvino series, another motif, also first used in the "Had Gadya" prints, began to dominate and finally to replace the cones and pillars—the wave. It appears first in* Loomings, *then splashes over the cone, pillar and French curve in* The Crotch *and surges into possession of the entire surface in* The Spirit Sprout.

Ken Tyler and Frank Stella pull a print of *The Affidavit* from intaglio plates at Tyler Graphics in 1992.

Philip Leider maintains that "no single move in Stella's art since his shift to Tri-Wall in the Polish Villages opened up more possibilities to his creative energy than his abolition of the distinction between created and discovered forms in the workshop." By 1990 he was making enormous paintings which were constructed as much of left over shapes from the studio and foundry floors as they were of the specific pieces cut from patterns.

The last painting in the Moby Dick series was completed in 1992. He had been working on the paintings (three groups, Wave, Beluga, I.R.S.) for nearly six years. By the end of 1994 most of them had been sold.

In March 1993 at the Gallery Kaj Forsblom in Zurich, there was an exhibition of the prints from the Domes of the *Moby Dick* Series and there were two surprises. *The Fountain* (Chapter LXXXV of *Moby Dick...*) is a sixty-seven color hand-colored woodcut, etching, aquatint, relief, drypoint printed on three sheets of natural Kozo fiber handmade paper with seven screen printed natural Gampi fiber handmade paper collage elements. The specs go on for three or four hundred more words. Ken Tyler told me it was the most complicated work Tyler Graphics has ever produced. It is a spectacular, remarkable, blockbuster of a printed collage with a few thousand man hours involved in its creation.

Besides *The Fountain* and the other prints, there were a dozen pieces of ragged sculpture on low pedestals around the room. They are cast stainless steel and they combine hardened poured globs with the familiar shapes and texture, metal mesh and bars and pieces left over from Cones and Pillars, *Moby Dick*, and even the discarded plates from some of the prints.

Works from the same series had been shown at Knoedler's in the fall of 1992. In his review, "Stella as Sculptor," in *The New York Times* of 16 October, Michael Kimmelman reported:

Each work is a combination of cast and found pieces. The shapes include great curving slabs, cloudlike forms based on cigar smoke rings, aluminum pellets piled like heaps of tiny rocks, explosions of tinsel, and here and there a jutting post rising from the cacophony like the mast of a ship. Mr. Stella's formal instincts turn out to be nearly flawless. Time and again he combines these disparate elements into sculptures that twist and whirl and yet maintain a balletic grace.

Kimmelman went on to point out the artist's admiration of and the work's connection to the sculpture of Bernini, Julio Gonzalez, the younger David Smith, Anthony Caro, and John Chamberlain.

A few days later in the *Observer* (9 November 1992) Hilton Kramer's review of the same show was headlined, "Stella's Comic Muddling of 60's Nostalgia, 90's Opportunism." Over the last decade or so, Kramer and other critics have used terms includings desperate, eclectic, unrelated, messy, uncomfortable, chaotic, muddled, bizarre, and occasionally, junk. In one of our talks in the summer of 1994, Frank spoke some about the mean-spiritedness he has encountered along the way.

There's this tremendous urge to be superior. A lot of people want to find the Achilles heel or the weak link. It's good, but it can't be that good, they think. There must be something wrong with it. But for me, that's a waste of time and also it's rather stupid that they don't bother to separate what they're looking at, what they're supposed to be seeing, from the name of the artist.

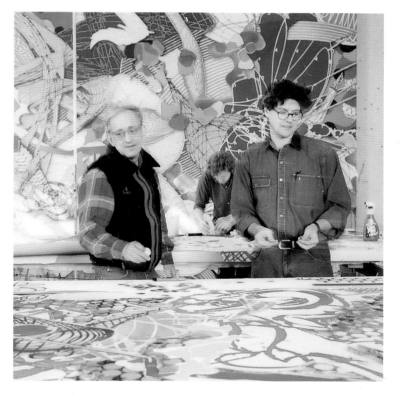

Stella and Earl Childress.

In the mid-seventies, Stella's operation was growing more complex and his work more complicated—to fabricate as well as to look at. He had bought the building on 13th Street and set about turning it into a studio. Earl Childress, a man in his mid-twenties, was working for the general contractor on the project of the conversion, the demolition and subsequent rebuilding of the interiors. By 1981, when most aspects of the studio refurbishment were wrapping up, Stella had gotten to know Childress and began asking questions dealing with fabrication techniques, metallurgy, and in particular, how he could improve aspects of the construction of the two enormous Shards pieces (*Shards III*, 3x and *Shards IV*, 3x) which were

problematic. Not only were they much more expensive than anticipated, but it also turned out that they were fragile, incredibly complex to handle, hence to move, and almost impossible to install without damage. "I spent a lot of time reworking the construction of these pieces and sometimes helping with the studio work," Childress told me in 1995, "This experience laid the foundation of our relationship, and I became an advisor in the construction of future work. I remember realizing at the time that if I was as good as I wanted to be, that is, if I solved all of the fabrication problems, I wouldn't be needed anymore. Fortunately, every new series has its own problems."

Salta del Mia Sacco! (1986) one of the Cones and Pillars, was a commission from the real estate developer, Mort Zuckerman, for the lobby of his building at 599 Lexington Avenue. It protrudes not quite three feet from the lobby's elegant marble wall but it is over thirty-two feet tall and twenty-eight feet across, the largest construction Stella had ever undertaken and so huge that when it came down from Bridgeport a hole had to be cut in the second floor of the studio so that the work could be put together and "hung" in one piece.

The 599 Lexington Avenue project marked the beginning of their new relationship. Childress has an uncanny grasp, not only of structures, how they go together and come apart, but an interest in and a feel for theoretical structures. Preparing the wall at 599 Lexington to receive this piece involved building a frame which would be attached to the building's steel frame, on the other side of the marble wall.

At about the same time Stella was beginning his career as a sculptor, he was also making a significant commitment in time and money to an activity akin to the practice of architecture. And as his activities grew more fragmented and widespread geographically, at the same time, as intense as ever, he relied more and more upon Earl Childress to oversee all the aspects of the fabrication of his pieces. In the summer of 1986, after they had rebuilt and painted and transported and installed the piece for 599 Lexington, Stella offered Earl and the XX team the job of operating the studio. "I accepted his offer, and we've been here ever since."

As late as 1985, Stella was steadfastly dealing with his constructions/paintings as works intended to be seen head on, from in front, and what went on with the backsides of their elements didn't matter. That philosophy resulted in each painting's having structural elements between the rear and frontmost planes which were intended not to be seen, and if seen, ignored. Childress maintains that his greatest contribution to Stella's art had been the development of a system of structure and bracing incorporating actual elements of the pieces. In other words, instead of structural members which looked like that, T-sections, I-sections, tie rods and assorted other bars, every member of a painting was to become a part of the structural system while at the same time being integral to Stella's fabulously Baroque or Gaudi-esque paintings.

Even though the Cones and Pillars popped out from two dimensions to three, it seems that the undulating, free-flowing wave first seen in the *Had Gadya* series was one of the most freeing aspects in the decade from 1985 to 1995. In any case, the undulation of the wave forms, the sinuosity of the smoke-ring drawings, and the repeating, baroque curve of the Brazilian beach cap (Frank bought the hat, a curious spiral of flat, yellow foam bands, from a vendor on Copa Cabana beach in Rio de Janeiro, and it has become an element common to his architecture and sculpture) combined to give the sculpture and architecture projects of the 1990s a looseness and, predictably, a sense of their own working space.

The wave form in Stella's work came along before there had been a whale. In the Had Gadya, in plate 8 of El Lissitszky's "The water came and extinguished the fire," the water's form was a great, semi-circular wave which mimicked the arch of the top of the lithograph. Also, the wave can be traced back to the French curves, the ships curves and the Flexi-Curve in the Circuits. Alfred Pacquement spotted the wave early on:

Insatiable, Stella occupied himself with a new motif which appeared in the Had Gadya suite. This undulating form, not strictly identifiable, with its own soft motion like the folds of a garment, was brought onto the scene with the little, ceramic reliefs, colored with wax (1985) later cast in aluminum. The form also gives its name to an ensemble begun in 1986: "The Wave."[1]

The hat form appears as a skewed, canted roof of the model for the gatehouse of a large project by architects Frank Gehry and Philip Johnson. Although the gatehouse will not be built, Stella is relentless, thinks he's on to a good thing, and will use it in other projects another day.

Presented with a commission to do an immense sculpture for Richard Meier's Hypolux Bank in Luxembourg, Stella went about the project as he would have with a painting commission. That is, he made a maquette of the project, then tried to create the actual thirty-foot-high *Sarreguemines* as an enlarged copy of the model. As Earl Childress recalls, "Luxembourg was a new beginning. We used the model directly to enlarge the sculpture."

By the time the next sculpture commission came along, a monumental piece for the Kitakyushu Municipal Museum of Art in Japan, they had become more experimental in working with the model and in producing the actual elements in the piece. Childress gives a succinct account of the process:

From a few sketches, Nippon Steel made some tests and video-taped the results, mailed them to us, and Frank and I made plans to return to Japan in November. We arrived on Tuesday morning. We both started working right away: I started bending the hat shapes out of prepared stainless steel, and Frank went to the Nippon Steel scrap yard to select other material. The rest of the week was spent

working with our crew combining these elements. The following Monday Nippon Steel shut down the facility where we had been working, and invited 150 members of the Japanese press to witness our "free-pouring" nine tons of steel into the sculpture. The making of the sculpture became a national news event. The following afternoon we delivered the finished piece to the Kitakyushu Municipal Museum of Art. All of the creation jokes aside, it really did take us only seven days. By the end of the week we had made a seven cubic meter sculpture that is one of the best team efforts we have ever made.

David Mirvish was Stella's dealer in Toronto for fifteen years from 1963 until 1978. In that year, he left the art business to join his father's company which owns and manages theaters in Canada and England. Over the years he has remained steadfast in his admiration for Frank Stella and his work. In 1990 Mirvish engaged the services of Lett/Smith Toronto architects to design a 2000 seat theater in downtown Toronto, The Princess of Wales. Peter Smith, the partner and designer on the project, was happy to talk about the project with Stella. He says of that meeting:

We explained the project with the drawings on the table in front of us, including our mandate to build a rather traditional theater. Frank asked a few questions. In half an hour the meeting was over. Frank said he could provide the murals requested. When we went back to Toronto we were confident that he had understood every aspect of the interior of our building.

The Gate House, 1994
paper model, 20 × 21 × 27".

Originally Stella was hired only to decorate the public hallways. But because construction had just begun, Stella could watch the building's development, and was asked again and again for his ideas on the ornament of many more aspects of the building's interiors. His murals fill the soaring lobby and the stairwell. They cover the lounges, foyers, and even the great ring around the dome over the auditorium. And there are fabulous abstract bas-reliefs on the dress circle, the fronts of the boxes, and on the ends of each row of seats. In the end, every public space in the theater had some of Stella's art.

What began as an offer for Frank to paint a few murals turned into one of the greatest commissions since Marc Chagall's murals for the Paris

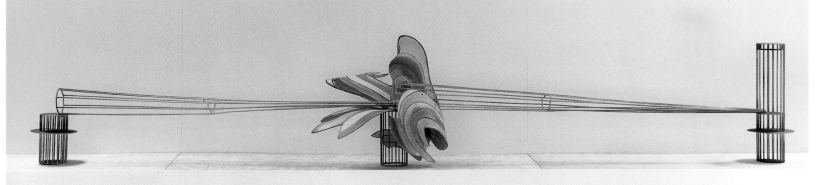

Opera in the 1950s or the W.P.A. projects of the 1930s in the United States.

Whether or not Stella's architectural projects get built, they generate a great deal of interest and discussion. One of them, a project for a bridge across the Seine in Paris, was brought to the attention of Peter Rice, a well-known structural engineer with an international reputation. The bridge not only got Stella involved with a highly respected engineer, but it led to the offer from the Italian architect Alessandro Mendini to design a pavilion for the exhibition of sixteenth- and seventeenth- century painting as part of his new museum project for Groningen in the Netherlands. In this structure, as with the subsequent design for the Dresden art museum, the derivation of the shape is heavily influenced by Chinese lattice patterns.

In the 12 July 1992 issue of the newspaper *Berliner Zeitung* there appeared an article titled "The Most Expensive Napfkuchen (Ring-cake) in the World":

Frank Stella has caused sensation after sensation with his works. Art historians argue that his works are too self-consciously bold and decorative. Now he is a causing a sensation in Germany with his latest trick: The art gallery project right next to the baroque tower in Dresden. Frank Stella wants his first architectural experiences to be in the highly historical center of Dresden, in the "Duchess Garden" area. A violent bright blue, cake-shaped structure is to materialize between the Neo-renaissance buildings, which are over 200 years old.

"After all, buildings are nothing more than oversized sculptures," asserts Stella in justifying his project. "The buildings are not threatening, and they fit in extremely well with the green garden landscape." The building, however, has caused great controversy and it is doubtful it will be realized.

In the course of a conversation in 1993, Richard Meier asked Frank if he got around to the galleries to see

Childress, Stella
Bridge Project across the Seine River, Paris, 1988, carbon steel and aluminum, 35½ × 196¾ × 27½".

Childress, Stella
Kunsthalle and Garden, Dresden, 1992 colored Sintra and plaster model, 10 × 56 × 36".

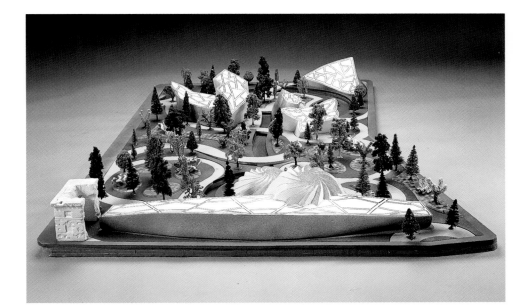

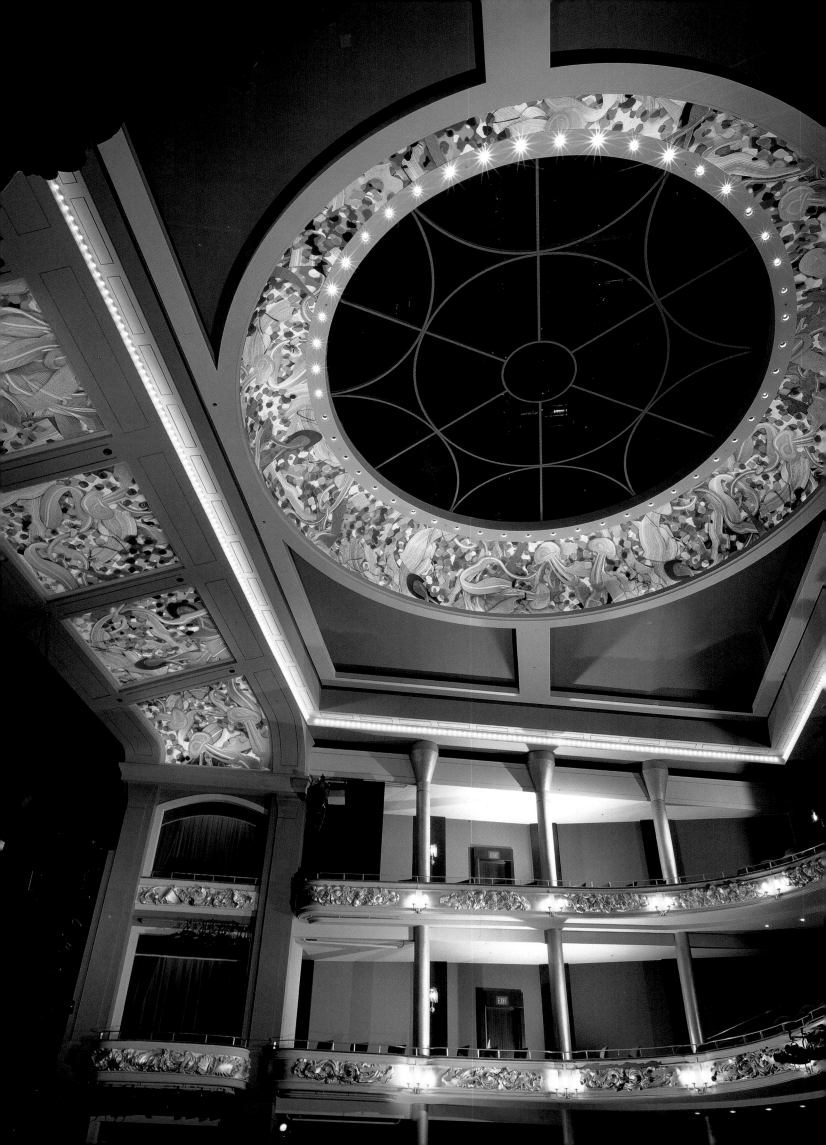

what was going on. "No, not very much," Frank replied, continuing:

I actually went to the Whitney Biennial yesterday. I know what the ideas are, what things are about. I can tell an installation from a pile of rubble. It certainly wasn't pictorially engaging. But that is not what bothered me because I don't really care what people do or even how they make art. I care about their effort to make art. If they find a nonpictorial way of making convincing art, they can convince me. The problem I had with the Biennial was the conformism. The social and political ideas were all slightly to the left of center, and were all basically the same, and I thought that reflected a kind of timidity. It seemed the curators went out and found the people who would give them exactly what they wanted. It just lacked any kind of spontaneity and personality. It also lacked failure. Nothing was that bad. It just was not very good.

In April 1994 Frank Stella spoke at Auburn University. His talk, which he calls "Grimm's Ecstasy," laments the direction contemporary art is taking:

Think of the kind of conflict that flourished here [New York] in the 1980s when painting seemed at odds with itself, desperate to stand up and deny any links to the

Princess of Wales Theatre Project, 1992–93, dome and proscenium murals, and balcony reliefs (left) and pit-lounge mural, Toronto, Canada.

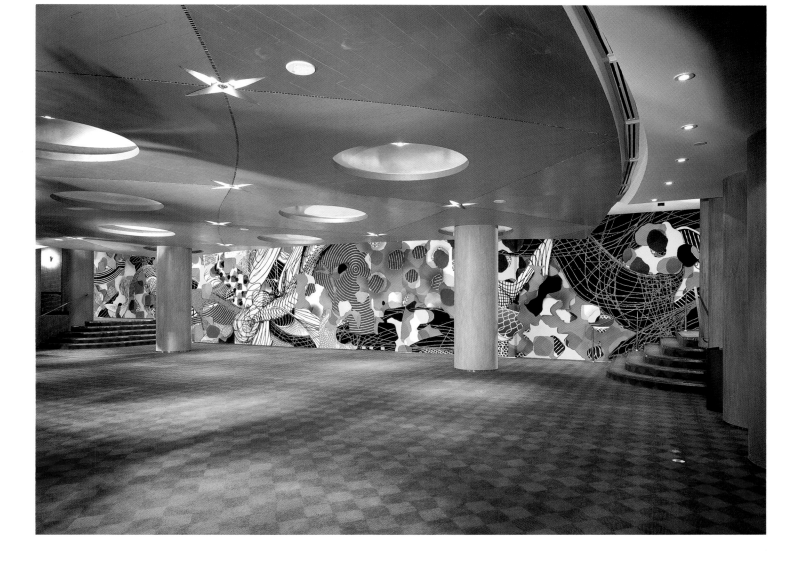

quality of the past, as if we all couldn't tell the difference. It was apparent that the decade's narcissism slash romanticism wanted to obviate the most obvious fact of its existence—that it was engendered by an accomplished and meaningful past. Some of this know-nothing, in-crowd attitude spilled over into the public domain. Suddenly the painting of the past was no longer a precious resource. It was just what happened before there were galleries on West Broadway.

In 1990 as Stella was approaching the completion of the *Moby Dick* paintings, he hit upon another visual leitmotif. Frank Stella is a lover of Cuban cigars, and like many connoisseurs he particularly enjoys the lazy Baroque curvings of cigar smoke in a still place. "What if we could make three-dimensional depictions of cigar smoke?" asked Frank. Earl, Andrew Dunn, a cinematographer, and Steve Sloman, the person who, over the years, has photographed most of Stella's work, came up with the idea of big black box. The box was a cube, six feet on a side with a single lens reflex camera attached to and pointed through a hole in the center of the each of the four sides, the top and the bottom. The box was lined with a completely non-reflecting black cloth and there was a hole at the center point of each of the four vertical edges. Two of these were fitted with incandescent light bulbs. The other two were open so that the artist could blow smoke into the cube. The cameras, synchronized to expose simultaneously, took hundreds of pictures of the smoke forms. Some of these images were sent to AB Tumba Bruk in Sweden, the world's foremost producer of the delicate engravings used on bank notes. Others were processed into three-dimensional computer models. The results were sets, series, and configurations of writhing, undulating forms made up of the computer generated lines—thousands of them—which are convincing facsimiles of smoke—clouds and rings, puffs, and ribbons—depicted in two and three dimensions. The first pictures of Frank Stella's boxed smoke were taken on November 26, 1990.

The first sighting of the smoke imagery is in *The Funeral*, the black and white print from the *Dome* series, published in 1991. The smoke imagery became increasingly significant in the prints of the final *Moby Dick* series, the Deckled Edges, and in the eleven prints published in May of 1995—The Imaginary Places series—the smoke imagery asserts itself, crowds the edges and compresses the centers. In October 1994 in an installation of hyperbolic paraboid shaped paintings at Knoedler & Company in New York, the smoke appears everywhere, in an assortment of sizes, and scales and drawn with lines of various widths.

The artist and his team are currently at work on the panels which will comprise a painting for the towering lobby of a Roche & Dinkeloo skyscraper in Singapore. The painting is actually a triptych with three "panels" each nearly five stories high and respectively seventeen, twenty-four, and seventeen feet wide. It relates closely to the smoke imagery paintings of the Toronto theater project.

The eleven works of the Imaginary Places series are complex visually and overwhelmingly complex technically—they involve, among other techniques, lithography, etching, screenprinting, woodcut, aquatint, collagraph, engraving— and appear to explode and implode at the same time. And like the Playskool series of constructions they magically look backward and forward simultaneously. These tightly wound images, with their dislocations of space and scale, seem to have strong connection to Giovanni Batista Battista Piranesi's *Carceri d'Invenzione* of 1760. As Malcolm Campbell, in his monograph, *Piranesi: The Dark Prisons*, writes, "In the art of the twentieth century, similarities to Piranesi's manipulations of perspective and scale in the *Carceri* can be found in the movements of Cubism and Surrealism."

But Stella's debt to the great art of the past is never his burden. And to understand just what these most recent works presage is to wait and see— as a rule not very long. Watching Stella, the surprises come along quickly. The late Morse Peckham wrote, "The highest praise is reserved for artists, like Michelangelo and Beethoven, who continued to grow until they died, that is, continued to exhibit a steady and sometimes an increasing rate of stylistic dynamism throughout their entire careers." By Peckham's standard, Stella will be worthy of the highest praise.

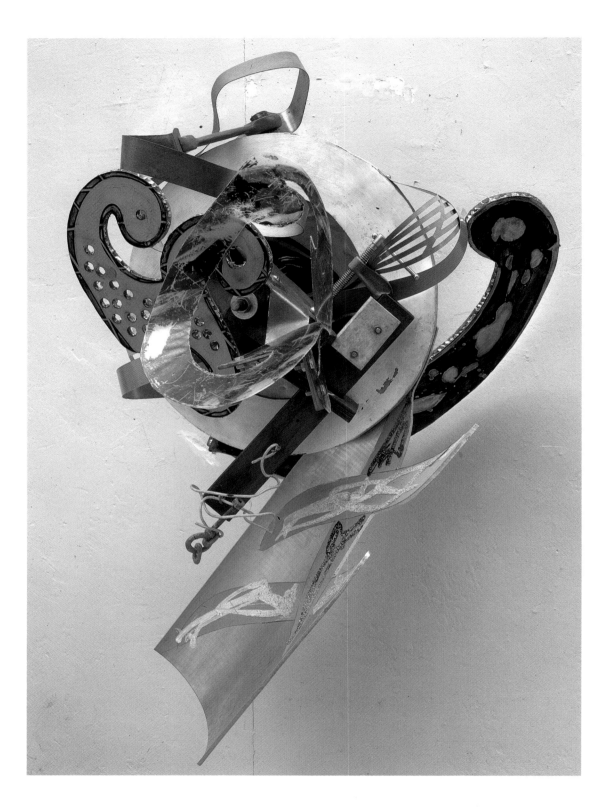

Playskool Clamp (AP), 1983
mixed media, 39 x 24 x 20".

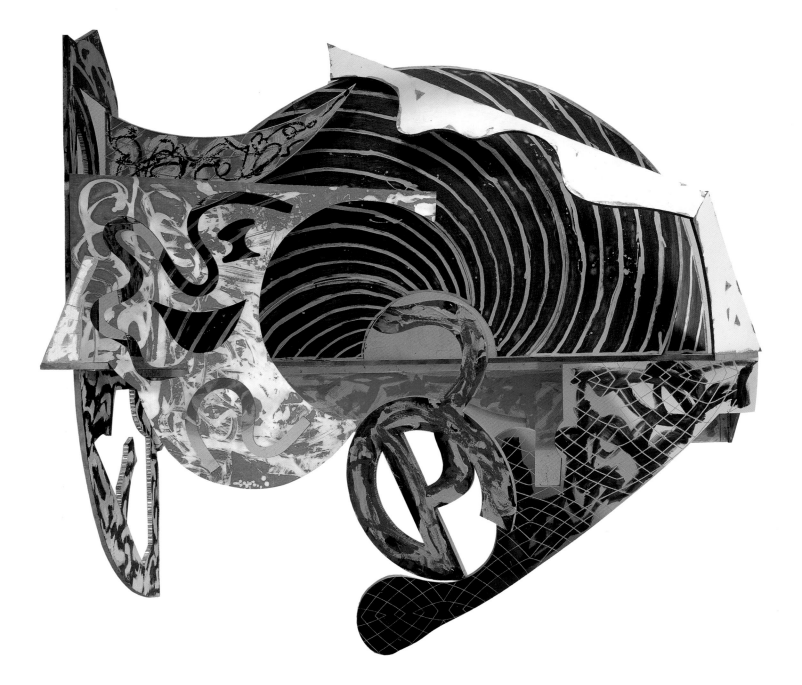

Birkirkara (#7), 1984,
mixed metal, 150 × 153 × 78"
Collection of the Nelson-Atkins
Museum of Art, Kansas City, Missouri.

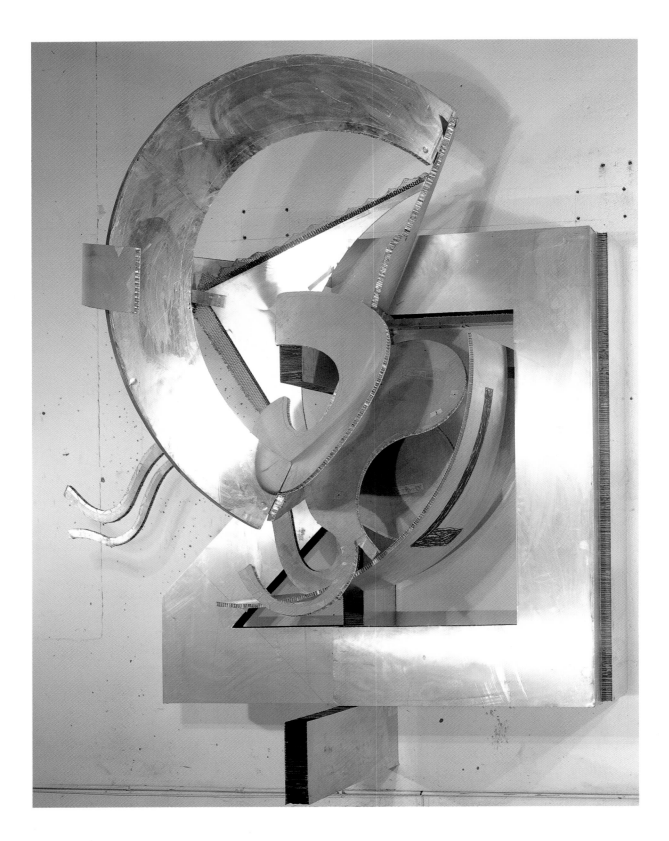

President Brand, 1982
unpainted honeycomb aluminum,
121 × 101 × 78"
The Saatchi Collection, London.

Then came a fire and burnt the stick,
1982–84
hand colored and collaged with litho-
graphic, linoleum block and silkscreen
printings, 52 × 52¾"
Courtesy of the Alan Cristea Gallery,
London.

A hungry cat ate up the goat,
1982–84
hand-colored and collaged with litho-
graphic, linoleum block, silkscreen
and rubber relief printing,
45½ x 53½".
Courtesy of the Alan Cristea Gallery,
London.

Diavolozoppo (#2, 4x), 1984
mixed media on canvas, etched
magnesium, aluminum and fiberglass,
139⅛ × 169¾ × 16⅛".

Lo sciocco senza paura (#1, 3.8x), 1985
mixed media on etched magnesium,
aluminum and fiberglass
126 × 117¾ × 20¾".
Kawamura Memorial Museum of Art,
Sakura, Japan

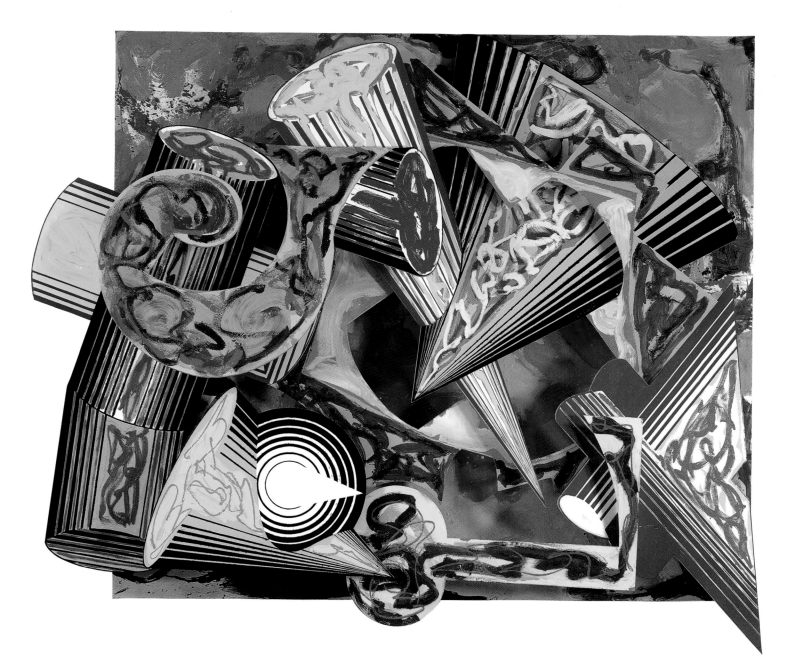

La vecchia dell'orto (#20, 4x), 1986
mixed media on mixed ground,
163¾ x 190¼ x 32½

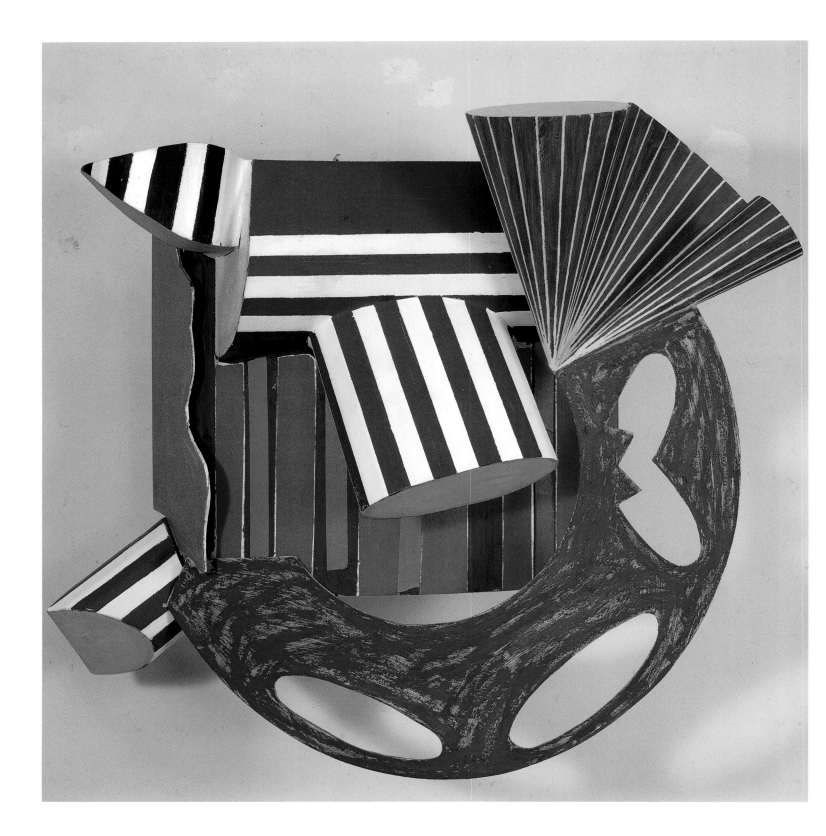

Bene come il sale (#4, 1x-3D), 1987
mixed media on fabricated
aluminum, 30⅞ × 34⅝ × 21⅜".

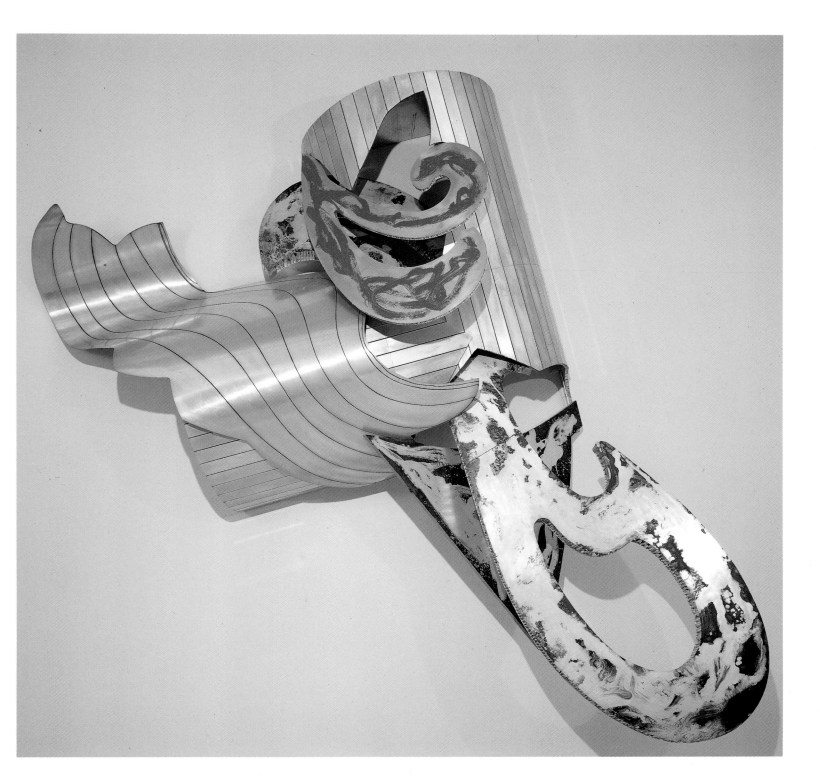

Loomings (3x), 1986
ink, oil on etched magnesium and aluminum, 142⅛ × 162½ × 44" Collection of the Walker Art Center, Minneapolis, Minnesota. Gift of Joan and Gary Capen, 1987.

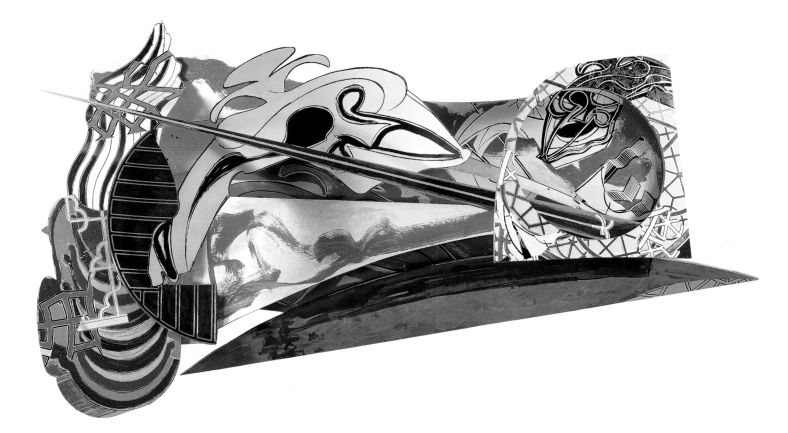

The Chase. Second Day (IRS #14 ,1.875x), 1988-89
mixed media on etched magnesium and aluminum
110¼ x 218⅝ x 51¾".

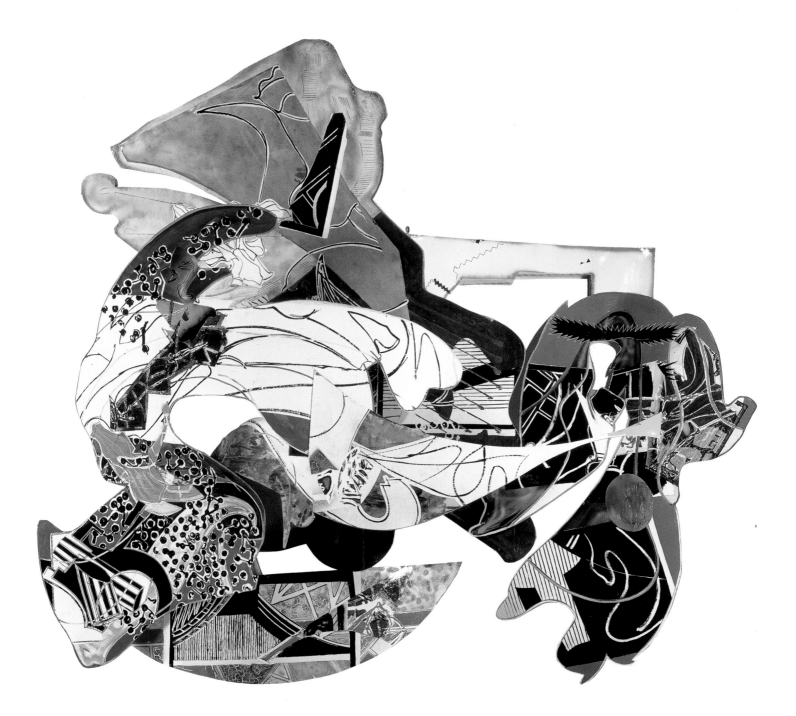

The Pequod meets the Rosebud (D-19, 2x), 1990
mixed media on aluminum and magnesium
159½ × 186 × 57".

Sarreguemines, 1992,
stainless steel, 21 × 17 × 17'
Commissioned by and installed at
Hypo Bank, Luxembourg.
Richard Meier & Partners, architect

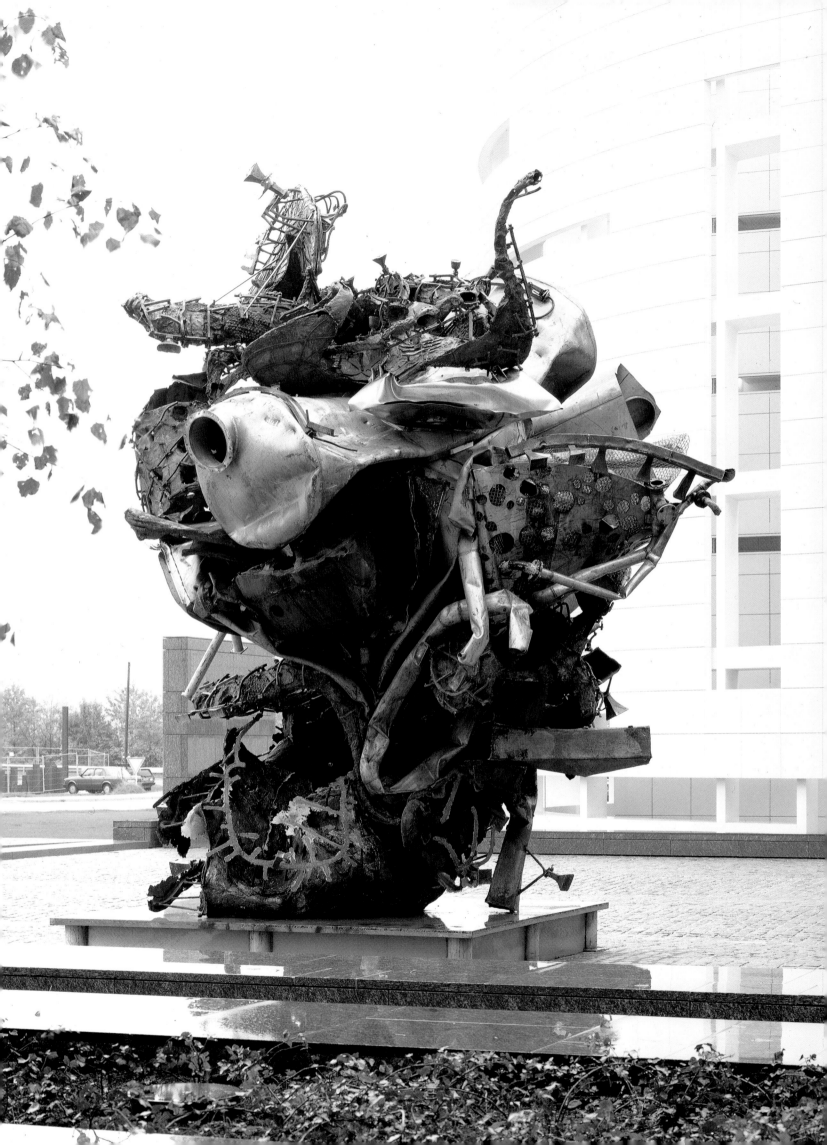

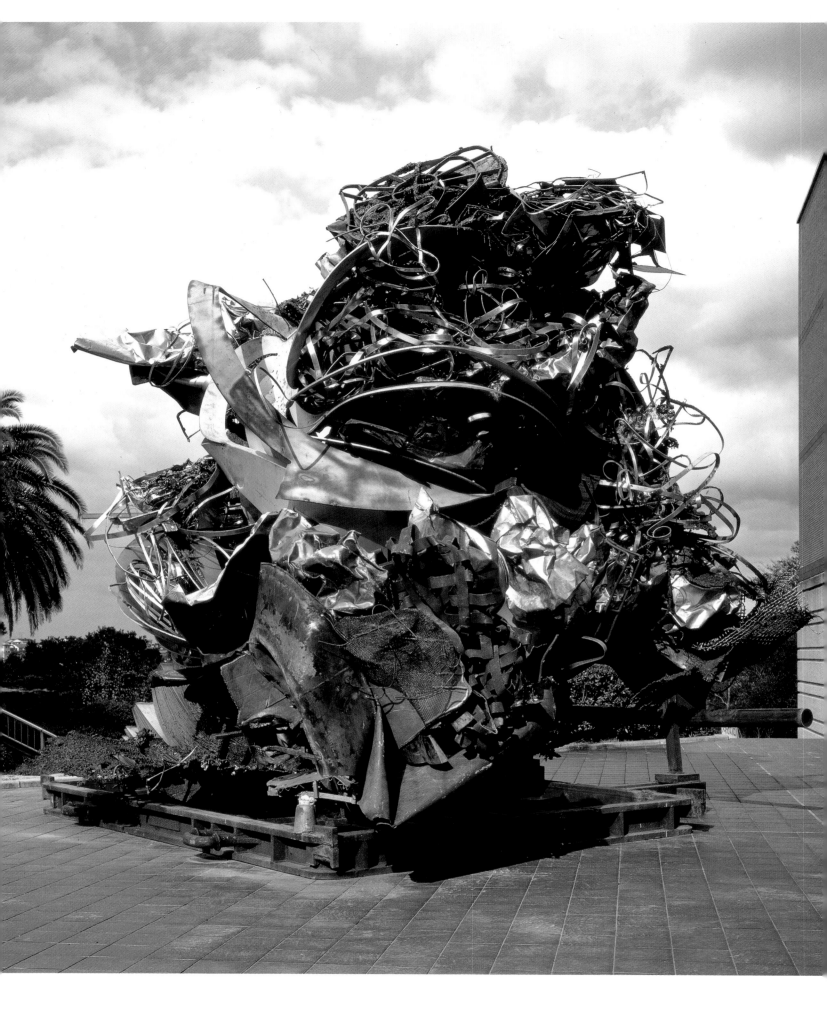

Yawata Works, 1993
stainless steel, steel,
168 × 187 × 189¾"

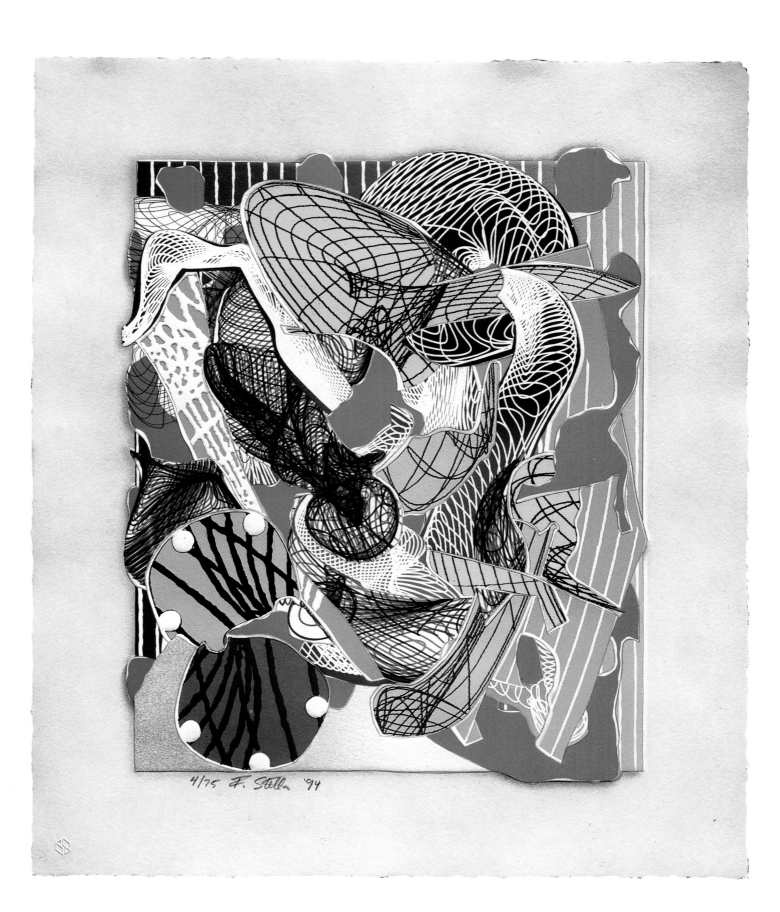

4/75 F. Stella '94

Limanora, 1994
lithograph, etching, aquatint, relief
24 x 21".

AFTERWORD

On February 17, 1994 Frank Stella gave a lecture at the Architectural League in New York entitled "Pictorial Architecture." The League asked me to introduce Frank's talk, which I was only too happy to do. But since I was planning on spending the day working on sculpture at Tallix Foundry in Beacon, New York, it was going to be difficult for me to get back to Manhattan in time to shower and change for the lecture. Frank and I discussed this and decided together that I, the "architect" would introduce the "artist" dressed as an "artist" and Frank, the "artist" would give his lecture on architecture dressed in tie and jacket as an "architect." In the end, however, we both appeared in tie and jacket. Frank, as usual, had been willing to break out of his expected role and take a risk.

From the very beginning of his career, Frank has been pushing the limits of his art. From the early Black paintings, to the irregular shaped canvases, to the three-dimensional pieces of the eighties, to the large-scale sculpture and architectural projects of the nineties, Frank is constantly working and exploring and re-examining the issues which are most important to him. This tenacity has been a source of inspiration to me during our thirty-five-year friendship. We have discussed and analyzed each other's work over the years, and I always find that I see something new in my own work after a visit with Frank.

Frank is a rare and talented artist who has created some of the best art of the last half of this century, but I suspect that the very best is still to come.

Richard Meier
New York
February 1995

NOTES

Quotations that are not cited in the notes are taken from interviews conducted by the author.

Chapter 1
1. Frank Stella, *Working Space,* The Charles Eliot Norton Lectures (Cambridge, MA: Harvard University Press, 1986) p. 162.

Chapter 2
1. Quoted in Brenda Richardson, *Frank Stella: The Black Paintings* (Baltimore, MD: Baltimore Museum of Art, 1976), p. 78.

Chapter 3
1. Quoted in Robert Katz, *Naked by the Window* (New York: The Atlantic Monthly Press, 1990), p. 100.
2. Richardson, p. 12.
3. William Rubin, *Frank Stella*, (New York: Museum of Modern Art, 1970), p. 44.
4. Emile De Antonio and Mitch Tuchman, *Painters Painting* (New York: Turin Film Corporation, 1984.)
5. Robert Rosenblum, "Introduction," *Frank Stella Paintings 1958–1965* (New York: Stewart, Tabori & Chang, Publishers, 1986), p. 10.

Chapter 4
1. Calvin Tomkins, *Post- to Neo-: The Art World of the 1980's* (New York: Penguin Books, USA, 1989), p. 155.
2. W. Rubin, *Stella*, p. 53.
3. Quoted in W. Rubin, *Stella*, p. 60.
4. Robert Rosenblum, *Frank Stella* (New York: Penguin Books, 1971), p. 21.
5. Rosenblum, "Introduction," p. 19.
6. Rosenblum, *Stella*, pp. 28–29.

Chapter 5
1. Rosenblum, *Stella*, p. 25.
2. Quoted in Tomkins, p. 160.
3. Rosenblum, *Stella*, p. 30.
4. Alfred Pacquement, *Frank Stella* (Paris: Flammarion, 1988), p. 44.
5. Lawrence Rubin, *Frank Stella Paintings 1958–1965* (New York: Stewart, Tabori & Chang, 1986), p. 247.
6. Rosenblum, *Stella*, pp. 41 and 43.
7. Rosenblum, *Stella*, p. 36.

Chapter 6
1. W. Rubin, *Stella*, p. 118.
2. Rosenblum, *Stella*, p. 43.
3. W. Rubin, *Stella*, p. 127.
4. Christian Geelhaar, *Frank Stella Working Drawings (Zeichnungen)*, translated by Cyrus Hamlin, (Basel, Switzerland: The Kunstmuseum, 1980), p. 110.
5. Geelhaar, *Working Drawings*, p. 111.
6. W. Rubin, *Stella*, p. 124.
7. Philip Leider, "Shakespearean Fish," *Art in America*, October 1990, p. 56.
8. Tomkins, p. 43.
9. Quoted in Rubin, *Stella*, p. 149.

Chapter 7
1. L. Rubin, *Stella 1958–1965*, p. 135.
2. Frank Stella, Institute of Contemporary Art speech, University of Pennsylvania, 1969.
3. Christian Geelhaar, *Kunstmuseum Basel: The History of the Paintings Collection* (Basel, Switzerland: The Kunstmuseum, 1993), p. 264.

Chapter 8
1. William Rubin, *Frank Stella 1970–1987* (New York: The Museum of Modern Art, 1987), p. 32.
2. W. Rubin, *Stella 1970–1987*, p. 32.
3. Philip Leider, *Stella Since 1970* (Fort Worth, TX: The Fort Worth Art Museum, 1978), pp. 11–12.
4. W. Rubin, *Stella 1970–1987*, p. 37.
5. Margit Rowell, *The Planar Dimension* (New York: The Solomon R. Guggenheim Foundation, 1979), p. 77.

6. Pacquement, p. 86.

7. Richard Axsom, *The Prints of Frank Stella 1967–1982* (Ann Arbor, MI: The University of Michigan, 1983), p. 88.

8. Axsom, p. 97.

Chapter 9

1. Axsom, p. 130.

2. Quoted in W. Rubin, *Stella 1970–1987*, p. 77.

3. Richardson, pp. 3–4.

4. Axsom, p. 130.

Chapter 10

1. Axsom, p. 138.

2. Leider, *Stella Since 1970*, p. 98.

3. Robert Hughes, *Frank Stella: The Swan Engravings* (Fort Worth, TX: The Fort Worth Art Association, 1984), p. 8.

Chapter 11

1. Tomkins, pp. 172–173.

2. Leider, *Stella Since 1970*, p. 89.

3. Howard Hibbard, *Caravaggio* (New York: Harper & Row, 1983), p. 151.

Chapter 12

1. Pacquement, p. 136.

BIBLIOGRAPHY

Books

Albers, Josef. *Interaction of Color.* New Haven, CT: Yale University Press, 1971.

Axsom, Richard. *The Prints of Frank Stella, A Catalogue Raisonne, 1967–1982.* Ann Arbor, MI: The University of Michigan Press, 1983.

———. *Frank Stella:The Circuits Prints.* Minneapolis, MN: The Walker Art Center Press, 1988.

Campbell, Malcolm. *Piranesi: The Dark Prisons.* New York: The Arthur Ross Foundation, 1988.

DeAntonio, Emile, and Mitch Tuchman. *Painters Painting.* New York: Abbeville Press, 1984.

Fedier, Franz. *Frank Stella: Werke 1958–1976.* Germany: Kunsthalle Bielefeld, 1977.

Fried, Michael. *Three American Painters.* Cambridge, MA: President and Fellows of Harvard College, 1965.

Geelhaar, Christian. *Frank Stella Working Drawings 1956–1970 (Zeichnungen).* Translated by Cyrus Hamlin. Basel, Switzerland: The Kunstmuseum, 1980.

———. *Kunstmuseum Basel: The History of the Paintings Collection.* Basel, Switzerland: The Kunstmuseum, 1993.

Goldman, Judith. *Frank Stella: Fourteen Prints With Drawings, Collages, and Working Proofs.* Princeton, NJ: Princeton University Museum of Art, 1983.

Hibbard, Howard. *Caravaggio.* New York: Harper and Row, 1983.

Hoving, Thomas. *Making The Mummies Dance.* New York: Simon and Schuster, 1993.

Hughes, Robert. *Frank Stella: The Swan Engravings.* Fort Worth, TX: The Fort Worth Art Museum, 1984.

Katz, Robert. *Naked by The Window.* New York: The Atlantic Monthly Press, 1990.

Leider, Philip. *Stella Since 1970.* Fort Worth, TX: The Fort Worth Art Museum, 1978.

Lodder, Christina. *Russian Constructivism.* New Haven, CT: Yale University Press, 1983.

Meyer, Franz. *Frank Stella: Neue Reliefbilder—Bilder und Graphic.* Basel, Switzerland: Kunsthalle, 1976.

Miller, Dorothy C. *Sixteen Americans.* New York: The Museum of Modern Art, 1959.

Pacquement, Alfred. *Frank Stella.* Paris: Flammarion, 1988.

Peckham, Morse. *Man's Rage for Chaos.* New York: Schocken Books, 1965.

Poling, Clark V. *Kandinsky's Teaching at the Bauhaus.* New York: Rizzoli International Publications, Inc., 1986.

Reynolds, Jock. *American Abstraction at The Addison.* Andover, MA: The Addison Gallery of American Art, 1991.

Richardson, Brenda. *Frank Stella: The Black Paintings.* Baltimore, MD: The Baltimore Museum of Art, 1976.

Rose, Barbara. *American Art Since 1900.* New York: Frederick A. Praeger, Inc., 1967.

Rosenblum, Robert. *Frank Stella.* Baltimore, MD: Penguin Books, 1971.

Rowell, Margit. *The Planar Dimension.* New York: The Solomon R. Guggenheim Foundation, 1979.

Rubin, Lawrence. *Frank Stella Paintings 1958–1965.* New York: Stewart, Tabori and Chang, 1986.

Rubin, William. *Frank Stella.* New York: The Museum of Modern Art, 1970.

———. *Frank Stella 1970–1987.* New York: The Museum of Modern Art, 1987.

Stella, Frank. *Working Space.* Cambridge, MA: Harvard University Press, 1986.

Sullivan, Louis H. *A System of Architectural Ornament.* New York: The Eakins Press, 1967.

Tomkins, Calvin. *Post- to Neo-: The Art World of the 1980s.* New York: Penguin Books USA, 1988.

Reviews and Articles

Chave, Anna C. "Minimalism and The Rhetoric of Power." *Arts Magazine,* January 1990.

Cohen, Ronny. "Frank Stella." *ART News,* May 1985.

Curtis, Charlotte. "Frank Stella and Art." *The New York Times,* March 17, 1984.

Dean, Andrea Oppenheimer. "Roman Prize." *Historic Preservation,* November/December 1994.

DeBure, Giles. "Frank Stella L'Etoile de l'Amerique." *French Vogue,* May 1988.

Dormer, Peter. "Frank Stella Paintings as Tapestry." *Apollo,* February 1989.

Farber, Harold. "Painter's Speeding Sentence: Art Lectures for Public." *The New York Times.*

Fedier, Franz. "Notizen zu Frank Stella." *Kunst Nachrichten,* November 1976.

Finkelstein, Lois. "Seeing Stella." *Artforum,* June 1973.

Fiske, Edward B. "Painter's Strokes Help Him in Squash." *The New York Times,* May 30, 1986.

Forgey, Benjamin. "Starring Stella." *Washington Star News,* November 23, 1973.

———. "The Charisma of Frank Stella." *The Washington Star,* April 21, 1979.

Fox, Catherine. "More In Common Than Meets the Eye in Stella, Freud Retrospectives." *The Atlanta Constitution,* October 18, 1987.

Frank, Peter. (review) *ART News,* September 1975.

Frackman, Noel. "Frank Stella's Abstract Expressionist Aerie: A Reading of Stella's New Paintings." *Arts Magazine,* December 1976.

———. "Tracking Frank Stella's Circuit Series." *Arts Magazine,* April 1982.

Friedman, Alan. "Frank Stella: Pop Versus Pagan." *M,* June 1992.

Galloway, David. "Stella's Deep-Dish Pie." *International,* February 1993.

Golding, John. "The Expansive Imagination." *Times Literary Supplement,* March 27, 1987.

Glueck, Grace. "Art: Frank Stella's Prints at the Whitney." *The New York Times,* January 14, 1983.

Heartney, Eleanor. "Frank Stella at 65 Thompson." *Art in America,* June 1991.

Hellekson, Diane. "A Renowned Artist Expands His Horizons." *St. Paul Pioneer Press Dispatch,* October 16, 1988.

Hopkins, Budd. "Frank Stella's New Work: A Personal Note." *Artforum,* April 1976.

Hughes, Robert. "The Grand Maximalist." *Time,* November 2, 1987.

Jones, Caroline. "Spaces and The Enterprise of Painting." *Harvard Magazine,* May–June 1984.

Kertess, Klaus. "Blade Runner Meets Bernini." *Elle Decor,* April/May 1993.

Kramer, Hilton. "Frank Stella Retrospective at the Modern." *The New York Observer,* October 19, 1987.

———. "An American Dommage To Matisse's Legacy." *The New York Observer,* June 21, 1993.

Larson, Kay. "Stella Performance." *New York Magazine,* October 26, 1987.

Leider, Philip. "Literalism and Abstraction: Reflections on Stella Retrospective at the Modern." *Artforum,* April 1970.

———. "Shakespearean Fish." *Art in America,* October 1990.

McGill, Douglas C. "A New Stella in Office Lobby." *The New York Times,* April 25, 1986.

Moorman, Margaret. "Frank Stella." *ART News,* Summer 1989.

"The Most Expensive Napfkuchen in the World." *Berliner Zeitung,* July 12, 1992.

Muchnic, Suzanne. "A Monumental Affair By First-Rate Artists." *Los Angeles Times,* June 11, 1984.

Peters, Brooks. "Behind Closed Doors: Frank Stella." *Met Home,* July/August 1993.

"Prints Published: Frank Stella, The Whale as a Dish." *The Print Collector's Newsletter,* Vol. XX 1960.

Rinzler, Peter. "Frank Stella: A 17-Year Retrospective." *Splash Magazine,* Winter 1987.

Ratcliff, Carter. "Frank Stella: Portrait of the Artist as an Image Administrator." *Art in America,* February 1985.

Raynor, Vivien. "Frank Stella Exhibits at His Alma Mater." *The New York Times,* November 7, 1982.

Rayport, Jennifer. "From Art School to Playskool." *Independent,* December 8, 1983.

Reiss, Robert. "Frank Stella '58—Opening New Realms in Contemporary Art." *Princeton Alumni Weekly,* June 11, 1979.

Richard, Paul. "Stella: Not So Simple Anymore." *The Washington Post,* November 10, 1973.

———. "But Long May It Live!" *The Washington Post,* November 21, 1993.

Russell, John. "Art: Beyond Good and Bad Taste." *The New York Times,* October 8, 1976.

———. "The Power of Frank Stella." *The New York Times,* February 1, 1985.

———. "Risky Works From Stella at the Museum of Modern Art." *The New York Times,* October 16, 1987.

Schwabsky, Barry. "Frank Stella." *Arts Magazine,* April 1991.

Smith, Roberta. "Frank Stella's New Paintings: The Thrill is Back." *Art in America,* November–December 1975.

———. "Schnabel and Stella: Art, Myth, and Ego." *The New York Times,* December 6, 1987.

———. "Frank Stella, 65 Thompson Street." *The New York Times,* December 14, 1990.

———. "Frank Stella's New Direction." *The New York Times,* October 21, 1994.

Stephens, Suzanne. "Portrait: Frank Stella, Blurring the Line Between Art and Architecture." *Architectural Digest,* July 1994.

Storr, Robert. "Frank Stella's Norton Lectures: A Response." *Art in America,* February 1985.

Wheeler, Colin. "Frank Stella: Reassuringly Expensive?" *The Independent,* July 10, 1990.

"Who What Where When Why." *The New York Thoroughbred Report,* May 1991.

Wilson, William. "Frank Stella: Minimalist to the Max." *Los Angeles Times,* June 4, 1989.

INDEX

Note: Page numbers in *italics* refer to illustrations. Artworks are by Frank Stella unless otherwise noted.

PHOTOGRAPHY CREDITS

Transparencies of works by Frank Stella are from the Knoedler Gallery Archives, Tyler Graphics, or credited institutions. Personal photos not credited are courtesy of Sidney Guberman or Frank Stella's family, friends, and associates.

Star Black: 206-207.

Courtesy of BMW: 178.

Martin Bühler: 28, 29, 51, 72, 98a, 98b, 98c, 98d, 99a, 99b, 122, 123, 124.

Leo Castelli Gallery: 49.

Ken Cohen: 92, 130, 169, 230.

Henri Dauman: 101.

Hollis Frampton: 41, 47, 64b, 84.

Lindsay Green: 182.

Courtesy of the Harvard University Art Museums: 193a, 193b.

Bruce C. Jones: 166, 171, 188, 224, 225, 226.

Joseph Klima, Jr.: 131.

Reto Klink and Urs Siegenthaler: 134, 145.

Malcolm Lubliner: 105.

Robert Mapplethorpe: 43.

Laura McPhee: cover, 213, 238, 239, 248.

Elizabeth Menzies: 22, 23.

Douglas M. Parker Studio: 168.

Courtesy of Phillips Academy Archives: 15.

Bob Rehder: 14a, 14b.

Sherwin, Greenberg, McGranahan & May, Inc.: 108.

Steven Sloman: 3, 10, 112, 113, 137, 144, 181, 184, 185, 186, 187, 204, 211, 212, 216, 217b, 222, 227, 228, 229, 232, 233, 235.

Rick Stafford: 4-5.

Lee Stalsworth: 67.

F.J. Thomas: 140, 147.

Luca Vignelli: 240.